Maya Yucatán

Maya

Summit vista—South Pyramid, Uxmal.

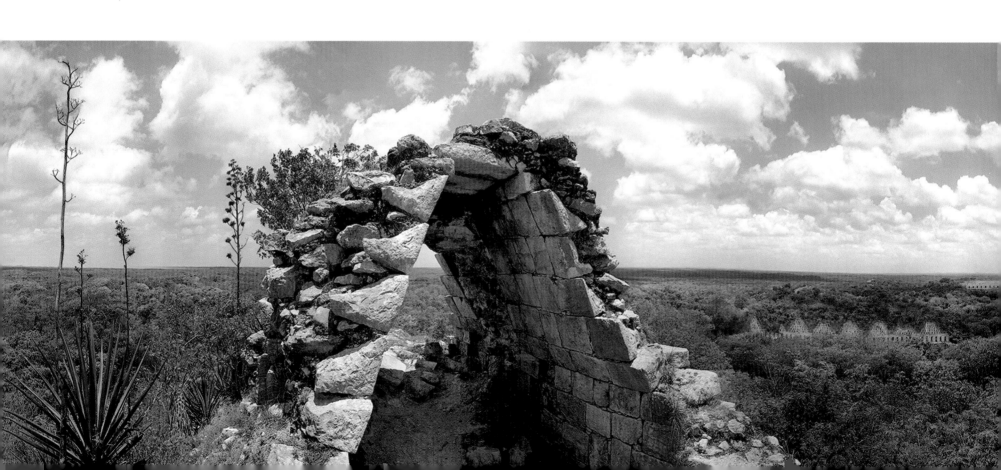

Yucatán
An Artist's Journey

PHILLIP HOFSTETTER

UNIVERSITY OF NEW MEXICO PRESS ALBUQUERQUE

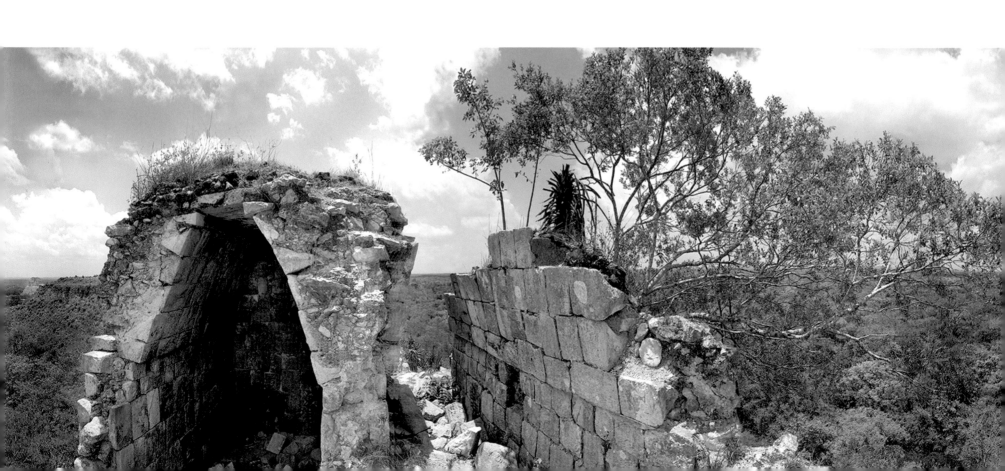

16 15 14 13 12 10 09 1 2 3 4 5 6 7

Library of Congress Cataloging-in-Publication Data
Hofstetter, Phillip, 1949–
Maya Yucatán : an artist's journey / Phillip Hofstetter.
p. cm.
Includes bibliographical references.
ISBN 978-0-8263-4694-0 (cloth : alk. paper)
1. Mayas—Antiquities.
2. Mayas—Antiquities—Pictorial works.
3. Yucatán (Mexico : State)—Antiquities.
4. Yucatán (Mexico : State)—Antiquities—Pictorial works.
5. Mexico—Antiquities.
6. Mexico—Antiquities—Pictorial works.
7. Yucatán (Mexico : State)
8. Yucatán (Mexico : State)—Pictorial works.
9. Excavations (Archaeology)—Mexico—Yucatán (State)
10. Hofstetter, Phillip, 1949—Travel—Mexico—Yucatán (State)
I. Title.
 F1219.1.Y8H64 2009
 972'.01—dc22
 2009014546

Design and composition by Mina Yamashita.
Text composed in Adobe Jensen Pro, an Adobe original designed by Robert Slimbach.
Display composed in Frutiger Condensed, designed by Adrian Frutiger in 1976, and
Cronos Pro, also designed for Adobe by Robert Slimbach.
Printed and bound in China by Everbest Printing Company Ltd.
through Four Colour Imports, Ltd.

For my wife, Nina, artist and world traveler

Contents

El Mirador, Sayil.

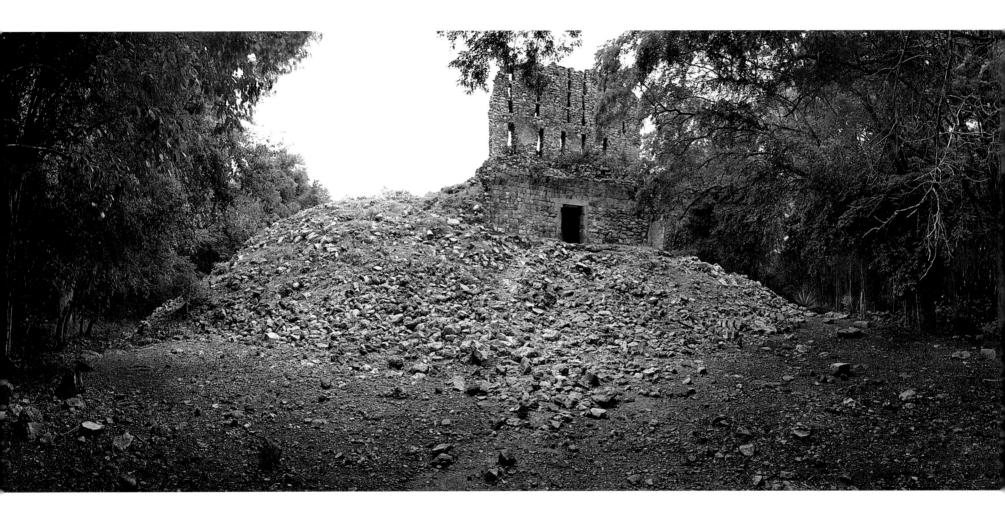

Foreword Being There in Yucatán | David Freidel

I have been blessed with artists in my life, so when I found myself in Palenque with Phil Hofstetter and Don Bright while they filmed a documentary about Merle Greene Robertson, I gave them my best effort. Phil befriended me and showed up at Yaxuná, cameras in tow, ready to go to work. He wanted to create a new kind of record of an archaeological project, a film record that went beyond the normal frames of time and logistics and plot to encompass the unfolding sense of things. Everyone on the project soon learned that Phil was much more than a photographer and filmmaker. He had many roles, first and foremost companion on the journey, friend, witness, councilor, "safety officer" (an inside joke as it is sometimes difficult to get field archaeologists to look out for themselves)—the list is a long one. He was part of the project. It's as simple as that. He was as necessary to the normal practice of the work as everyone else there, and in many ways particularly important to the life of the camp.

But he is a photographer of exceptional genius and eye and a remarkable film documentary master in Maya archaeology. I have learned to at least catch a glimmer of how that genius captures images of antiquity, archaeology, the Maya, which always make my heart leap, images that ornament this book. He has a way of being there. Over the many years we have collaborated in the field, I have never ceased to admire his disappearing act. Phil has an uncanny ability, when filming events or activities on an archaeological project, to become virtually invisible when he wants to. I think it has to do with the way that he becomes part of the social fabric of the work. The archaeologists and the Maya know he is there. But, accepting that he is doing his job just as they are doing theirs, people generally ignore him while focusing on the task at hand. In this way, Phil disappears into the ambient scene he is photographing. While his mind is contemplating

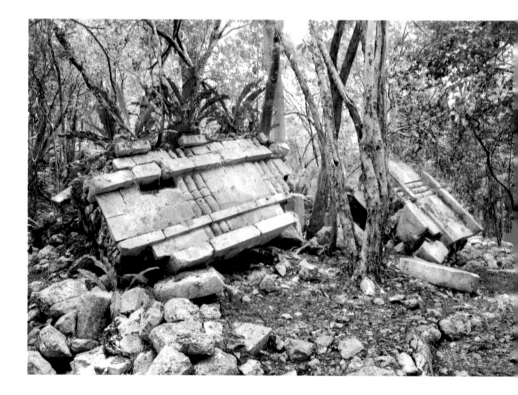

Fallen facade at Kiuic.

The Monjas Plaza at Chichén Itzá.

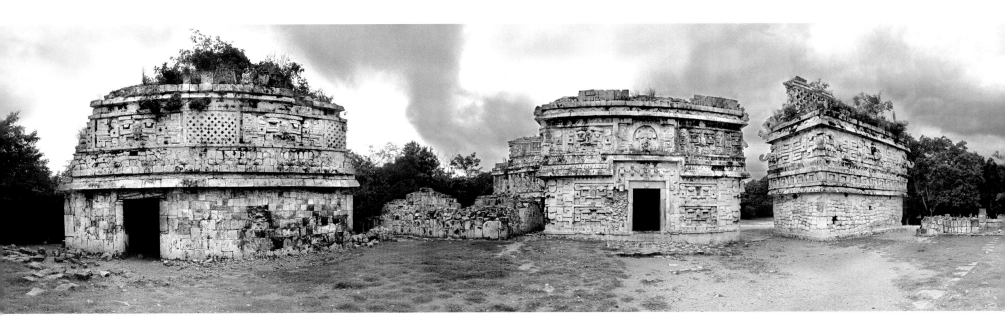

light and composition, his being is in the moment, engendering image. Incidentally it's different when Phil wants a sit-down interview. I have never minded talking to cameras, but some people in the field find it hard, at least at first, and it takes sensitivity and skill to draw them out as Phil does. After a while they get used to it, and they have in the process learned something about being public archaeologists.

Phil is what we anthropologists call a good participant observer. Once he had participated in one archaeological project, he followed friendship networks to more. Gradually Phil came to have a uniquely informed perspective, visual and otherwise, on the field of internationally collaborative archaeology in Yucatán. The field is a portal, suspended beyond the ordinary experiences of academic campus life somewhere out in the general direction of creative encounter. Archaeologists pride themselves on being scientists disciplined to make meticulous observation in the field. When excavating, they get just one chance to get the observational record right, a pressure-laden experience that healthy projects balance with improvised R & R. Like a Zen master, Phil could sometimes stop the clock right in the middle of a stressful day. One image sticks: a photo of Phil's face looking at the camera while a butterfly harvests sweat from his forehead. Most

of the time, he just does what he can to cleanse the camp of those stresses everyone brings back with them, packed in their minds and bodies along with the irreplaceable observations of their craft. He understands and comfortably inhabits the in-between places where archaeologists find themselves when trying to decompress. In those places archaeologists sift through their experiences of the day or take breaks from conscious effort through seemingly absurd activities like croquet played by rules of which the Red Queen would likely have approved. Science is, of course, a creative process, and field science needs open and flexible minds. Flexing minds is an art that Phil performs among archaeologists even as he observes and records in his own ways.

After the Yaxuná Project ended, Phil kept right on participating in archaeological projects in Yucatán and, to my great fortune, in the El Perú-Waka' Archaeological Project I direct in Petén, Guatemala. He only mentions El Perú-Waka' Project in passing, as he shows pictures of discoveries to our friends on the projects in Yucatán. Hopefully, Phil will follow up this marvelous book with one on his experiences in Petén. What Phil says about the projects at Chunchucmil, Kiuic, and Xuenkal is as captivating in its insight and immediacy as I know his account of Yaxuná to be. All of the archaeologists in those projects are cherished friends and colleagues of mine, and I think I can speak for all of us when I say that Phil tells true stories. We are all used to having reporters and journalists write about our work, and about us. Sometimes it is a bit painful to read when a writer gets a story wrong, but we have to try to teach in the public forum if our work is to compete with the fantasies Hollywood spins about archaeology or the Maya. So when you read this book, pass it on and let your friends know that this is the real deal, and fun to boot.

Phil is a gentle person, slow to anger and not given to raising his voice. But as he winds down his story he reminds us that it has not been just about the ancient Maya or the archaeologists who are devoted to revealing their world. It is also about the living Maya, more than half a million strong when it comes to people who speak Yucatec as a first language in the Northern Lowlands. All of the archaeologists in this story collaborate with the Maya, live and work with them, and advocate for their voice in the conversation about the future of their past. Phil and I have spent time together on the Maya Riviera, and he has been there often over the years with other friends and archaeologists. His photographs tell a lot about what is happening and how he feels contemplating the changes. In his quiet narrative he details how things are; how disjoined are the Maya world and that of the wealthy tourists now inhabiting it. Those worlds are not inevitably on a collision course, although if the reader has paid attention, he or she will note that in the not too distant past the Maya rose up against oppression and courageously confronted it. Phil talks about people like Grace Bascope and her collaborators at Yaxuná who continue to strive for a new kind of tourism in which the Maya are actively engaged. In my view, that is the best future for all involved in the Northern Lowlands.

What Phil captures as image registers the encounter between him and what he saw and how he wishes to relate that encounter. Sometimes we can easily comprehend how he got there, and sometimes his process is enchantingly, hauntingly ineffable. But in any case it is enthralling to me. What Phil has written is no more a passive record of what he has observed than his imagery is. But it is authentic and original, a real insider's take on what the field is like for archaeologists and the Maya people they live among in Yucatán.

East Acropolis, Yaxuná.

West Palace of the Nunnery Quadrangle, Uxmal.

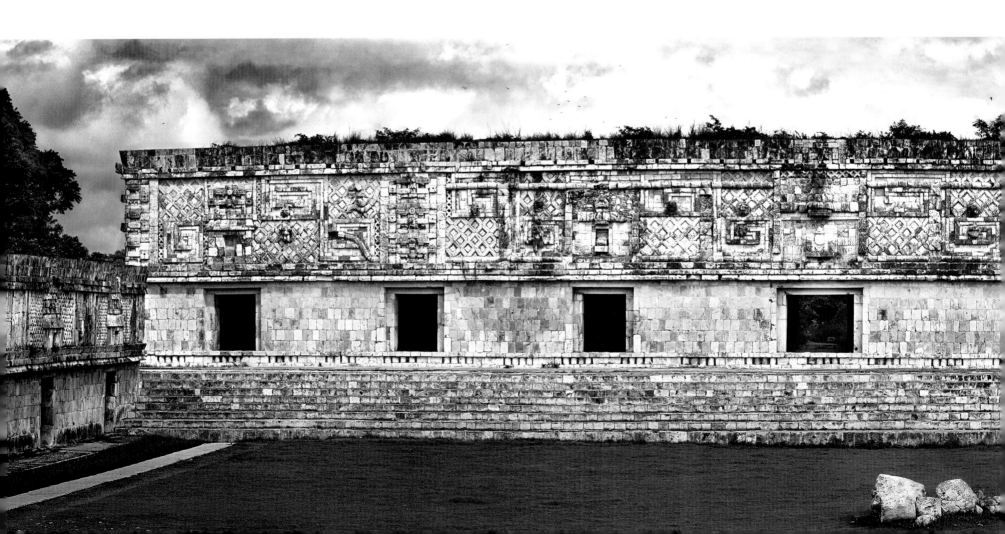

The Ancient Land

Yucatán—to me the name itself sounded a golden, mythic tone. The picture that springs to mind is an image of tropical forest, bright sun on white beaches, and the churches of colonial times. But at the center of this vision the ancient Maya cities that appear, almost supernaturally, from the deep jungle are the hallmark of the landscape. In that vast limestone plain I learned early in my travels that when I saw a lonely hill standing in the flat it was certainly a pyramid of the ancient Maya, still clad in vegetation and surmounted by tall trees. I have

climbed many of these temple-pyramids and was thrilled to glimpse ranked courses of smoothed stone and sometimes the sculpted faces of deities, or of kings and glyphs from a thousand years ago.

Before ever setting out on my adventures in Yucatán I did not know that I was preparing to walk a spiritual path in that ancient country. Before going there I had not taken much account of my yearning to seek out sacred places. But in Yucatán I discovered this longing, for wandering among the people and landscapes of the

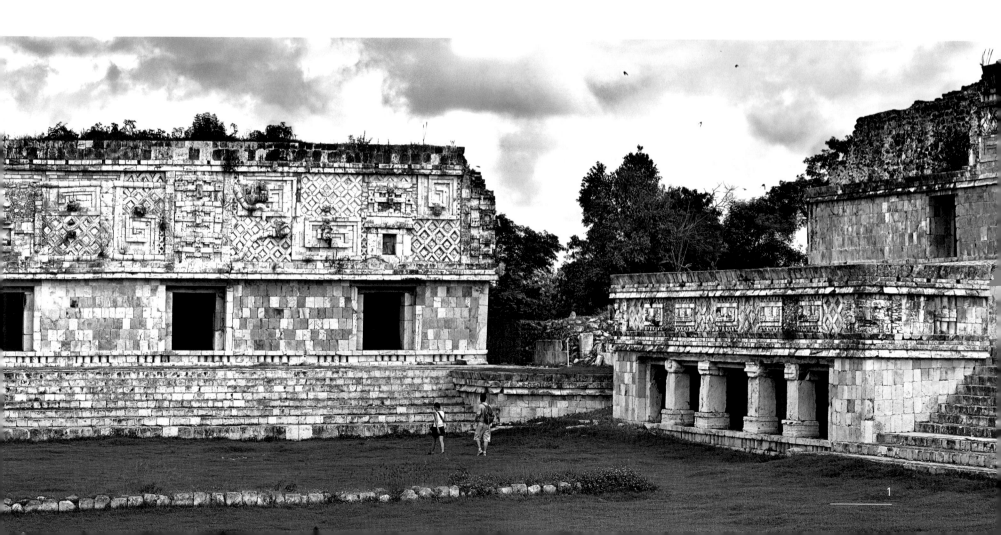

Mission Church, Yaxuná.

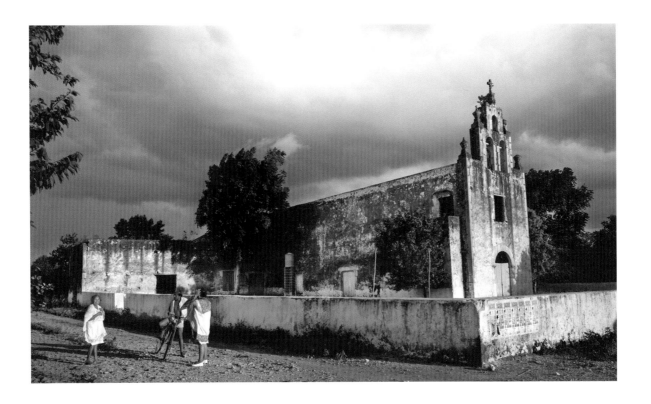

peninsula, I eventually understood that there was an invisible spirit world of the Maya that animated their stories, their old ruins, and all their works from three thousand years of living in that ancient land. Alongside that unconscious quest for the spiritual, I was also looking at the ancient Maya through the eyes of its artists, for those people who could read and write hieroglyphs, design buildings, paint and sculpt the programs of public expression all sought to embed the strongest emotional and cultural power in the arts of the city. Though I was only dimly aware at the time, it is these powerful arts that reveal the spirit world, and I realized in the end that it was therefore their arts and their spirit world I had set out to understand.

I grew up in California's Mother Lode. This is the gold rush country, that foothill region of the Sierra Nevada where gold-laden quartz veins plunge deep inside the metamorphic hillsides. Coming from the mountains, I thought that beautiful geography was mountainous. Yet, the first time I arrived in Yucatán I drove for hours on the straight

roads in that flat land, and my first impression was of monotony. I had come prepared to love the place, this Yucatán with its rich name, redolent of mystery and adventure. But it turned out to be a flat plain of jungle, where you could not see more than twenty yards into the twisted vegetation, and whose hot and waterless trails seemed a dangerous labyrinth, even to a country boy like me, familiar with the mountain forests of home.

However, that was only my first, and very briefly held, impression. A few days exploring the ancient ruins set me straight. Upon seeing the people of the traditional pueblos, the Franciscan churches, the secluded remnants of old haciendas, I understood that the subtle complexity of the land far exceeded the plain flatness of the place. My prejudice for hill country against flatland was quickly overcome by the sacred air of the place, the beauty of its tradition, and the effect of the ruins on the imagination. I realized that the beauty of Yucatán rested in the historic layers of Maya culture, past and present, as well as the promise of a future by way of a resilient and tough Maya people.

Over the longer run I needed to experience the daily rhythm of Yucatán, to enjoy the daily change of sky and sunlight, and to explore the hidden byways and corners of the history found in the scattered ruins. With its stern sun and the monsoon clouds of the rainy season as a background, and with the ruins of several historical episodes all strewn about the country, in the end it was the enduring character of the Maya people that spoke to me of a place not so much of sheer physical beauty but of an ancient land that has at its core the spiritual integrity of the Maya race.

Later I would find that Yucatán also had some hills, densely populated with ancient ruins. And they were beautiful, haunted hills.

Climbing on their steep slopes and summits, I discovered ancient temples, their sculptures scattered in ruins, and whose barely sensed breathing filled the air with melancholy and solitude.

Obsession with Pyramids

It was a photograph of a pyramid that brought me to the Maya. As a child I dreamed of pyramids, naturally enough since I remember being powerfully impressed by images of Egyptian and Maya pyramids. One picture stood out in my fascination for these buildings: a tall, slim pyramid framed by jungle trees. I recall being enthralled by those enigmatic buildings and by the exotic hieroglyphs written in them.

This pyramid obsession cropped up again in my college studies. In a sculpture class I cast a bronze pyramid patterned on the Great Pyramid of Giza; in a theater class I designed a costume and danced with pyramids on my head and hands. But these were pyramids after the classic Egyptian style, wonderfully proportioned and, at that time in the early seventies, said to have mystic powers for the concentration of cosmic energies.

Then a small event, a virtually unnoticed turning point, occurred that decided the friendly battle between the Maya and the Egyptians. My teacher and friend Keith Muscutt left our university to begin a lifetime of exploration in South America.[1] From somewhere in Mexico he sent me a beat-up paperback book titled *Maya Hieroglyphs without Tears*, a highly misleading (perhaps ironic) label, since my personal study of Maya hieroglyphs *was* accompanied by tears. On the cover of that book was the same picture of a Maya pyramid I had seen as a child. Later I would learn that this was Temple I at Tikal, Guatemala. Also known as the Temple of the Great Jaguar, this sacred building was the funerary monument of the greatest king of Tikal, Hasaw Chan

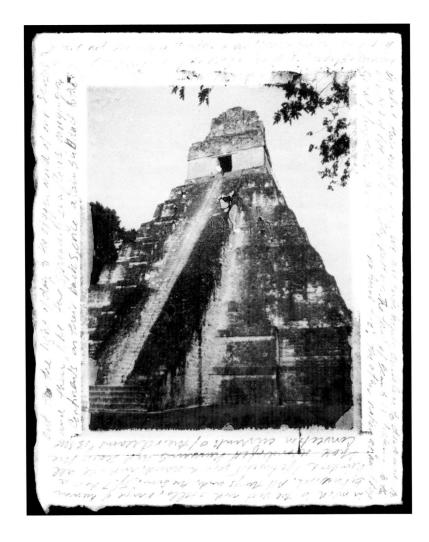

K'awiil (K'awiil That Clears[?] the Sky).[2] I would come to know his story much better in later years.

That picture of Temple 1 represents the essence of a pyramid of the Southern Maya Lowlands. Narrow and high, its nine platforms step up to a small temple building surmounted by a ruined roof-comb. Apart from this legendary temple at Tikal, two other Maya pyramids hold a special place in the public imagination. The Temple of Inscriptions at Palenque and El Castillo, the large pyramid at Chichén Itzá, would also become specially iconic to me as they are to many others. I would focus on their stories later in my travels. At that time though I wanted to travel to Tikal and its immense ruins because of my long fixation on that alluring, and for me practically mystical, image of a Maya pyramid.

In 1987 I finally and decisively acted on that original childhood inspiration. While exploring Belize, I drove with my wife, Nina, from Belize City through the highlands of the El Cayo district and passed over the single-lane iron bridge at San Ignacio. Paying a small bribe to bring our rented jeep through, we crossed the dusty frontier at Benque Viejo to the Guatemalan town of Melchor de Mencos. This was still the time of the civil war there, but we did not see any sign of it. We did pass, however, the dreaded Kaibiles army encampment. All day we drove on deeply rutted roads on our way to Lake Petén Itzá and the ruins of Tikal.

Exploring the ruins of Tikal that April we suffered the hottest days I ever remember. Trying to avoid some of the heat, we waited until the very late afternoons to begin shooting with my 4 × 5 view camera. One day toward evening I carried it up the scary, steep stairway of Temple 1 and took a sunset picture of the pyramids over the Great Plaza. Resting atop the pyramid summits, we watched the night fall over the

El Castillo, Chichén Itzá.

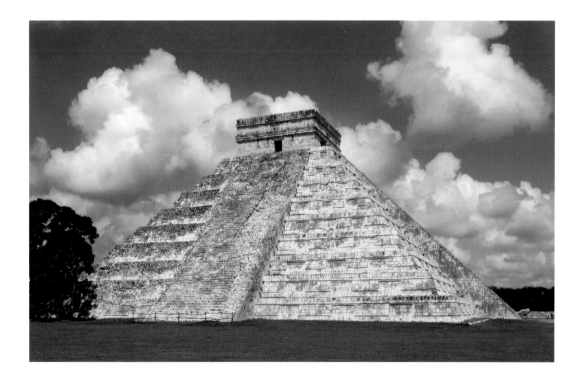

brooding North Acropolis, the dynastic burial place for a thousand years of Tikal kings and queens. We listened to the seemingly electronic call of the cicadas and heard the garrulous flocks of parrots fall silent after sunset. Lingering in the darkness of that wilderness, imagining the politics and the pageants of Tikal's Great Plaza, I realized that I had found my passion and, perhaps, my voice as an artist.

High Sierra Genesis

That passion, however, had to find its way back to the Maya regions.

Back home in California I intensified my reading about the Maya, and three summers after the Tikal exploration, another breakthrough developed. It began in the high country of Yosemite where I was camped out by a small alpine lake on the John Muir Trail. I was taking a break with a colleague, Don Bright, with whom I worked shooting corporate video. Around the campfire we were complaining quietly about how colorless that work had become—we wanted something more exciting and challenging. So the conversation turned to documentary movies and what our subject could be. At the time I was

Merle Greene Robertson with Stela 16 at Dos Pilas.
Copyright Merle Greene Robertson. Used with permission.

reading about the Maya city of Palenque, and a number of writers had proclaimed it the most beautiful of ancient ruins. With a brilliant Sierra Nevada night sky overhead, we decided that the ancient Maya ruins of Palenque were the perfect subject. But how should we begin this arduous project, this brave fantasy?

The next day, as we hiked through Tuolumne Meadows on the Tioga Pass Road, we stopped in at the small granite-stone store for a newspaper and picked up a day-old *San Francisco Chronicle*. On page six we discovered a long article about Merle Greene Robertson and her research on the acid rain damage to the sculptures at Palenque. This was amazing! We had just been talking about Palenque the previous evening. We took this as a dazzling and propitious sign, and indeed it turned out to be life-changing luck. Back in the Bay Area, I called Merle, who lives atop Nob Hill in San Francisco. Even though she did not know me she said, "Come on over. Let's talk." Later we learned that this was how Merle operated: she was open and friendly to everyone. I told her about our idea for a Palenque documentary, and she immediately invited us to accompany her on her next trip to the ancient city, to stay at her house, and to begin videotaping interviews with her among the ruins. We did not know at the time how important she was in the history of Maya studies.

Merle in Palenque

We agreed to meet Merle's plane in Villahermosa early in December 1990. She was arriving separately from a conference in west Mexico. We watched her plane touch down, and we waited on the tarmac until everyone had descended the apron stairs. But still no Merle? Then we saw one of the stewards push out a wheelchair with Merle seated in it. She had broken her hip at the Ballcourt Conference

Floyd Lounsbury resting in the shade of the Temple of Inscriptions, Palenque.

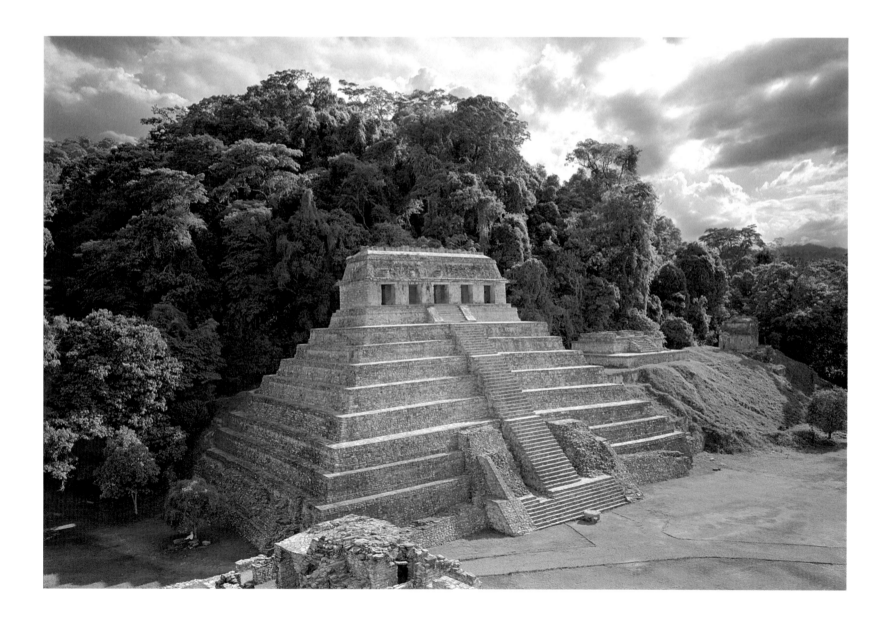

in Culiacán—where hill people there still play the Mesoamerican ball game in the mountain villages high above the city—and now she was wounded but in high spirits as she waved us forward down the road to Palenque.

All that following week she healed, and she showed us her beloved ancient city. Merle was a bit mad though. She complained that with her hip busted up like this, she could not run up and down the stairs like she wanted. Despite the grousing she did fine, and we filmed great footage of her on the high staircases of the temple-pyramids.

Before this trip we did not know the extent to which the city of Palenque and, for that matter, the entire field of Maya studies honors Merle and her work. But we learned soon enough once we were there. Merle's story revolves around the legend of the First Palenque Round Table (Mesa Redonda de Palenque) where the final breakthrough to deciphering the Maya hieroglyphs was made. In December 1973, at her home in the modern city of Palenque, she hosted the conference where the last pieces of the puzzle fell into place. Merle was in the middle of her great multiyear project to photograph all the sculpture of the city, and she invited all the leading hieroglyphic scholars to her house for an informal conference. Her plan was to arrange for all the right people to meet in the ancient city, thus allowing them to go to the ruins and read the hieroglyphs. This plan worked spectacularly, directly leading to the last breakthrough in deciphering the Maya hieroglyphic code.

The Maya decipherment was arguably more difficult than Jean-François Champollion's achievement in 1812 when, using the Rosetta Stone as his guide, he deciphered the Egyptian hieroglyphic code. The Maya code did not have such a fabulous clue as the Rosetta Stone, just some scattered and confusing signs to its "alphabet." Based on previous research by brilliant scholars around the world, the Maya

decipherment at that first Palenque Round Table was a monumental, largely unheralded accomplishment, and it stands as one of the crowning achievements of twentieth-century archaeology. This decipherment led to a revolution in Maya archaeology, and researchers began to take into account the historical record that the ancient people themselves left behind.

We heard this story, not so much from Merle, but from Gillette Griffin, a curator at the Princeton University Art Museum, and from David Freidel, one of the leading archaeologists of Maya studies. Our uncanny luck saw them both visiting Merle while we were there. We interviewed the two of them, and they began my instruction about the ancient Maya and about Merle's place in the history of Maya archaeology. More important to me, David began outlining the revolutionary effect that the decipherment had on our understanding of the Maya. In due course I came to understand the enormous effect this discovery had on the archaeological research I witnessed in Yucatán. That fortunate visit to Merle's place in Palenque was the beginning of my first-hand lessons with great mentors in Maya studies.

Palenque

Ancient Palenque stood well to the south and west of the geographic heart of Yucatán and somewhat outside the pictorial subject of this book. The ancient connection to Yucatán, even so, is clear—they held to a culture in common during the Classic era, and both regions connected to each other with strong, vital economic ties. For me, though, the connection turned out to be the archaeologists.

At the time I believed that Palenque, this extraordinary city handsomely set on its steep hillside terraces, would become my lasting passion, and I've visited there several times since. However, when I left

Gulf of Mexico and the Maya Domain.

Late Classic Atlantean figures stand guard at Hacienda Grenada.

Palenque that first time, David Freidel invited me to visit his research project at the ancient ruins of Yaxuná. At the time I did not know where Yaxuná was located, but that invitation set the course for my personal study of the Maya. When I pulled out my maps I saw that the ruins and village of Yaxuná stood in the heart of the peninsula, that great limestone plain that defines Old Yucatán and the Northern Lowlands of the Maya. Six months after visiting Merle at Palenque, I showed up on David's doorstep in Yaxuná. Accepting his invitation led to eighteen years of documentary work with several archaeological projects in the peninsula. And in those years I was privileged to witness a great wave of discovery in northern Yucatán archaeology, and slowly, inevitably, it was Yucatán that stole away my heart.

The Enduring Ways

After only a few hours in Yucatán I realized that I was ignorant of many things, but the most surprising was my unawareness of the existence

and life of the contemporary Maya who live all throughout the villages and cities of the peninsula. It was an instant revelation, but all the same I had not grasped beforehand the profound Maya-ness of the land.

I was unaware when I first visited the famous Maya ruins at Chichén Itzá and Uxmal that Mérida, the capital of Yucatán State, was populated with half a million Maya people, one of the largest ethnic Native American cities in two continents. Nor did I know that a dozen other cities of ten thousand to thirty thousand inhabitants,

mostly of Maya descent, live in a vibrant expression of culture reaching back to ancient times; nor that Maya people are also the majority in the city of Cancún, which boasts five hundred thousand inhabitants and is the premier tourist destination in the peninsula; nor that Maya people lived in a traditional farming culture all throughout the villages and pueblos in the countryside. As I lived in the archaeology camps and traveled the land, I quickly came to understand that the Maya are the fundamental and pervasive culture of the Yucatán.

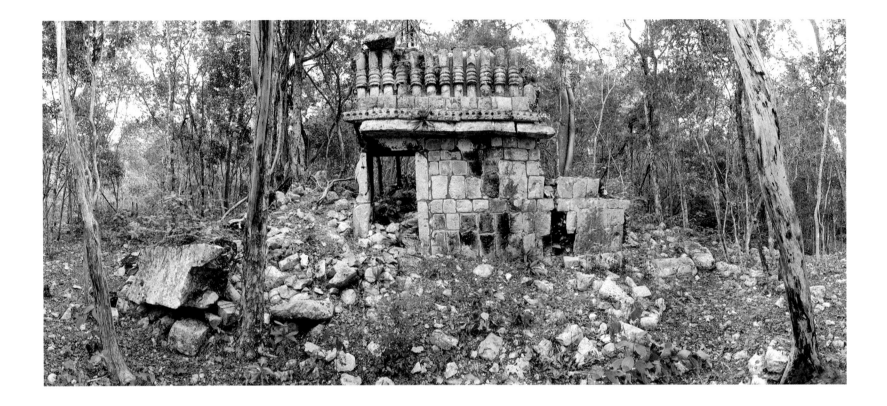

So even if in the popular imagination the adjectives most commonly used to describe the Maya and their ancient civilization are *lost* and *mysterious*, the Maya are not hidden or lost or mysterious. Today they live in their millions throughout Yucatán, Chiapas, Belize, and across the Petén and rugged highlands of Guatemala. They still speak in the Mayan languages of their ancestors and still resist in subtle, myriad ways the conquest by European culture.

One day in Espita in north-central Yucatán, I was speaking with my good friend Traci Ardren, director of the Xuenkal Project. She said something striking to me: "Phil, you must remember that the Spanish adapted, perhaps, as much to the Maya as the Maya did to the Spanish. The Maya are a conservative and stubborn folk. They insist on their folkways."

Layers of Memories

To me one of the most striking aspects of this Maya cultural

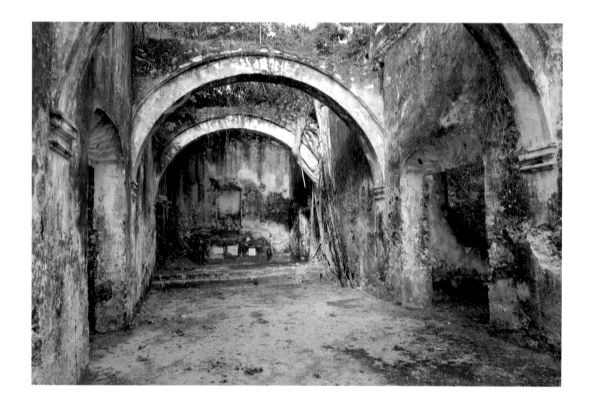

continuity is the layering effect of the historic episodes on the Yucatán landscape. Across the face of Yucatán these episodes are plainly visible in the innumerable ancient sites, the churches of the Franciscan mission period, and the ruined haciendas of the henequen period.[3] They are the embedded, physical memories of place, a remembrance of past glory and history.

For three thousand years Maya people have passed through cycles of remembering and forgetting. They have built up phenomenal civilized spaces and have seen them decline and fade to ruins. Each time they have embedded meaning in those spaces, thinking how to express their most important ideas in their temples and public spaces, and even in the humblest of places, their homes.

From a photographer's perspective, this layering of eras leads to an attractive feature of the landscape, a romantic concealment, a hiding of the civilized traces of each episode in Yucatán's history. The primary reason for this is that every structure in Yucatán—ancient,

colonial, or modern—faces the same inexorable process. The tropical heat and moisture begin to work for their ruin, and once abandoned the forest rapidly claims them. I have seen the splendid country mansions and factories of the old henequen plantations standing desolate under the assault of strangler fig trees. These tear the roofs off, lever the floor joists and wall braces. They explore the stones, then pry apart the masonry seams and leave former palaces as derelict walls and piles of stone and cement rubble. This after only a century of abandonment, of buildings built during the industrial age of iron and advanced design.

My favorite discoveries, then, come as surprise encounters in the shade, under the huge ceiba trees, and amid the tangle of hardwoods. These are entrancing, sometimes secret meetings with a camouflaged temple or a concealed palace. Many more times the small buildings of the various eras have wasted away to practical nothingness. Only archaeologists and keenly observant amateurs can spot the ruined houses and walls of a small site, hundreds of which pervade the countryside.

The ancient ruins are not alone in their seclusion. Wandering around the countryside of Yucatán I have come across many abandoned haciendas and ruined churches, almost as numerous as the palaces, temples, and houses of the ancient people. All the layers of history shroud themselves in the corners of the forest, at the edge of the plantation, off the beaten path. Whole towns and villages and the destroyed mission churches cloak themselves in forgotten corners of woods and at the end of jungle trails.

The Maya themselves never forgot these hidden places, for they continue to live, farm, and hunt in these reticent corners of the forest and plain. Over the centuries they have brought forth in contrasting cycles of reverence and destruction the termination or rededication of the previous order. Only the Maya themselves know and remember the most sacred places.

The Arch and El Mirador, Labná.

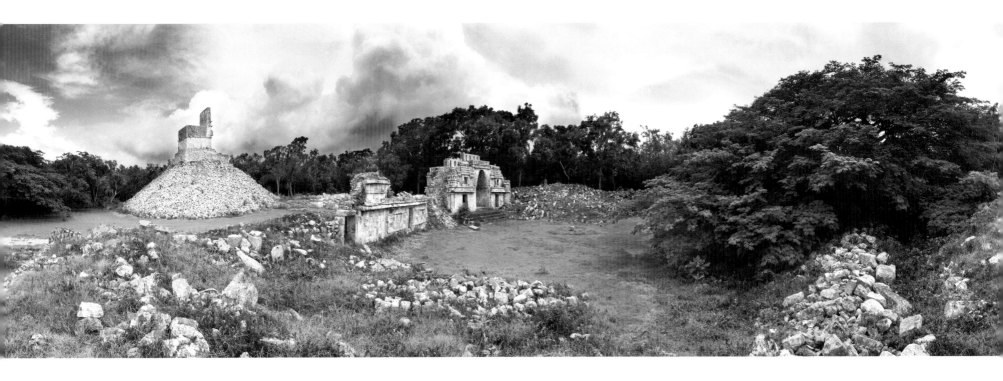

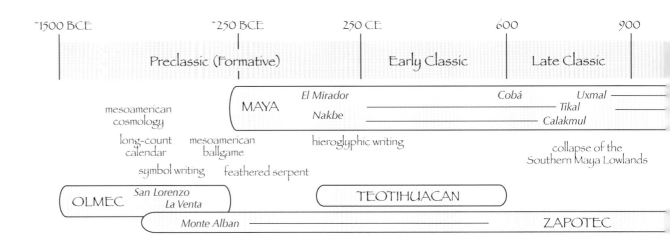

~1500 BCE		~250 BCE	250 CE	600	900
	Preclassic (Formative)		Early Classic	Late Classic	

MAYA
El Mirador — Cobá — Uxmal
Nakbe — Tikal
Calakmul

mesoamerican
cosmology

long-count
calendar

mesoamerican
ballgame

hieroglyphic writing

collapse of the
Southern Maya Lowlands

symbol writing

feathered serpent

OLMEC
San Lorenzo
La Venta

TEOTIHUACAN

Monte Alban — ZAPOTEC

The Maya in Yucatán

The Ancient Maya

The largest of Maya sacred places are quite easy to see for they are the focal points of Chichén Itzá and Uxmal, the two chief tourist sites of the peninsula (not counting Tulum, the middling Postclassic site close to the resort *playas* of Cancún). These two large sites are by far the most visited in Yucatán State. In their time they were imperial cities, holding sway and forming alliances over large areas of the peninsula. Even so, the careers of these two cities with their famous pyramid-temples arose quite late in the Classic period.[1] Across the peninsula other great cities held power earlier in the Classic period, and archaeological excavations of the past twenty years have uncovered many more Preclassic (or Formative) era cities—predating approximately AD 250—than were previously realized to have existed.

Mesoamerica

These period definitions, Preclassic (Formative), Classic, and Postclassic, can be applied generally to the larger cultural area called Mesoamerica of which ancient Yucatán was an important part. This area stretched from present-day central Mexico and the Yucatán Peninsula north to the southwest region of the United States. To the south Belize and Guatemala and parts of Honduras, El Salvador, and Costa Rica were all important areas of the Mesoamerican universe.

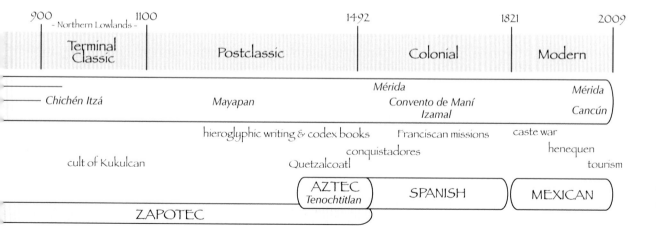

Timeline of Mesoamerican Historic Periods. Created by the author.

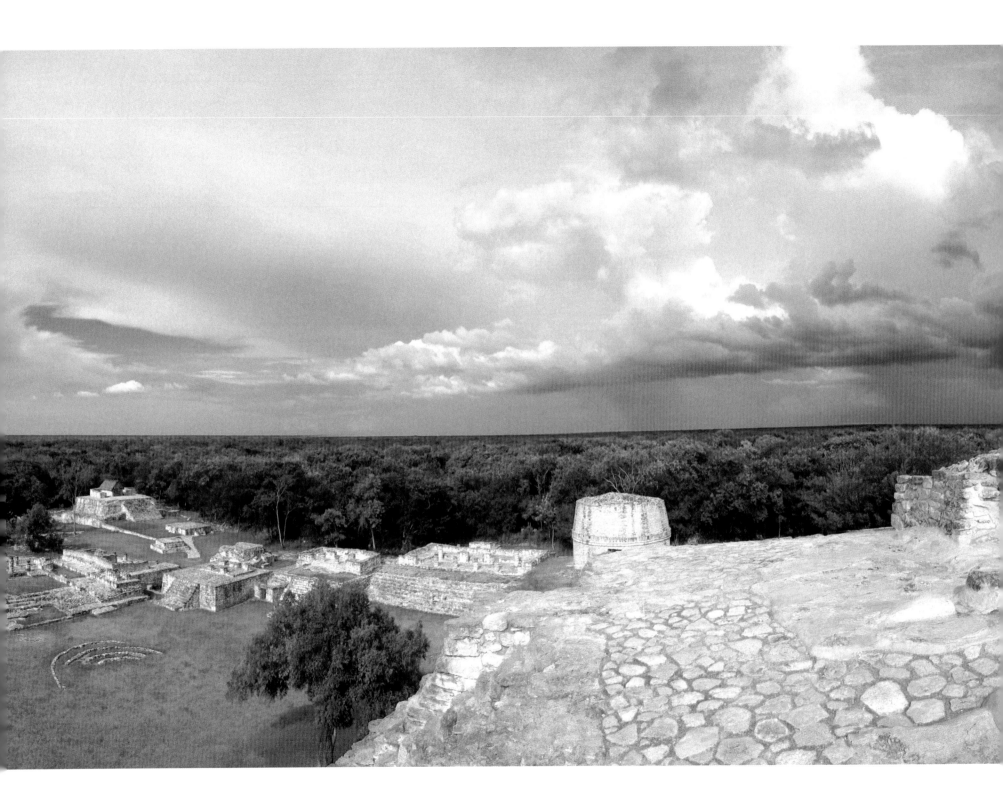

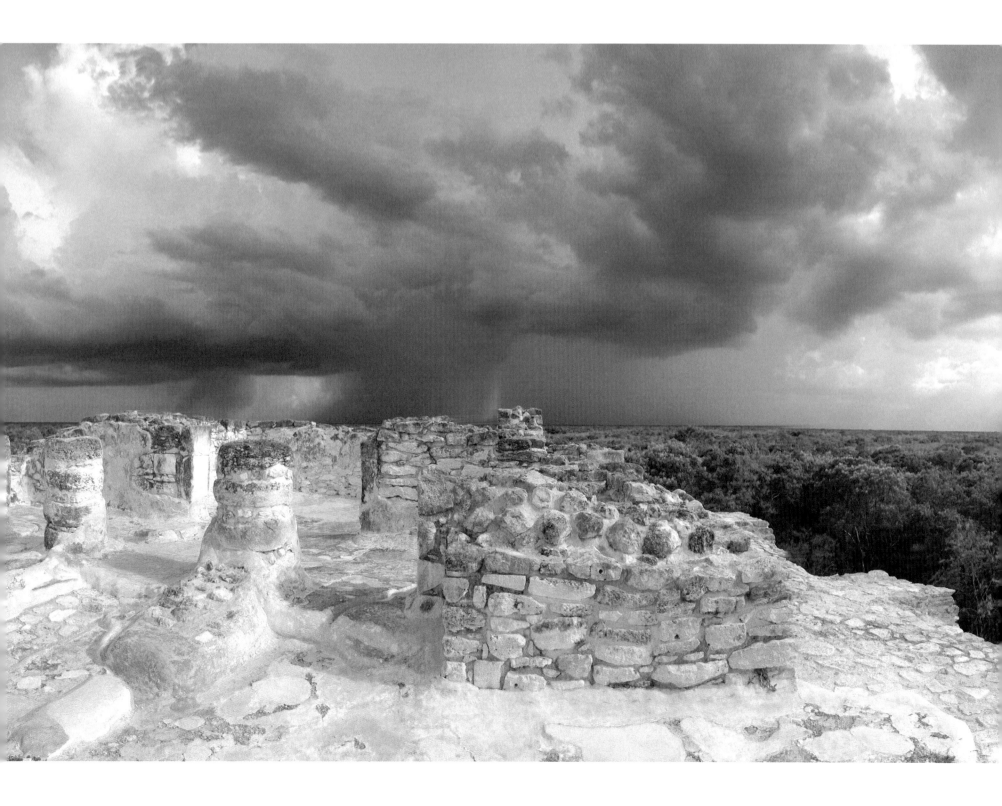

Summit vista from El Castillo, Mayapán.

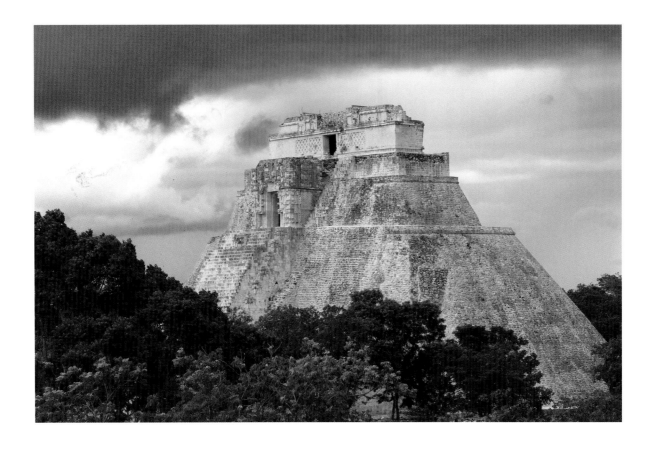

Beginning at about 1000 BC with the Olmecs of the Gulf Coast of Tabasco and Veracruz, the civilized portion of this vast culture area held several common cultural attributes, among which were the 260-day ritual calendar, the Mesoamerican ball game, similar cosmic creation stories, maize agriculture, the three-stone hearth, and a vigesimal (base 20) numbering system. For three thousand years before the European contact, these cultures developed and shared common architecture, art, religious beliefs, and technology. One could say that even in the modern period they still hold these attributes in common.

In Yucatán substantial cities arose during the Late Preclassic period from circa 300 BC to AD 250. The Early Classic period is from AD 250 to AD 600, and the Late Classic extends to about AD 900.[2] Most scholars of the ancient Maya now also include a period they call the Terminal Classic surrounding that AD 900 date, which is also

Palace at Grupo Kuché, Kiuic.

the time of the great cultural collapse in the Southern Lowlands. The collapse in the south and the disruption of the cultural status quo throughout Mesoamerica may have inspired major changes in art and cultural expression in the north, and Maya culture continued there while the southern regions saw a demographic collapse. At this time, at the end of the Classic era, almost all the southern cities fell into ruin and silence.

Even today, a thousand years on, vast areas of the Southern Lowlands are still uninhabited, or are only recently seeing new populations. During the Terminal Classic and Postclassic periods, in contrast, the Yucatán saw an emergence of energetic city-states in the Puuc Hills of southwest Yucatán and the rise of a cosmopolitan imperial power at Chichén Itzá, followed in the Postclassic by the Mayapán confederation. By the Late Postclassic, however, the political and cultural

Hillside palace, Huntichmul.

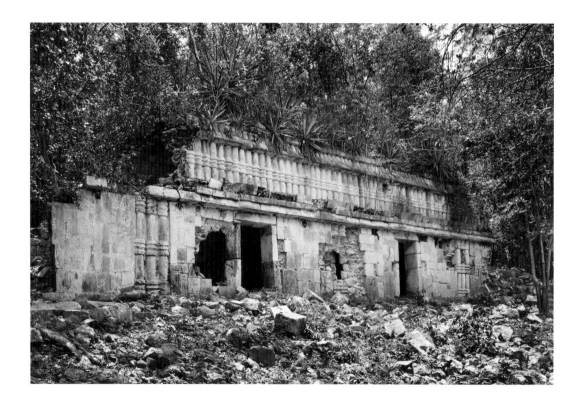

coherence of the north saw a decline just before the conquistadores came ashore for the first time on the continent.

When tourists stand in the great plaza of Chichén Itzá to behold the famous El Castillo pyramid, they are gazing at a Postclassic Maya building. Tulum is also a Postclassic city—a beautiful ancient seaport on the Caribbean coast. These two most popular cities are what the great majority of tourists see when they visit the peninsula, and thus they

experience only the last epoch of the ancient civilization. Most viewers miss the vast range and depth of ancient architecture in Yucatán.

In contrast to those of the Postclassic, we do not see many of the earliest structures, those of the Preclassic, in cities founded prior to AD 250. Except in rare cases Preclassic buildings are buried and hiding within later construction. Recent archaeology seems to indicate that many cities of the peninsula began their careers in the Preclassic,

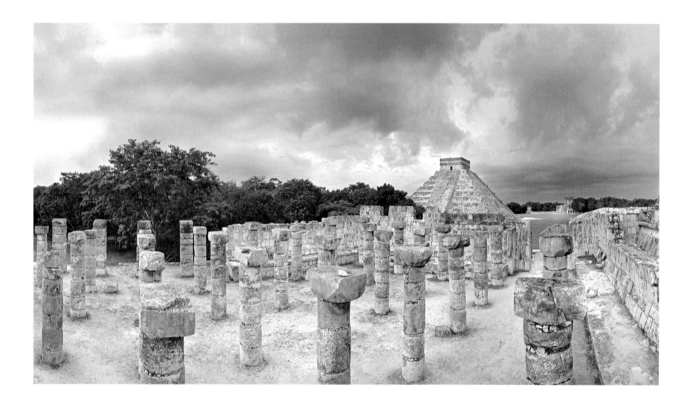

prominent examples being Yaxuná, Poxila, Izamal, Acanceh, Aké, Santa Rosa Xtampak, Edzná, and Dzibilchaltun. Another important early site, Xocnaceh, on the edge of the famous Puuc Hills, did not survive into the Classic period.

This quickening discovery of the Preclassic in the north presupposes the connection to the enormous southern cities of the Mirador Basin in Guatemala's Petén. There the gigantic site of El Mirador, with

the largest pyramids ever built in Mesoamerica, was the center of a dominant early culture in the southern jungles. These potential connections are stimulating the study of the Preclassic trade routes and political connections between the two regions. And new archaeological discoveries, like the now-famous wall murals at San Bartolo, demonstrate the existence of a precocious and complex culture much earlier than previously understood.

In my own studies of the ancient Maya ruins I had a great advantage, for archaeologists tend to be excellent teachers. My good fortune was to learn from several brilliant tutors. They emphasized several points in contemplating the ruins:

- Most of the ruins are seven hundred to eighteen hundred years old, with some being much older. In accord with a civilized history of two thousand or more years, it is important to keep a sense of time and cultural periods.

- Hundreds of ancient towns and other small sites inhabit the land—the countryside of Yucatán is filled in with ruins.

- Even in the midst of famous, restored ruins, the majority of structures have yet to emerge from the jungle growth. Quite large buildings and complexes remain hidden. For instance, the eastern city of Cobá, once a hegemonic power in the Middle to Late Classic period, harbors an enormous acropolis that is yet unexcavated.

- The large, famous sites have no monopoly on the size of structures. For example, El Castillo at Chichén Itzá has a few challengers. This great foursquare pyramid with the square temple at the top is commonly thought to be the largest building in Yucatán. But a surprising number of other pyramids match it in size. At Xuenkal, a temple-pyramid rivals El Castillo; at Yaxuná the Central Acropolis is larger in volume and was constructed a thousand years earlier.

- Among the reconstructed ruins I had to keep in mind that in ancient times the buildings were painted, as we now know that the Parthenon of Athens was painted. Their stones were not raw white or light gray but painted in bright colors whose meanings were well known to the ancient population.

- At the center of the present-day cities of Mérida (Tiho) and Izamal (Itzamna), the Spanish conquerors dismantled large temple-pyramids to provide building material for their government palaces and the basilicas of the Roman Catholic Church.

- These were Stone Age, Neolithic cities. The Maya owned no metal to shape the stone blocks. They used flint or chert to work softer stone, or they stone-pounded the rocks to form rough blocks. Neither did they have the wheel—nor beasts of burden—to ease the movement of huge stone slabs. This was a Neolithic civilization unlike any in the Old World. To build their stone cities, their main assets were time and manpower, not technology. Within these limitations, it is astonishing that only with an expansive sense of time and their own muscle-power they built square miles of massive construction, plazas with thick layers of gleaming white plaster, wide staircases, dividing walls, terraces, courts, porticoes, piers, *aguadas*, temples, and, in the richest cities, acres of artworks—a baroque and rococo profusion of painted and sculpted art.

As an artist I view with pleasure the confidence that Maya artists show in their work. As with all other cultures, the Maya were thinking about their existence, their cosmology, through works of art. In their case the images and sculpture confess a preoccupation with spirit

Thunderhead over Umán.

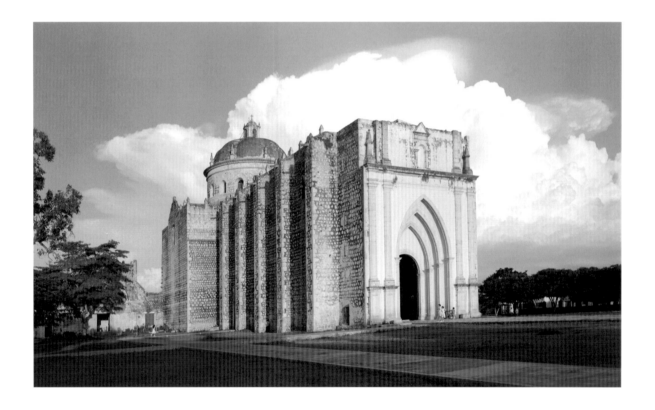

and power and cyclical or eternal life (although certainly they are not alone in this—see baroque art as an example). And the most important expression of all this symbolism, including the legitimacy and authority of the king, was enshrined in the temple-pyramids and tied to their story of creation and sustenance in the cosmos.

Inherent in all Maya—indeed all Mesoamerican—pyramids was the twin symbolism of Snake (Creation) Mountain and Sustenance Mountain. This essence spanned at least two thousand years of history and reflected the story of creation and sustenance, the principal concerns of Mesoamerican culture. Furthermore, this story is told in ancient Maya cosmology: creation and sustenance as a pattern in the stars overhead. The continuance of the universe and the responsibility for sustenance made civic authority and legitimacy dependent, therefore, on the constancy and precision of the celestial order.

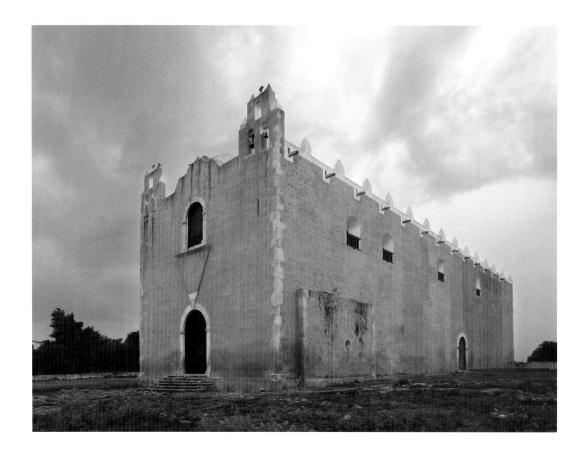

With their architecture the Maya appealed directly to this order. Their building orientations contained sight lines to the rise and fall and the pathways of the stars and other heavenly bodies. They erected wondrous observatories and ritual spaces to relate directly to their sense of the cosmic story. Almost every building alignment of the Maya had an aspect of geomancy about it—every building appealed to the cosmic order. To do otherwise would be to hazard the connection to creation, and thereby risk a catastrophe to sustenance.

Maya Archaeology

Finally—the archaeologists reminded me—the story of the ancient Maya keeps changing as active study speeds ahead and new discoveries require new interpretation. The ever expanding story of the ancient

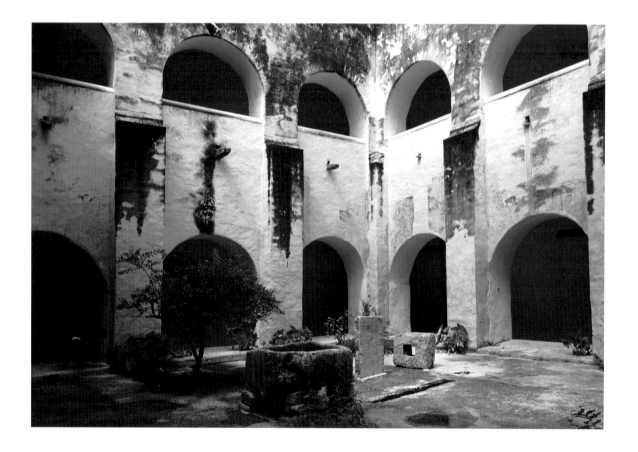

Maya continues to astonish the world. The writings in the codices and the Books of the Chilam Balam have broadened the interpretations of history, and archaeologists are using these insights to guide their own research in the excavation trenches. The archaeologists know that every year they or one of their colleagues will find something in the ground, or figure out what some iconography means, or decipher some new hieroglyphic text, and this research will change the story a little bit, or even quite a bit. But they also know that this is the wondrous nature of an expanding universe, that the story just becomes larger and more interesting, not because it is a fictional story, but because the story can be told from the astounding facts that researchers wrest from the earth.

Maya and Franciscan

In Yucatán all cities, towns, and villages have churches on the zocalo,

Teabo church.

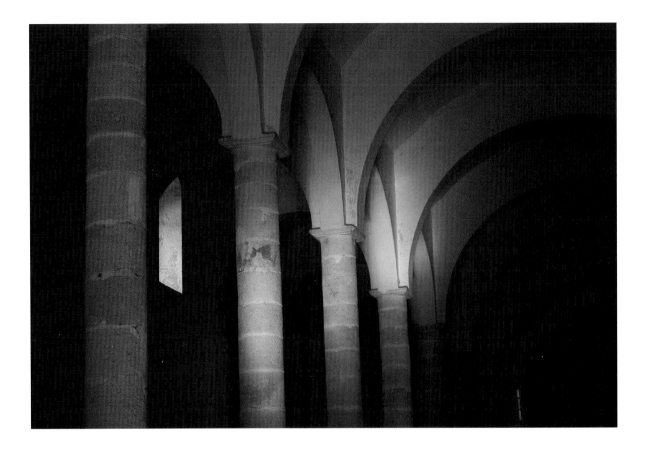

the central plaza. Almost all of these churches face west. So my favorite time to arrive in a town to photograph these buildings is the late afternoon. At that time of day the late sun shines onto their austere baroque facades, and often right through their open, weathered doors. Inside the church the sunbeams stream up the central aisle to bathe the altar with a golden glow—to my mind a perfect light.

Likewise, it is late afternoon when the great thunderstorms tower over the land, and then, approaching sunset, the sun disk slips under the edge of the cloud-line and casts a glorious light across the darkening land. At that moment I always felt like I was receiving a sacrament to witness from afar the solitary church towers light up, beacons against the dark sky and verdigris forest, like a lighthouse shining across an immense and tangled sea.

In 2002 *Archaeology* magazine asked me to take photographs of

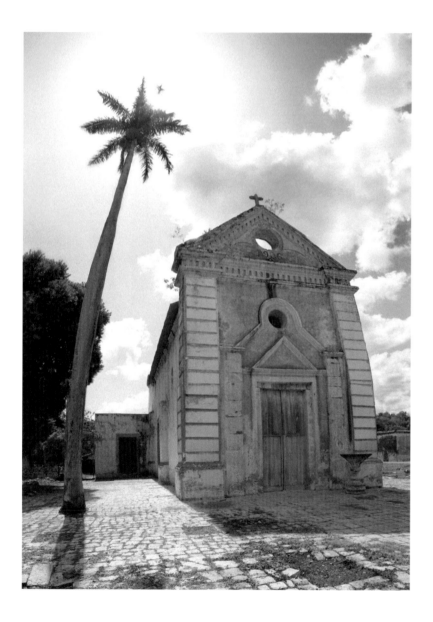

churches in Yucatán. I visited three dozen sacred places of the colonial era during that rainy season, taking to the old roadways, visiting the convent towns along the storied Mani Trail of the Franciscans, and photographing the architecture and treasures of art from four centuries of colonial worship. Beyond the Convent Trail at the foot of the Puuc Range, I wandered all the other regions too—the northern tier of cities that led through Izamal, the bishopric seat of colonial Yucatán,[3] and out to the eastern frontier at Tizimín and Valladolid (whose church is one of the few to face north). Of course, during the years I worked with the Yaxuná Project, I photographed in Yaxcabá Parish whose mission churches were the focus of fierce battles and destruction during the Caste War year of 1848.

Later, in 2005 I had an opportunity to visit some of the churches in the southern frontier, at Tihosuco and Sabán, both important in the Maya struggles for justice. Here the rebellion of the Caste War began. These churches—among others in this area—burned early in the revolt, and perhaps as a measure of the Maya reputation for having long memories, these churches still have no roofs.

In the northwest, though, the churches have by and large been restored, and they are still active. During my expeditions to Yucatán I spent a lot of time passing through or staying in the capital city, Mérida. I took those opportunities to slip into the cathedral, San Idelfonso, and spend a few minutes meditating on the devotion of the Maya in that sacred limestone house.[4] I would also visit Dzibilchaltun, a short distance north of the city, to gaze on the old ramada church amid the ruins of the ancient city. Musing upon that church I could see clearly its firm intention. Standing square in the main performance space of the ancient city, it wished to dispel, erase, and displace the old ways and throw out the ancient deities. It would

San Idelfonso—night on the Mérida zocalo.

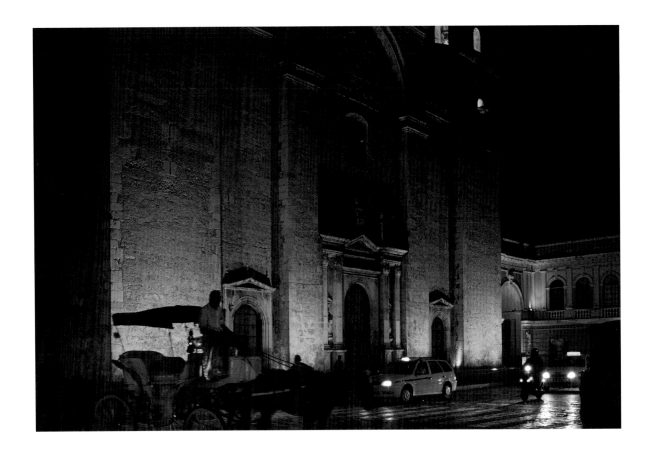

do this by pronouncing its vitality among the ruined buildings of the ancient order.

The designers of these missions were the Franciscan friars who had followed the conqueror, Montejo the Younger, into Yucatán. In many cases they had been appalled in central Mexico by the greed of their countrymen and by the treatment of the indigenous people of the new empire. In Yucatán they could begin to reform some of that treatment—although many would say through forcible means under the terms and conditions of the conquest.

Nevertheless, the Franciscan bishops, monks, and priests set out to establish mission churches throughout the peninsula, and it was the discipline of poverty that informed those basilicas of Yucatán. Their churches impressed with solid, unadorned monumentality. The friars and their Maya charges built up their temples with thick

San Idelfonso interior 180-degree panorama. When in Mérida I make a point of stepping into the cool interior of the main church on the zocalo, the Cathedral of San Idelfonso. Begun in 1556, it was constructed from the stones of the dismantled Maya city of T'ho and was the first cathedral built on the American continent. I step inside and sit in one of the pews to meditate. A truly sacred space, imbued as all sacred spaces are with the spiritual intention of many thousand people of the past four centuries.

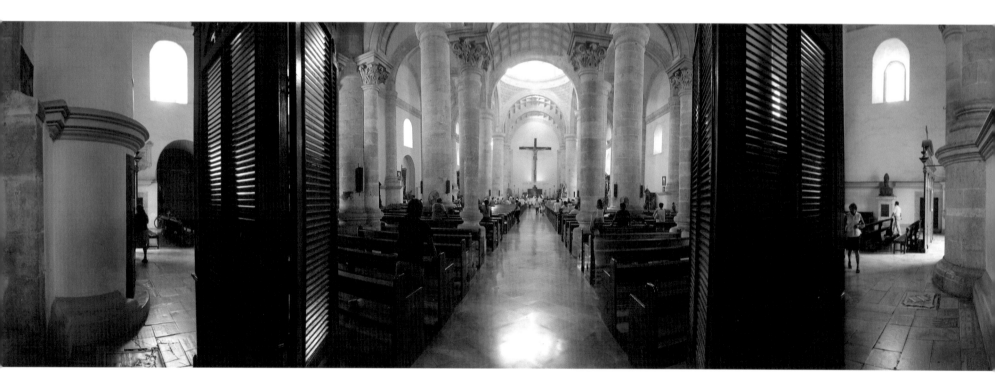

limestone walls, following the simplest, the most severe expression of baroque design. These were massive and minimalistic buildings, and the Maya recognized them immediately, for just as in ancient times, the Maya people were pressed into labor in order to tell a spiritual story. Maya hands and backs built these new sacred buildings. This time, however, they could proceed more efficiently with the use of metal tools, the wheel, and the extra strength of mules or oxen to transport the stone blocks. Maya masons also adapted instantly to the usefulness of the keystone arch, an innovation introduced by the Spanish masters.

The Maya quickly recognized these temples, for the story told by the mission churches was more or less the same as that told in the old culture. Both stories were of sacrifice, blood, redemption, intercession. During the ancient rituals, the Maya kings drew their own blood to

The ramada at Dzibilchaltun.

celebrate the Creation, and under the World Tree intercede with the ancestors. In the Christian ritual, the Christ-king sacrifices himself on the World Tree—the Holy Rood—in order to intercede and gain the redemption of humanity before the eyes of the Creator.

Thus, the old belief of the Maya in blood sacrifice and the resurrection of the Maize God translated naturally into the blood sacrifice and resurrection of the Savior. The iconography required only a slight adjustment.[5] The sacred narratives being similar, the Maya of the colonial era adapted to the sacred space of the conqueror, but kept the foundation stone of their own ancient belief underneath.

This syncretic relationship between the old system and the Roman Catholic Church continues today in the old villages of the countryside. Traditional Maya Catholics carry the kernel of the ancient religion. An example can be seen in the traditional

Devotions in the Yaxuná church. This grainy nighttime picture called out to me. It contained a sensation of the dark empty space, like the unconscious cave, with just a handful of candles to light the few sacred images and the two people there speaking—or not speaking. I remember many other instances of enlightenment in that village, but that moment—beholding the worn icons of the altar, the bare stone walls, and the intensity of the people there—I will always remember as one of the most striking and quietly transcendent moments during my time at Yaxuná.

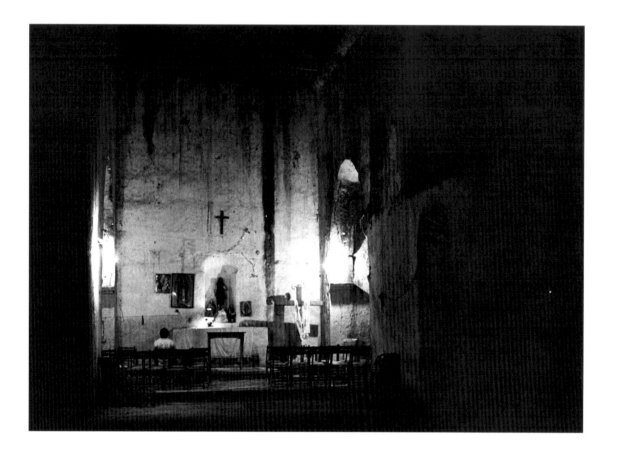

Maya pueblo of Yaxuná. The old parish support system has broken down. No priest has lived in the village for years. But the old mission church there is used by the people who consider themselves Catholic. They also follow the ancient rituals of don Pablo who is the *h-men*, or shaman, of the village. In a personal communication, Grace Bascope, who has been doing research at Yaxuná for twenty years, writes:

About the priest—when I first went to Yaxunah the head of the parroquia in Yaxcaba was a priest who spoke Maya and was amazing. I never got out on the road going anywhere that I didn't pass him and his little blue truck several times. He went to every church at least once every two weeks—I think there are 19 of them (churches) that belong to Yaxcaba. He came to the village to baptize and visit the sick, to hold mass

An altarpiece at Tecoh.

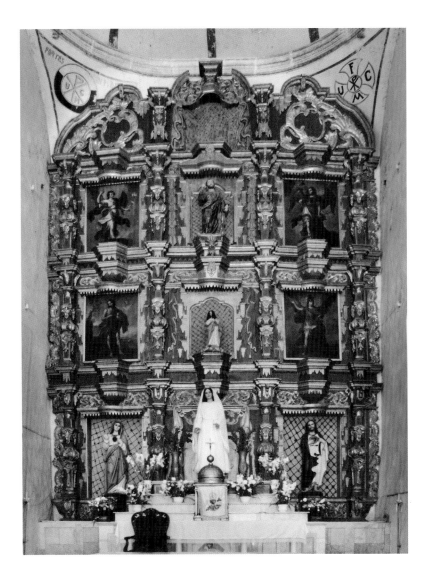

and take part in the festivals. His name is Santos Viegas, and I think he's in Valladolid now, though I haven't seen him in years.

After Padre Santos left a much older man came to Yaxcaba. I think due to age and ill health he lived in Mérida most of the time, and the Yaxcaba church was frequently locked. He held what seemed to me to be very short masses. Once on the day of San Francisco (the patron saint of Yaxcaba) the church was packed with celebrants, and he conducted the entire mass in less than 15-minutes, turned on his heels and walked out the back door, leaving all the community to parade the saint around the town without him. Now there is a new much younger priest. While I'm not sure he travels as much as Padre Santos, I know he does say mass in Kancabdzonot frequently and is well liked by his parishioners.

In Yaxunah there is a sacristan who opens the church daily so the rosary can be said. A few people attend services nightly. They go elsewhere for other types of services, though (baptisms, marriages, etc). By my census and that of Elias as well, 50% of the village is Catholic. Some few of these are the New Catechists while most of the rest are what is often referred to as folk or syncretic Catholics. These villagers may perform more traditional rituals, as well (i.e. may ask the h-men to perform curing rituals for themselves and their children, may take part in a Cha-Chaac ceremony). The rest of the village families come from those who were proselytized by the Presbyterians in the early 40's. Since then there have been schisms among them so that there are now two Presbyterian churches in Yaxunah, one recognized by the synod, and one Pentecostal church. It has been an interesting

part of my study to see how the Protestants have held on to some of the traditional beliefs and rituals but redefined them as Maya rather than as folk Catholic. (Personal communication; with permission.)

Diary Entries: 2002 Rainy Season

August 4 and 5

The Puuc Route and the Mani Trail[6]—we've had intense rains the past three days. Today in Muná, buckets of rain and streaks of lightning breaking the dark profile of clouds. Inches of water at once on the streets and the watermelon sellers, and with a foot of water on the streets, everyone watched from the shop doorways to see when it would relent.

Earlier in Umán, a soft light had played for an hour on the basilica as I photographed there.

I arrived in Santa Elena late and climbed the long, steep stairway under a brooding sky. I photographed the exterior with two northern Europeans who were taking pictures too, but they were posing with the free-ranging pigs nuzzling around the church yard. For an hour I feared for my life, since the lightning struck all around the village and the high hill where the basilica stands. A sacristan eventually came out to open the church, and I was rewarded with a viewing of the old santos in their glass cases and a wild- and black-haired Jesus on the cross. I did not get to see the mummies reported to be in this building somewhere.

Santa Elena has recently painted its church a smoky rose color. I remember back in '94, I stopped on the long uphill stretch of the Ticul road, and the bright, new tin roof of the church stood out in the wilderness of the Puuc plateau. It was the only man-made thing in the

vista, its metallic brilliance almost equal to a mirror reflecting the sun or a new supernova in the vast firmament of gray-green forest.

I arrived at the Uxmal Villa Arqueológica under a hard rain. Here were memories of other travels. I have been in this place four times, often with soft flashes of lightning on the dark horizon, sometimes with the glow, over the trees and the Adivino Pyramid, of the nighttime tourist show, "Son y Luz." This evening I am alone, eating quietly, listening to the murmur of English folks. Over my table, the termite drones spring up by the hundreds, perhaps thousands, from the thatch roof when the lights come back on. (The lightning had disabled the system somewhere in the Puuc.) The geckos know exactly where the termites will congregate around the lights, and they strike swiftly, grabbing and chewing without malice.

Sunday, August 11, 2002

As I drove out of the entrance to Uxmal I picked up two hitchhikers, Alain and Michelle. One is a telecom technician, the other a mathematics teacher from the coastal area of Brittany. They wanted to see Kabah, Sayil, and Labná, and that's exactly where I was going.

Along the road to Cooperativa afterward, we went in search of the mission church at Tabí, but the road got impassably rough. We backtracked and found the new asphalt road that takes off from the Loltun bypass. But this one also turned to dirt and then progressively into "red death" puddles as far as I could see. We reluctantly turned back and made our way to Mani where I photographed the church. INAH is doing restoration work inside and in the beautiful cloister area with old murals on the walls.

I went to late lunch at 4:00 p.m. to Principe Tutul Xiu Restaurant: ordered the *relleno negro*. Next, swung by the small mission church and

The ramada at the great monastery complex at Mani, famous site of the auto-da-fé that destroyed hundreds of Maya books.

thatch ramada at Chumayel where the boy was ringing the bell and children were studying and making art.

The big treat for the Bretagne folks, Alain and Michelle, was our stop in the big town of Mama where the townspeople were holding their grand fiesta. The church was festooned with colored streamers; many women in *huipiles*, the signature dress of Yucatán women, marched with sacred banners down the side street to the church. Later we saw many young women dressed for the *jarana*, the traditional dance from the colonial period. Big band and many dancers. This is the biggest fiesta I've seen yet in Yucatán. Three-story bullring about halfway constructed.

In the Maya manner, everyone seemed happy. Young men were firing off rockets across the street from the church while the folks in traditional dress attended services inside.

Back in Mérida, after stopping at a dozen places all day, I dropped off the happy Brittany folks at the Hotel Santa Lucia and was disappointed that the *trova* clubs were both closed.[7] Went to the mall alone and saw *Minority Report*. Travis had been sick all day and was asleep early.

Monday, August 12, 2002

Breakfast at VIPS restaurant at the mall for the last time this trip. Afterward, I had the "red death" major dirt coating washed off at the local car wash: thirty pesos. I went back for the last time to the Yaxuná Project house in the Colonia Pensiones and spent all day packing in these over-warm rooms. I said good-bye to Travis and good-bye one last time to the house, where this year by chance I spent a lot more nights than ever before. We have a new house now to which Travis will move all the ceramic sherds from ten years of excavations at Yaxuná. (Later, that new place we would call T'ho Na, and three or four different archaeology projects stored their stuff there.)

At the airport, we sat in our plane on the tarmac for twenty minutes as an extremely violent storm raged directly overhead with a savage wind shear and primal lightning. The plane out of Mexico City was an hour late taking off, but over western Mexico now we are flying along a series of nighttime thunderheads that are crackling up a powerful light show below us. I will be coming in late to San Francisco. Three hours to home and another hour to my own bed for the first time in five weeks.

The Caste War

Once I heard an archaeologist say, "The Maya are the finest and nicest people on earth, unless of course they rise up against you." In 1847 the Maya of the peninsula rose up in rebellion against the social and

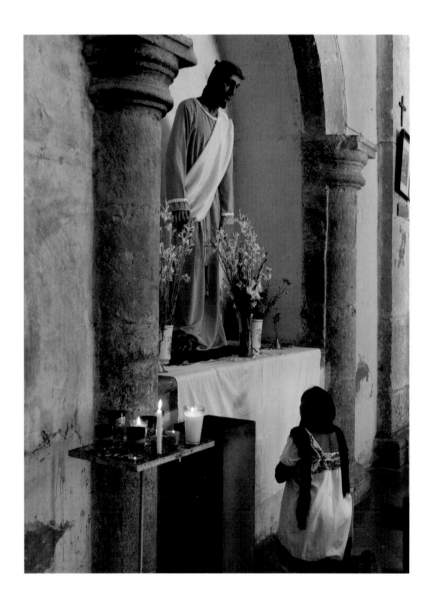

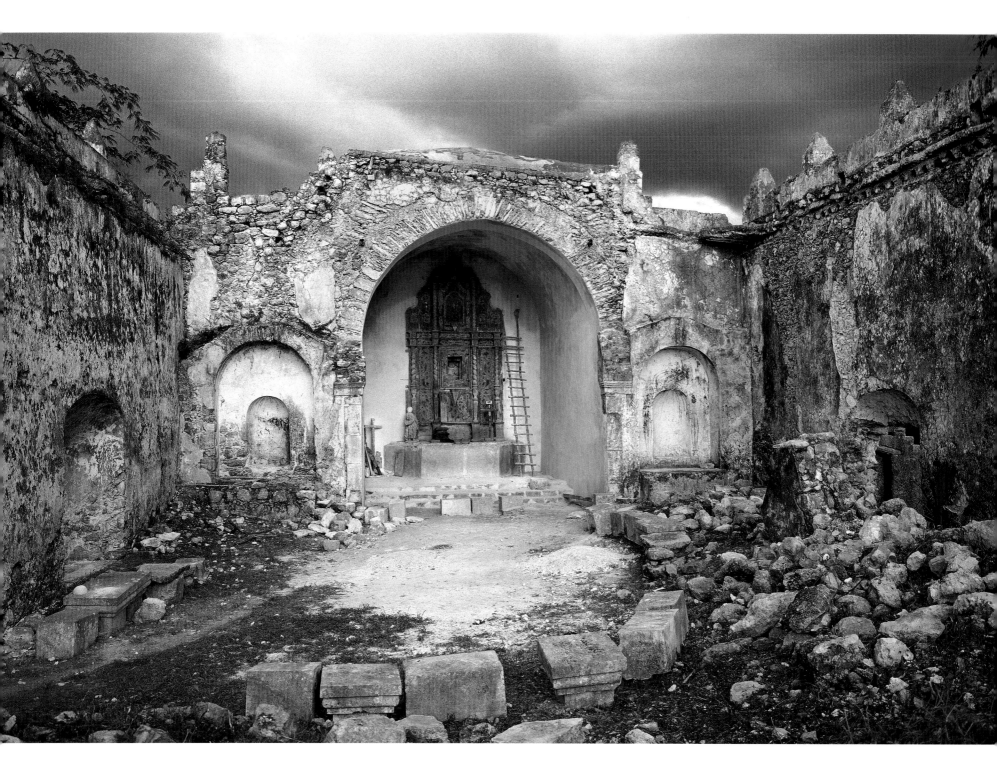

Mopilá is an old church, one of the original *encomiendas*. It was destroyed in the Caste War, but the original wooden altarpiece remains, and the Maya of the fields still hold this place as sacred. One of the old wooden santos stands on the altar. It is missing its carved wood head, and the local people have set a rough stone head in its place.

The fortress church at Yaxcabá.

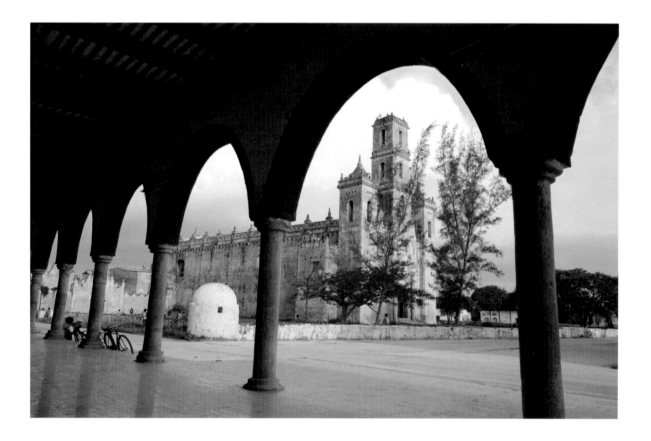

economic organization imposed on them over the previous three hundred years. This rebellion stemmed from the late eighteenth-century Bourbon political and legal reforms in the Spanish empire that favored the expansion of haciendas, the large agricultural estates held by the landed gentry. These changes had the effect in Yucatán of making the *ejido* lands—the Maya common farming lands—available for sale and to reduce, thereby, the area for traditional milpa farming.[8] The reforms slowly constrained and burdened the native Maya even above their usual oppression.

Beginning in the central and eastern peninsula, the Caste War broke out in a violent expression of grievance. By the spring of 1848 large Maya forces, armed and trained as militias after the wars for independence, had seized most of the peninsula and had almost completed the encirclement for the siege of Mérida. Believing that the

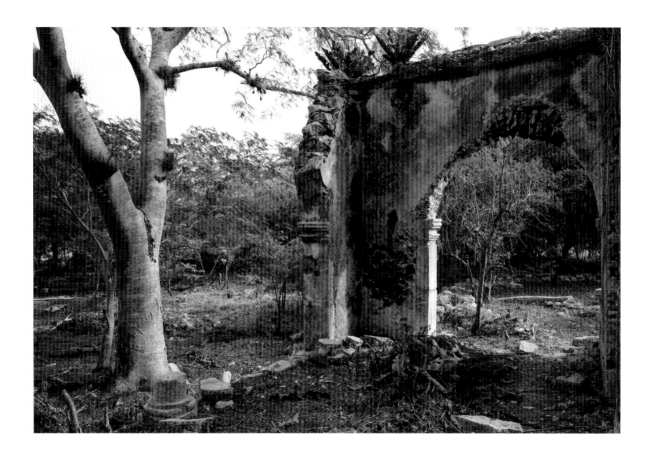

city was lost and about to be ravaged, the population of the capital streamed in panic toward their coastal port. But then, on the eve of battle, at the most critical moment, the arrival of the annual clouds of flying ants in the Maya combat lines signaled to the rank and file that the planting season was at hand. The Maya army dissolved as the peasantry left the front to prepare, as a sacred duty, their milpas for planting.

This miraculous reprieve gave the Spanish and Creole population enough time to reform and counterattack. In a series of campaigns over the next several years they pushed the Maya armies back through Valladolid on the eastern frontier of their former domain. Savage fighting accompanied these campaigns in which most churches and haciendas burned in the central zone. This area also saw massive depopulation, perhaps as much as 90 percent in Yaxcabá Parish during this period.

The beginnings of the Caste War in the south destroyed the church at Saban.

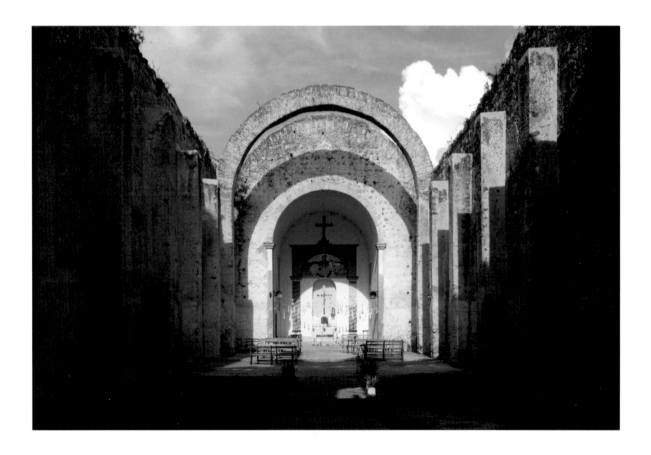

After this initial phase of the war, the Chan Santa Cruz—the People of the Talking Cross—retreated to the dense jungles of the southeast peninsula and resisted openly for another half century. They purchased arms from Belize, at that time known as British Honduras. Old-timers still fondly remember the British queen monarch and keep hoping she will soon return to aid them in their struggle. Although the last combat skirmish took place in 1933, only after the tourist mecca of Cancún was built in the 1960s did the Mexican government throw roads down to the southeast peninsula and bring the jungle Maya, the Chan Santa Cruz, under bureaucratic and national political control.

But in another sense the Maya were successful. Although they had been pushed back in the early years from the gates of Mérida, they controlled the southern and eastern parts of the peninsula, and they reasserted their traditional ways of farming and life there. In practical

terms then, and seen from a span of 150 years, the Maya people view the Caste War as the end of the *tiempo de esclavidad*—the era of enslavement—and with the government program of 1937 that created two hundred communal ejidos on the traditional model, these were all seen as a successful outcome of the war, redressing the balance in land reform, which was at the heart of the original grievance.

The Caste War of 1847 officially lasted until 1901. Today the old Chan Santa Cruz hold out hope for an apocalypse that will destroy their enemies, and the Cruzob people can then lead the world toward a utopian peace that arises from the old world's destruction.

Green Gold

Henequen (Agave fourcroydes)—an indigenous Yucatán agave plant whose large, swordlike leaves, when crushed, produce a sisal fiber used in the production of rope and twine.

I took a long time to truly notice the ruined haciendas of the henequen boom. I believe this was due to the several years working at Yaxuná in the central zone. My focus had been on the archaeology project and on the ancient ruins of the central and eastern Yucatán where few, if any, henequen haciendas had been established. And indeed I had seen some solitary ruins of eighteenth-century cattle haciendas, but by and large I dismissed them. To me they seemed more modern, not like the bleached rock of the ancient ruins or the massive stone block buildings of the Franciscan missions.

My point of view changed, though, when I moved from Yaxuná in the center of the peninsula out to the Pakbeh Project in the western zone at Chunchucmil. This village at the edge of the wild coastal swamp zone was an archetypical henequen hacienda and production factory. Living with the archaeologists in the *casa principal* of the

hacienda—our "field camp"—gave me an immersion into that historical period and also some sense of the hacienda's relationship to the Maya village culture that became enslaved to its workings.

The Maya villages in that area—Grenada, Santo Domingo, Kochol, as well as Chunchucmil—were examples of these hacienda "company towns." They all followed a similar layout. The owner's mansion or casa principal; the steam-powered and belt-driven machinery rooms to crush the large agave leaves; the buildings for spinning, packing, and storing the rope product—all these were arrayed around a large central plaza. The village church or owner's chapel stood with them. The Maya houses, forming a village in the traditional manner, would adjoin one or two sides of the hacienda buildings and plaza.

Life in these company towns was wholly bound to the cultivation of the agave henequen plant and the production of sisal rope. Living in and among the ruins of this bygone era I tried to imagine the reality and conditions of life of the Maya workers who labored on these plantations. The ruined haciendas and the life of the villages that center on the plazas of the old factories emphasize still the key role that henequen had played in Maya and Yucatán history.

In fact, the henequen boom stands with (between) the Caste War of the mid-nineteenth century and the tourism boom of the late twentieth century as one of the three important episodes defining the economic and social composition of Yucatán. As we have seen, the Caste War concluded with the retreat of the rebellious Maya to the southeastern frontier of the peninsula. At war's end people of Spanish descent controlled the northwest and the capital region where market-oriented activities prevailed. In the central peninsula, traditional Maya farmers moved back to the areas of destroyed haciendas and

The factory at Hacienda Chunchucmil.

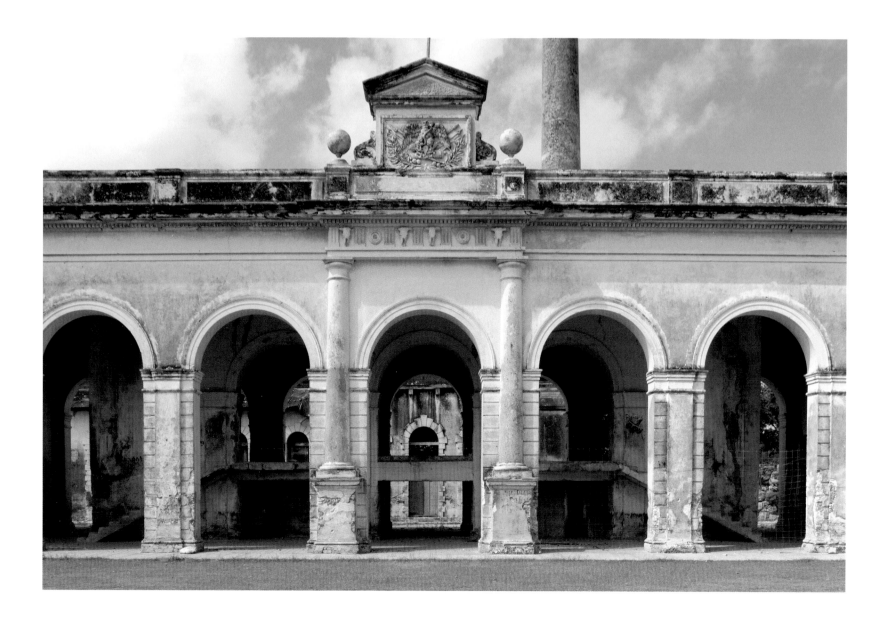

Restored Hacienda Temozon converted to luxury resort and meeting place of presidents.

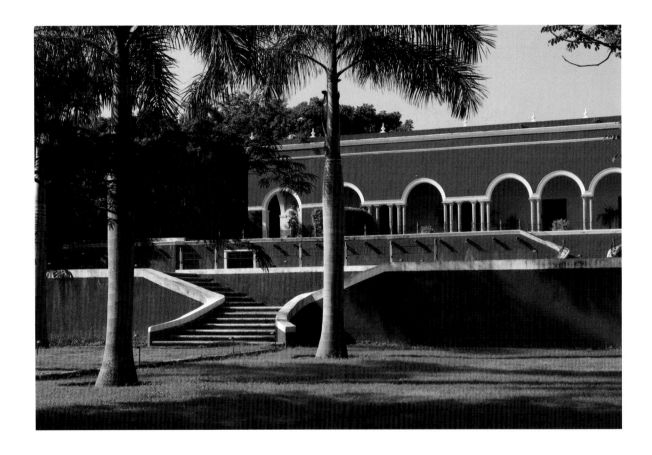

churches and resumed their milpa maize production as the principal economic activity.

Before the Caste War Maya farmers in the northern and western regions had grown henequen on a small scale. Beginning in midcentury, highly capitalized commercial growing and processing of henequen arose and came to maturity during the 1860s and 1870s. More than a hundred production haciendas sprang up to supply the fiber of the henequen agave plant fashioned into rope and twine. This high-demand product was shipped to the newly opened international markets, particularly the North American farm sector where binding twine was needed in vast quantities for use in the improved McCormick reaper-binder. With low production costs due to extremely cheap—practically slave—labor and the proximity of its principal market terminal on the Mississippi River at New

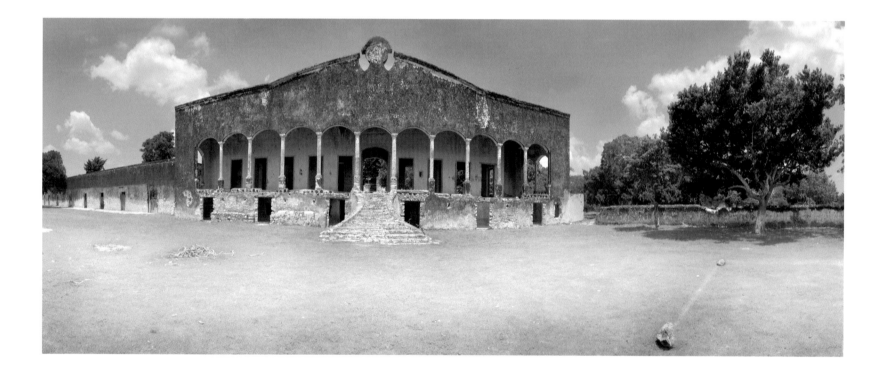

Orleans, the henequen industrial system produced immense fortunes and a booming economy. By the 1880s, Yucatán was one of the richest areas in Mexico. A reflection of this boom time and the emergence of Mérida as an important commercial center can still be glimpsed in the ostentatious luxury of the *bella época* mansions on and around the city's grand boulevard, the Paseo Montejo.

Henequen production was the main economic activity of the northwest peninsula for almost a century. Output peaked during the First World War, and many of the derelict haciendas with their abandoned industrial plants date from that period. After the war henequen production declined rapidly due to competition from manila hemp rope from Asia and the invention of synthetic fibers. Although the boom times and glory days were gone, as late as 1970 the henequen industry employed 45 percent of all workers in the state of Yucatán,

The factory and giant ceiba at Hacienda Uayamon.

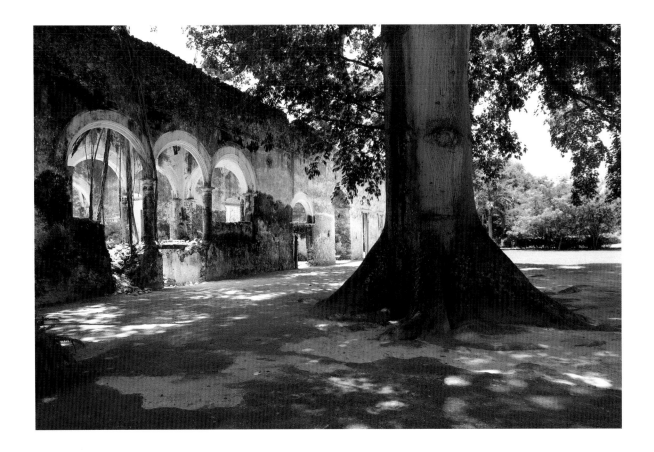

dropping to only 5 percent by 1993. Mere vestiges of this industry remain, most notably at the hacienda factory at Aké near the eponymous ruins.

In the northwest and central peninsula, most of the henequen and cattle haciendas of the past century stand now in ruins, and most remain abandoned in Maya villages throughout the countryside. Many hide themselves in corners of the forest, yet others lie abandoned in the midst of Maya pueblos. In some cases recently, some of the henequen haciendas have been purchased anew, and renovation has brought them back to their former glory. They serve now as luxury resort hotels in the countryside or private, upscale haciendas that are forging new relations with the Maya villages within which they reside.

Sheaves of henequen swords waiting for the crusher.

The last *sisalero*.

Spinning the sisal fiber.

Farm and garden twine.

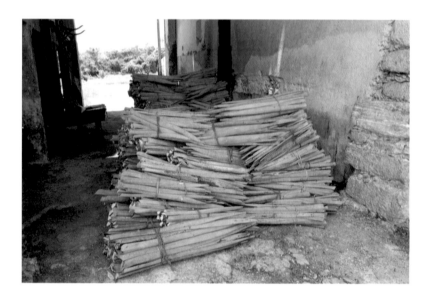

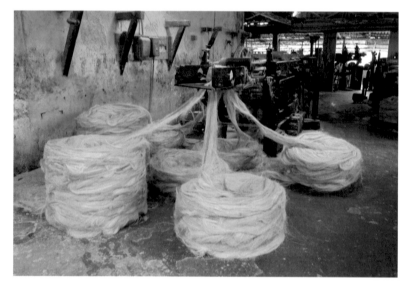

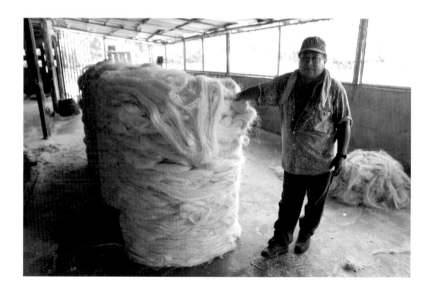

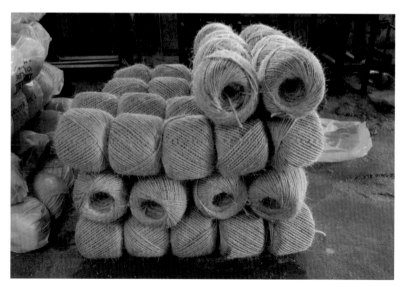

Industrial Archaeology

When I visit the melancholy remains of Yucatán's haciendas I am struck by how rapidly the buildings have melted to ruins—in less than a century in most cases. I always come away with a clear appreciation of the implacable destructive force of vegetation and tropical weather, not to say a weary sense of history's relentlessness. Here is a case of industrial archaeology on a vast scale, for the ruins of the henequen haciendas with their plantation systems and their steam-powered factories cover the entire northwest quadrant of the peninsula. Exploring these modern ruins often puts me in the same frame of mind as the ancient ones do, for even though we have pictures and written records of that modern era, the ruined places themselves equally seem to be the haunt of a life gone away, a disappeared time and place whose secrets seem just beyond reach or imagination.

The Least Earth

Yucatán is the country with the least earth that
I have ever seen, since all of it is one living rock.

—Diego de Landa, Bishop of Yucatán

All of Yucatán's history played out upon a special, if not peculiar, geography. This large peninsular region, also known culturally as the Northern Maya Lowlands, is powerfully influenced by the interplay of the waters of the Gulf of Mexico to the west and north and the Caribbean Sea to the east. This peninsula is a great limestone shelf with scarcely a hill in sight for two hundred miles from the east coast until the visitor reaches the rampart of the Puuc Sierra, a low hill range that takes up the entire southwest quadrant of the peninsula. The peninsula is thus an immense carbonate stratum tilting gently to the west and north, so gently that once out to sea the depth of the water is shallow for miles. Limestone is the only rock in the entire peninsula, and that dominance creates peculiarities of geography.

These peculiarities form the classic karst landscape: caverns, underground rivers, sinkholes with water, called cenotes,[1] and twisted and etched limestone outcrops and bedrock called *laja* (lah-hah). The landscape is pocked with caverns, small and large. The caverns that reach down fifteen to twenty meters almost all have water in the bottom, and often that water is running through as an underground river or slowly moving water table. North of a line about halfway up the peninsula this is the only running water, for none streams on the surface of the land, nor can one witness any lake or pond. The water flows through the dark cenotes that dot the face of the land, and they are practically unique to the northern Yucatán plain.

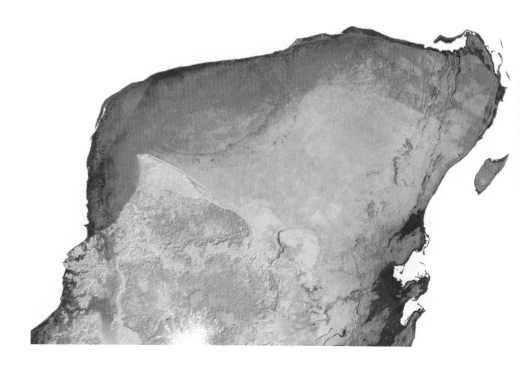

The rim of the great Chicxulub bolide impact shows faintly in the northwest of the peninsula. Image courtesy of NASA.

The Sacred Well of the Itzá—the Great Cenote at Chichén Itzá.

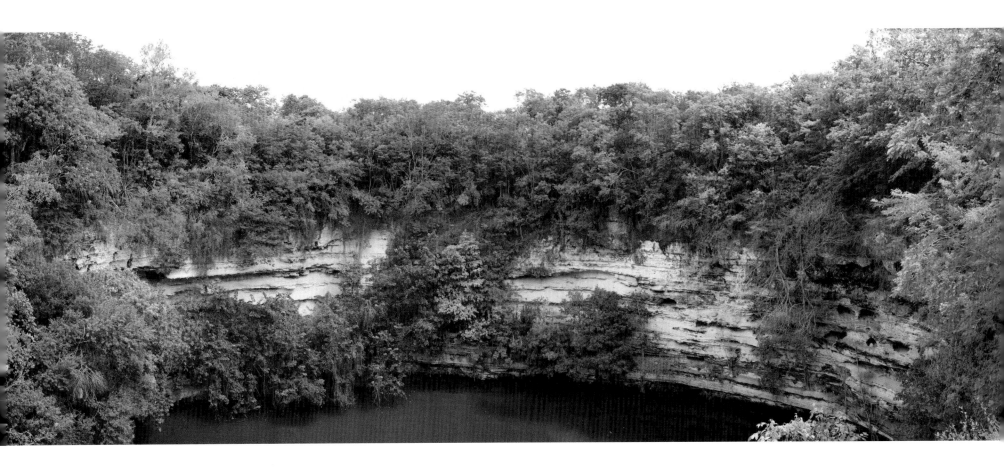

The Cenote Zone

The NASA satellite image of the Yucatán exaggerates a slight land deformation that is important to understanding a major feature of the peninsular geography. The image amplifies the topographic relief to show the outer rim of the Chicxulub (sheek-shoo-LOOB) asteroid or comet (bolide) impact of 63 million years ago. This now famous impact is cited as the cause of the worldwide demise of the dinosaurs who dominated the biosphere for 160 million years before that time. The Chicxulub impact crater hides itself under hundreds of feet of overlying limestone strata. Using remote sensing oil exploration studies, a geophysicist, Glen Penfield, first noticed this sub-surface crater in the early '80s by examining gravity and magnetic measurements.

This crater rim is also interesting because it defines a zone of cenotes that cluster in great numbers at that rim. In western Yucatán many large and lonely cenotes are found in the dense bush, and many more dot the circular rim as it approaches the northern coast. This northern coastal region is now only sparsely inhabited and seems to have been in ancient times as well, so the number of cenotes did not materially aid in the growth of civilization in these areas. In the interior, though, cenotes were important markers for the crystallization of a city or town.

The permanent water supply of the northern plain therefore is typically ten to twenty meters below the ground, leading to a notable dryness of the surface, a dryness that is corroborated by clumps of cactus and agave, known for their stamina against drought and their marked preference for dry ground. In fact, the limestone bedrock is fractured and fissured so much that the deluge of water from the rainy season thunderheads passes right through the surface, and two hours

after a downpour, aside from a few puddles in the road, the *monte* is largely free of running or even standing water.[2]

Cenotes are found in all stages of development. They can exist as half-collapsed sinkholes or caverns that have not collapsed yet or even dry cenotes not deep enough to find the water table. I find it wonderful that most of the cenotes are fairly round as they sink below the water table. The ones I have seen seem about twenty to thirty meters in diameter, with some that are larger. The famous cenote at Chichén Itzá, the "mouth of the well of the Itzá," is one of the largest at about seventy meters across and is circular in form as it reaches to great depths below the water table.

In the late nineteenth and throughout the twentieth centuries, archaeological diving at the great cenote brought up—among many other objects—some gold artworks, which would have come probably from highland Mexico in the Late Postclassic era (fifteenth century), and a small sculpture associated with one of the last kings of Palenque during the Late Classic era (eighth century). This cenote was thus a pilgrimage site for a full millennium, if not longer. John Lloyd Stephens noted Maya pilgrim visits during his sojourn there in May of 1841. Maya folk still visit the Great Well of the Itzá, and tourists from all over the world make the pilgrimage. So its role as a sacred place has already stretched over two thousand years. Who can deny that it may continue its sacred status for another millennium or so?

With the advent of satellite imagery, we can now spot many hundreds more cenotes in the rugged countryside that previously were known only to the local Maya residents. These numerous water sources may explain the high demographics of the ancient populations.

In the northern limestone plain, water often collects in aguadas, permanent or intermittent ponds that the Maya relied upon.

In addition to the natural aguadas that form occasionally on large concave bedrock, the present-day Maya often use the aguadas constructed by their ancestors. These were often stone or clay lined, and in the rainy season the ancient Maya used these collection surfaces. Following an idea of my old friend and Andean explorer Keith Muscutt, I believe that the great plazas of the ceremonial precincts were perfect for water catchment—which they drained off to cisterns and water *chultuns*.[3] Keith also fancied that the water standing in these internal plazas could have served as reflecting pools as well. I don't know if this is true, but I can easily imagine that the stars and other heavenly bodies reflecting in these shallow pools at night may have corroborated and reinforced the Maya cosmological schema. That nice thought set aside, however, it remains that water was the foremost environmental constraint for the ancient Maya, and the development of hydraulic systems was crucial technology for survival at all levels of the civilization.

Constructed aguadas were, and are, frequently placed in and around *rejolladas*. These are large collapsed cenotes or sinkholes, or incipient cenotes, and they can be very valuable property in this land of rock. These large depressions of the ground in the flat land are a natural place for the rare formation and collection of soil. In the bottomland of the rejolladas villagers grow banana and citrus trees, and some truck crops too. In ancient times, scholars think that dry cenotes and rejolladas were perfect for the cultivation of chocolate trees, a source of wealth and—due to its importance as a medium of exchange—of geopolitical competition among the cities of ancient Yucatán.

Besides cacao, the other ancient trading mainstay was salt. The entire Maya civilization in the interior depended on salt, for human

The salt mountain at Río Lagartos on the north coast.

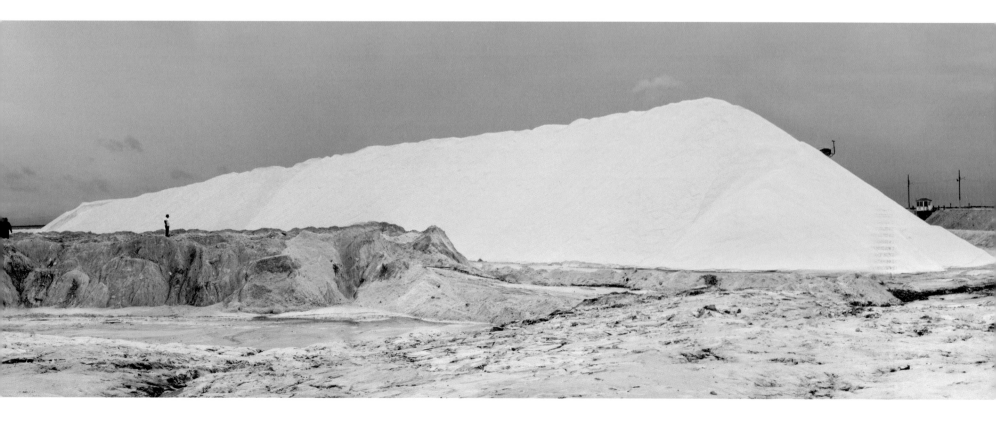

Rainy season Yucatán—from the back porch at the Yaxuná Project.

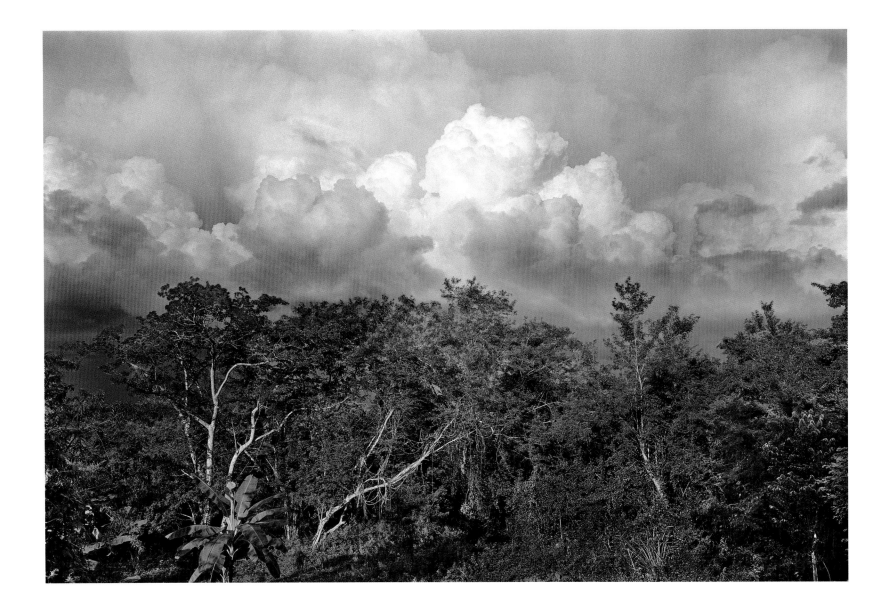

survival in the intense heat of the tropics requires great quantities of this resource. In fact, the interior of the country could not have been settled, much less civilized, without a distribution of salt from the evaporation salt pans of the coast. Therefore, water in the cenotes and salt brought in from the coast determined the place and possibility of cities in the interior. Some of the best and purest salt in ancient Mesoamerica was produced on the north and northwest coasts of Yucatán. Near Celestún, the pure salt ponds went out of production early in the twentieth century, but the great ponds near Río Lagartos on the north coast still produce mountains of salt that ships take directly away for trade.

Rainy Season Climate

Yucatán, like most of the tropics, has two seasons: dry and wet. The term *rainy season* in the peninsula might be misleading, and therefore may keep most tourists from visiting during this exceptional time. For my part, it is my favorite time to travel around. I found that the rhythm of the day is the key to enjoying the rainy season. Everywhere I went on the peninsula the mornings began the same way. At dawn, if lightning, thunder, and rain had crashed about in the past few days, then a cool ground fog would settle in. As the sun rose a bit, this fog would rise and come off of the ground and begin softening the light around the buildings and the surrounding monte, the jungle just outside our doors. By midmorning the fog would rise further still and form low, low clouds, dancing and curling overhead. Glancing on both sides of the sun disk, I would see sun dogs, gleaming with iridescent rainbow colors.

By midmorning in the interior of Yucatán as I walked up to the ruins of Yaxuná I often saw an intriguing optical phenomenon. In the face of the fierce morning sun, the water resting overnight in the ground and upon the vegetation would rapidly evaporate and begin raining skyward. I could see this dense water vapor rushing and streaming up, and as it rose overhead it created an optical sensation as of a star gate corridor, the moisture hurrying toward the zenith, the molecular multitude forming clouds three or four hundred feet above my head. These clouds themselves would rush further on and begin coalescing as the cumuli of the forenoon.

Then the noontime cumuli would float lazily and gather together, and probably under the influence of a provocateur cloud, they would crowd together in more and more massive nimbostrati, the lower parts grayer and grayer, then blacker and blacker, the high columns and crowns still brilliantly white. At some point—just as a human crowd becomes a mob—they would begin to gather and rise in the huge columns and spheroids and florals and protuberances of the thunderhead. Rising to the stratosphere, the thunderhead, with the swift air at that level, flattens to its signature anvil shape and from its dark lower expanse throws sizzling lightning and immense detonations of thunder, before unloading benevolent rain squalls across the jungle lands and the milpas of the Maya farmer. Chac, the Maya Rain God, carries all these impressions with him, the smoky fire flint of lightning, the axe of thunder, the headdress of agricultural bounty. He even looks like a speedster, moving quickly, forcefully, like the thunder from horizon to horizon.

In late July into August a peculiar climate feature threatens the maize crop, especially in the center of the peninsula. This is the *canícula*, a dry spell in the otherwise wet rainy season.[4] The etymology of the word is strange: it means dog, and is related to Sirius in the constellation Canis Major. Also known as the Dog Star, Sirius

is the brightest star in the heavens. Many ancient agriculturists all over the world paid close attention to its movements, not least the ancient Egyptians who understood that the annual appearance of the Dog Star heralded the flood of the sacred Nile. Why the dry spell is called the canícula in Yucatán I could not discover, although at this time of year and just at dawn, Sirius shines brightly on the southeast horizon.

Hoping to survive through the canícula, Maya farmers, like all agriculturalists, watch the rains closely. In a conversation at an end-of-season dinner in Mérida, Tony Andrews, one of Yucatán's leading archaeologists, related an exchange with older farmers in the north-central henequen zone out to the east of Motul. They remarked how the rains seemed more plentiful in the local area because more and more henequen fields had been turned back into forest and restored to the twenty-year fallow planting regime. The henequen fields retained less water and gave up less moisture to the daily and seasonal hydraulic cycle, all in contrast to the behavior of the traditional milpa system. Following up that talk with the farmers Tony checked rainfall records for that region and corroborated their folk knowledge. He found that the farmers in their observations over many years were, of course, perfectly correct in their impressions.

Outside of their milpas, the Maya take advantage of many animal and other plant resources, among which are beekeeping and hunting small animals, mostly with ancient small caliber rifles and small bore shotguns. Striding to the ruins on occasional early mornings at Yaxuná, I would encounter villagers as they went out mounted on their bicycles, or perhaps a small pony, and sometimes they would come back with small game. Although the white-tailed deer and the Yucatán brown brocket deer both range throughout the peninsula,

I never saw deer in the northern areas, only in the Calakmul Biosphere Reserve. These deer certainly live in the wild edges of the western peninsula where the villagers cannot live during the seasonal inundation of the wetlands periphery. These lands are not exactly swamps or estuary lands, for the limestone bedrock is right at the surface, but so is the water table. In the rainy season the water table rises just enough to put a vast tract of land with its small trees and bushes under several inches of water. This uninhabited zone has probably always been wilderness, and living in this trackless place are the wild and rare animals. During the 2001 field season, the villagers of Chunchucmil—who live at the edge of this wilderness—killed a mature jaguar who had been encroaching on their cattle and goat herds. The wild cats enjoy some protection but lose the battle when they come too close to humans.

The great predator of the peninsula is the human. To survive, the predator cats of Yucatán must remain shy. Nonetheless I did see a miracle one late afternoon. I believe it was the summer of 2002, and with my colleague Michael Henninger, I was driving in the Puuc Hills on the road north toward Santa Elena from the ancient site of Kabah. In one electrifying moment we were astonished when, just in front of our car, a black pantherlike animal sprang from the jungle embankment and sprinted across the pavement into the tangled brush opposite. In an instant it was gone, but the experience of it seemed a slow-motion marvel. That evening at Tiho Na, our archaeology project house in Mérida, we asked Travis Stanton about the sighting. He said it was a young jaguar, and if we could have looked closely at his fur, hidden beneath the black coat we could have seen faint outlines, the floret signature of the jaguar pattern embedded in the shadow of the black.

A palace doorway in the Grupo Kuché, Kiuic.

CHAPTER FOUR # Imagining Maya Ruins

Place of Revelation

In their ancient cities Maya artists knew well their urban and agricultural landscapes. They designed them to be charged with emotional power and bestowed in them all the social power and ideological atmosphere that public writing and public art can communicate so powerfully. When I visited Maya ruins packed with their ancient emotions, I was drawn most powerfully, as most people are, to the high pyramid-temples. For the ancient Maya these pyramids were Portal Mountains. They represented both the celestial mountain and the cave in the summit where they could conjure and speak to the ancestors. Taken together the mountain and cave symbols juxtapose the heights of the celestial sphere with the recesses of the human unconscious. I understood this immediately. In this symbolic architecture I saw the holy grail of the artist: *This was the place where revelation may happen.* I felt this often when standing in front of ruined temples, especially those that stood alone and remote in the wilderness. These reclusive places seemed all the more powerful in their loneliness, without the taint of modernity nor tread of tourist thousands. Thus arose an instinctual knowledge: the summits of pyramids were places of revelation.

I came, therefore, to believe that merely standing on those ancient pyramid summits was tantamount to creative discovery. It was upon wild summits in particular that I felt a primordial source of human imagination. Ascending them I longed to glimpse an undiscovered country, to hear the ghosts amid the small sounds of the summit winds. I imagined that if I could be quiet for a moment the portals would open, and visions and messages could fly back and forth. I embraced that hope for a vision, and at the same time I was also afraid that it might happen, afraid that I would see or feel something that I could not explain. In those moments a small kernel of dread (or

wonder) would grow inside, and I sensed that it was entirely possible that powerful deities and spirits, which the Maya artists described so well, would appear, and I would be changed forever. I feared this epiphany, but nevertheless I walked the world of ruins hoping to meet up with that precise revelation.

It was a profound personal affirmation when I discovered that Maya artists created acres and acres of sculpture in their cities and produced a myriad of codex books with their astonishing illustrations. But perhaps I should not be so surprised by this tide of ancient artworks. Nowadays, our own artists produce virtual storms of messages in film, television, books, magazines—enough to envelope the earth with a cloud of culture. In the same way Maya artists flooded their civic buildings and libraries with the theatrics of the creation story, often in support of the authority of the rulers who wished to tie their legitimacy to the cosmic order. (It is the same today: artists create cultural messages in support of ruling elites and the national mythologies of all the various earthly and heavenly states. But truly, in contrast to ancient peoples, the overwhelming role of modern creative work is to support the global ideology and operations of Commerce.)

Art and Memory

At Uxmal, the capital city of the Puuc region, the profusion of relief sculpture that decorates the elevated facades of the civic buildings is a fine example of the importance of public art in Maya cities. Ancient Chichén Itzá boasted just as much art in the Great Ball Court and upon the square columns surrounding the Temple of Warriors. But I had not thought through the implications of this sculpture for memory. This required a personal observation at El Perú-Waka' in the Southern Lowlands before I fully grasped the connection between

Maya sculpture and Maya memory. During the 2005 field season David Lee, a graduate student at Southern Methodist University, with David Freidel as his guide, was excavating an extensive palace staircase, and they came down upon a series of rooms that had once ranged along the face of this palace complex. This facade of the palace must once have displayed an extensive program of relief sculpture that told a brightly colored narrative in stucco, because the ancient builders had dismantled this sculptural story, broke it to pieces, and placed them carefully in the rooms below. In an adjacent room, they found a ritual deposit that contained artifacts that ranged in age over hundreds of years of city history.[1] The ancient dynasty had buried heirlooms of both the early city and the late city in order to keep a memory in place while—it seems—they left the city for awhile. Later it seems the dynasty returned and tried to reestablish their authority in that precise place. By hiding the broken stucco facade in those special rooms, its memory could be solidified and recalled as a spiritual and authoritative entity.[2] The Maya have a deserved reputation for long memories, and this reverential placement of the heirlooms and stucco sculptures in buried rooms served as a remembrance of heredity and authority as the returning dynasty attempted to reestablish their presence in their palace of old.

In 1998 I had received another, sadder, lesson about memory that is strewn about in Maya ruins. In that year's rainy season I toured the perimeter of the peninsula with a small group of artist colleagues. This was the first summer in several years that I was not working with a research project, and that gave me the opportunity to photograph many more sites and was a perfect time to practice the digital imaging technique for creating my 360-degree panoramic photographs. We visited twenty-two Maya ruins all around the peninsula. Of course we visited the well-known sites of Chichén Itzá and Uxmal, and traveling south we crossed the wide Usumacinta River to wonder at Palenque. But many more Maya cities repose throughout the land, so we also visited lesser-known cities, large and small: Edzná in the Chenes region and the southern interior peninsula sites near Calakmul and the Río Bec. We saw the large temple masks at Kohunlich, and driving north through the lakes district of Bacalar, we ended up in the east at Cobá and Tulum with its aquamarine beach.

In all these ruins we wished to discover their poetics and their emotional power. My friend and sound recordist Tony Idarola sought out soundscapes, and listening to the ruins, the ancient buildings, and the surrounding landscape, he imagined what the ancient people heard on a daily basis and in their special ceremonies. I was visual: I saw the geomancy of places and the bright, almost rococo design of the architecture and art. At the time these design schema seemed so complex to my eye that seeing the elements and beginning to understand the message required special concentration. (I suppose the same could be said about modern art.)

Of that tour what I remember especially are the ruins of Calakmul. I was melancholy for days—remembering it, I am still melancholy—after our visit to that sprawling city, that great superpower rival to the ancient capital of Tikal. These two cities held a grudge against each other for five hundred years, and their rivalry and combats dominated the geopolitics of the Southern Lowlands through most of the Classic period. My melancholy, though, stems from the 152 stelae that imbue the ruins of Calakmul with sadness, for the hieroglyphs and iconography that once graced them all are mostly unreadable due to the poor, soft stone in which they had been carved. Of course history is lost all over the world, but here at Calakmul that lost history is plain to see. The hieroglyphs are there, but they are

eroded, fugitive, and unrecognizable. I came away from these ruins very dispirited, for what had vanished was the detailed story and memory of a city, its people, and a royal dynasty that gloried in that jungle place for a thousand years.

Principles for Imagination

In my quest for the spiritual, the most fulfilling act while in the sacred space of the ruins is an act of imagination. But for a reality-based person the process of imagination must be rigorous. To some people, this may seem to be an oxymoron. However I have found that our mind-set and perception can often be in contradiction to the reality of the ancient culture. Our eyes see the restored ruins, and we are most moved by what we see firsthand. And what we believe often governs how we imagine the truth here. But the present state of the ruined cities, the ideas and techniques that guided their restoration, the appearance of their interiors as well as encircling landscapes, and the popular imagination surrounding ancient Maya culture all conspire to mislead us.

Therefore, imagining the ancient Maya in their ruins, I evolved some guiding principles for myself. The first of these was basing my imagination on the results of 150 years of scientific exploration and research. This is a key principle, for the descriptions of the archaeologists are founded on the scientific reality of their excavations. Even so, there remains plenty of room for informed speculation, even if hard, physical reality is at hand. The possibility for a range of interpretations is broad enough—and believe me, archaeologists vigorously debate their interpretations—without also bringing fanciful explanations such as pyramid-building UFO aliens or the ideological biases of ethnic and political parties to the argument.

In no particular order, here are my other guiding ideas for contemplating the ancient cultural landscapes of the Maya.

The land must be imagined not as wilderness or jungle as it appears today, but rather as a much more developed, civilized, and cultured landscape. Absolute population numbers and densities were much higher in ancient times, so house and garden dominated the settlements, all surrounded by the milpa system. Every square foot was either cultivated in the garden and orchard system or producing maize, with some larger areas resting fallow to recover their vegetation.

The flat expanses between the big buildings were not grassy or forested in ancient times. These plazas were brilliant white spaces, with acres of thick plaster, abstract and stunningly minimal. Likewise, the ruins today are bare rock, gray and brown, but during the time of their use, these buildings were richly decorated and painted. Expanses of red reflected from the buildings and pyramids. The ancient artists painted the decorative sculptures in bright colors of blue, yellow, white, and black. In fact, these pigments would have constituted one of the luxury goods traded between the mineral sources and the cities that wished to paint their buildings with a narrative of color and creation myth.

Furthermore, in the ruins I realized that I was often looking at the remains of ten or fifteen centuries of building activity. For example, the Central Acropolis at Yaxuná stood perhaps for a thousand years in the center of the living city. It may or may not have been in ruins for a great part of that time. I can imagine that the ancient Yaxuneros allowed this building to majestically stand in ruins, amid all their other beautiful buildings, clad in trees, just as we see it today.

When contemplating the ruins I often ask myself, what am I missing? For we see now only the surface, not the depth, of the remains. Almost all the possessions of the ancient people have perished and

gone to dust. Lost is most of the art, most of the buildings, most of the sense of these places. We must construct from small pieces our understanding of the whole. I think it is a heroic notion that we can understand these ancient cultures from the few, rare clues that are unearthed by archaeologists.

What do they find? What survives such long burial and the whims of climate and vegetation? What I have witnessed mostly in the excavations are ceramic sherds, lots and lots of sherds. This fact surprised me at first—why are there so many broken pieces of clay? I realized finally that this was the garbage. Every time a vessel broke it was thrown in the garbage; it was thrown underneath the table, behind the house, in the middle of the floor construction, underneath the stone stair. And since they were themselves hardened dirt they survived the centuries of neglect. Unbroken whole vessels, though, are found underneath the dirt floors of the Maya houses where the ancestors are buried with the pots and heirlooms they will need in the afterlife.

Stone carvings, jade jewelry, bone, carved bone, the impressions of perishables, and of course the skeletons of the ancestors, these often survive. On occasion, by some luck or some miracle, a fragile, insubstantial, or organic artifact survives, rarely as an object itself, but occasionally as a barely visible impression in the mud, as a casting in volcanic ash, or as a representation in a painting. Upon these clues the archaeologists with a rigorous method build their fantastic story about the ancient people.

Sacred Performance Place

For all those ideas, I have come to an (unoriginal) realization that cognition and power are embedded in artworks: buildings and decoration, paintings, and the painted ceramics. The sculptures, the

power-objects, through their aesthetic programs explain the thinking of the ancient culture.

Beyond everyday use, the architecture of the ancient cities carried another purpose. The big buildings, the pyramids, the observatories, the plazas and ballcourts were all constructed to tell the creation story of ancient Maya culture. These buildings embodied and sustained the mythological foundations of the culture. They did this in specific ways. First, the pyramid-temples and ballcourts were constructed to specifically serve as portals to bring the gods and ancestor spirits into these theatrical spaces: to perform, to communicate, to intercede. Meanwhile smaller spaces and buildings—the shrines, the palaces, the administrative buildings through their emblems, their decoration, and their spatial orientations—also contributed to the communication between the people and their gods and ancestors.

At a larger scale, the design of the overall city plan expressly took on the shape of cosmograms, that is, the placement of important ritual places in the city to resemble the relationships of heavenly bodies or the cosmic relationships that were understood from the creation myth. And almost all cosmic designs were tied to an understanding of the starry night sky.

Accordingly, temple buildings, astronomical observatories, ballcourts and public plazas, royal courtyards and residences, and the raised causeways (*sacbeob*) that connected them were designed to physically and graphically resemble those cosmic and heavenly relationships. The creation story of the ancient Maya pervades all of their politics and geopolitics, and all of their cultural expression. The cosmogram of the city embedded that story and all its power relationships in the very stones of the city. Walking today through the fallen cities, we can still sense these cosmological poetics and appreciate them in the ancient

architecture, even without specialized knowledge of the ancient Maya.

The principal motivation of the Maya, it turns out, for the alignment of the city, its architecture, and its ritual life was to connect the creation story to the authority of the divine rulers. A powerful way to do this was to turn their cities into theater states, where the rulers, the people, and the city itself became performers. The meaning of these great theatrical spaces and the centrality of the creation story to Maya belief has not entirely been lost. They can still be sensed, sometimes even glimpsed, in the hidden corners of Maya towns or secluded recesses of the backwoods, beyond the prying eyes of the modern world.

Maya Continuity

Throughout the backwoods, sometimes in the backyards of Maya houses, and certainly in some of the ancient ruins and desolate churches, I would find signs of the persistence of ancient Maya belief. Literally hidden away, or sometimes in plain sight through common folkways, the Maya carry on rituals of ancient worship and belief. These signal the fundamental strength of a cultural persistence, a cultural unity, and thus a cultural survival.

For more than two millennia, from Preclassic times to the present, the Northern Lowlands has been culturally united, a unity strongly supported by the use of the Yucatecan Mayan language throughout the peninsula. Here we have a continuity of blood, of language, and of connection to the land, a connection borne out by the persistence of the ancient agricultural system of the peninsula.

The Maya agricultural system—an effective and long-standing subsistence strategy—is a mix of maize farming, small-scale animal hunting and husbandry, and sustainable exploitation of forest products. This system is evolved and closely fitted, with very small tolerances, to the environment in which it lives, and Maya belief systems, which are also evolved and closely tuned to this system of sustenance, reflect the longevity of both the physical and cosmological practice.

Maize Farming

The most common term used for Maya farming is *slash and burn*, which has a pejorative ring to it, with overtones of unsustainability. In fact, the system the Maya villager uses has served since the beginnings of agriculture in Yucatán some four thousand to five thousand years ago. Proven through long use, in a land of barely perceptible agricultural virtues, this farming practice has proved itself sustainable, and in the backcountry areas of Yucatán Maya people still make it work.

This farming system relies on an average twenty-year cycle. Each year just before the rains begin, the farmer picks out a new plot in the forest. He cuts and burns the trees and understory, and in the layer of ash he plants maize, squash, and beans, the "three sisters" of Mesoamerican agriculture. In the first year, if thundershowers appear overhead every three or four days, the field will produce a full crop. The second year it will produce about 60 percent of the first year. In the third year the 30 percent yield from the thin field does not pay for the effort. He then leaves it fallow to reforest itself for up to twenty years thereafter.

When I first arrived at Yaxuná, looking at the landscape, the essence of the village, and the milpas, I thought that—except for the metal tools and the modern clothing upon the farmers—I could have been in twelfth-century or even eighth-century Yucatán. But it was mid-May that first time, and the sky oppressed us with a smoky pall from the widespread burning of the milpa plots across the peninsula.

Over the years I became more aware of the milpa growing cycle and took an interest in how the crops were doing. Did the plants look healthy or wilting? Had the thunderstorms come this way recently? Is this a first-year or second-year milpa planting? When will the farmers break over the stalks to dry the corn before harvest?

Whenever I could I would stand in milpas during my Yucatán wandering and try to imagine the maize field as a sacred space. After a while, imagining the sacredness of the maize field in Yucatán seemed easy and natural. It seemed natural because the Maya farmer's milpa is and was the great creation ground of the cosmos. The two main storylines in Maya cosmology are one of Creation, the other of Sustenance. They are naturally and closely intertwined. A simple retelling of the story goes like this: The Creator Gods, after two failed attempts using mud and wood as raw material, fashioned the third wave of humans from maize. The universe itself was created out of a fissure in the shell of a cosmic turtle, from which the Young Maize God emerged. This crack in the cosmic turtle is also symbolized in the Mesoamerican ballcourt, from the middle of which the World Tree–Axis Mundi is rooted and grows. Creation and existence are represented and sustained in the daily and yearly cycles of the rising and setting of this World Tree—the Wakah Chan—as represented in the position of the Milky Way in midsummer (early August). This rising and setting of the galactic center symbolizes the birth, growth, and death of the maize plant in the simple farmers' milpa plots.

The Maize God lives and rules in the milpa. The milpa thus becomes a microcosm of the universe, and with the cultivation of maize at its heart, it recapitulates the creation and cyclical force of the universe. The four corners of the maize field are the four corners of the cosmos, and Maya farmers still dedicate the corners of their plots with rituals from ancient practice. That first creation *must* be reenacted for the universe to remain in existence. This is the sacred duty of the Maya farmer centered in his maize field in the center of the forest in the center of the cosmos.

Maya cosmology and the perception of sacredness in the world arise from the realities and mysteries of growing food, and all is linked to the narrative cycle of the starry heavens. The recurring annual creation story as the stars circled the heavens tied to the miraculous cycle of the growth of corn maize was the fundamental truth and understanding of the ancient Maya. This was true, not only for the Maya farmer, but throughout all of ancient Maya cultural expression for which the story of creation and sustenance is the central theme. This story appears in practically all displays of Maya art, from simple family burial goods to the exquisite paintings on royal ceramics to the legitimizing propaganda of the rulers. This story naturally reveals itself in the ceremonial buildings and in the cosmograms embedded in the architectural layouts of Maya cities. Sacredness inhabits all the ruins, even as it lives on in the rituals of the Maya farmer.

Maya cosmology and belief are very appealing. My sense is that the ancient, primordial landscape lies nearer to the creation of the world. Likewise, ruins hold ancient knowledge, ancient technology, ancient secrets and mysteries. In their ruined state, moreover, they are usually set in old forest and glade, symbolizing the primordial garden. In the final analysis, Maya temples impress me as either sacred buildings in harmonious groves or, in the form of the pyramid-temple, as overpowering architecture, close to the sky, and close therefore to the otherworld where the gods created the universe. Wandering the ruins then, I realized finally that all architecture, whether monumental or humble, becomes sacred to the extent that human labor and reverence is put into it.

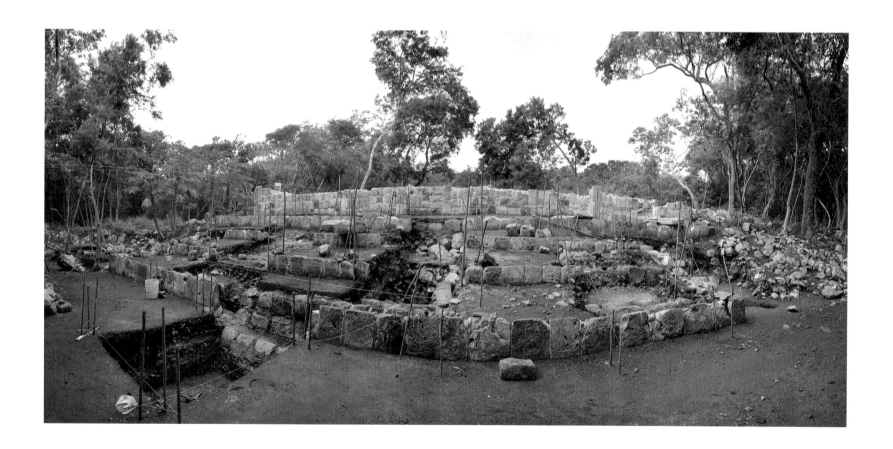

Archaeology in Yucatán

I arrived in the Yucatán at the best possible time, for these past two decades have seen a revolution in Northern Lowlands archaeology. This revolution had its roots in the late 1950s when the Mexican government through its federal agency INAH (Instituto Nacional de Antropología e Historia) began large restoration projects at Uxmal and Chichén Itzá for the development of tourism. In tandem with the restoration projects, standardized scientific research was begun at Dzibilchaltun, north of Mérida. Since then numerous INAH restoration projects have been going forward, while the trend toward rigorous archaeological study accelerated through the 1990s and continues today with multiyear excavation projects working at a host of sites. This stepped-up tempo of research in the Northern Lowlands has propelled a highly beneficial collaboration among a new generation of Yucateco

and North American archaeologists, for this generation has grown up together in the excavation projects of the past twenty years.

In the past two decades, a more confident picture has emerged about the northern Maya, in large part due to the refinement of the ceramic sequence and its time scale that is used to date discoveries. Along with the ceramic analysis, the excavations themselves, as well as the iconographic and epigraphic (hieroglyphic) research, have sharpened our understanding of the ancients. Among the subjects that have come into better focus are the role of trade and commerce throughout the peninsula and their connection to the wider Mesoamerican world; how militarism and imperial ambition affected trade and culture, and vice versa; as an adjunct to militarism, how the termination ritual complex of behavior reveals the relationship between cities; the recent discovery of the extensive Preclassic in the north as well as the working of the Postclassic; the rise and decline of the Franciscan mission era; and the ideological effects as revealed through analysis of the iconographic and epigraphic record.

Adding to this increasing knowledge base, scholars have made great advances in the reading and understanding of the Books of the Chilam Balam. These highly metaphoric books of prophecy and history originated in Postclassic Yucatán and are transcribed oral histories written down in Roman letters during the early colonial era. New scholarship on these has yielded more understanding of the role of war and exodus in the north and provides tantalizing clues to the catastrophic days of the collapse in the Southern Lowlands as the exodus of those peoples may have impacted the northern Maya.

As I lived and worked with the projects in various places in the north, I was impressed with the dedication and brilliance of the young researchers, mostly graduate students working under their

mentors of the current, mature generation of researchers. These directors of projects have led their students in making careful and thoughtful researches throughout the Northern Lowlands and guided them through a revolution in techniques and conceptualization—including the decipherment of the ancient Maya writing, digital recording of data and survey, and breaking the bonds of obsolete paradigms and conceptions of Maya culture.[3] All this while instructing and insisting upon the rigors of scientific method in the excavations and in their analyses.

Whether young or mature, Yucatán archaeologists recognize that the investigations have only just begun. In the majority of sites researchers have excavated or restored only small sections of the central or ceremonial precincts. Although recent surveys have touched many dozens of sites hitherto unexamined, almost all—including the bulk of the famous sites, like Uxmal and Chichén Itzá, along with a host of important and impressive secondary sites—remain largely or wholly unexcavated. Furthermore many are still not even recorded. I remember in 2002 two friends, Traci Ardren and Travis Stanton, were telling me about their explorations in the southern cone region of Yucatán State. They reported many unrecorded ancient sites, some quite large, and hardly any appearing on the official maps at INAH Mérida.

Imagination Informed by Science, and Vice Versa
Archaeologists are scientists.[4] But down deep I have seen another sort of actor: I have seen them in dream time. They take the data, they construct rational explanations, but at the same time they are imagining the very human lives that the ancient people lived. For an example among many I could relate, one day at the Kiuic

Project, archaeologist George Bey walked me up to the top of the ridge in the central ruins and traced out for me the stone remains of some residential buildings. He slipped into a reverie about the people who dwelled on that hill over a thousand years ago. He imagined them as happy people, living their lives, raising children, cooking food, trading goods, creating ceremony, and following ritual. Standing among the ruins of this ancient house, I fully agreed with his vision. And after our warm ascent to their ancient overlook, we both could imagine them enjoying the cool breezes at their hilltop home.

Archaeologists, after all their disciplined techniques for excavating ancient ruins, must turn to imagining them as places where people lived and imagining the meaning that those people put into their lives and the meaning they placed in the universe. Using mere traces and clues in the earth, this is the important leap archaeologists make to impart meaning to their study. The work that I saw in Yucatán was just that sort of imagining, a process of carefully excavating in earth and stone, recording the findings with drawings and photographs, then sensibly contemplating what is revealed. The most exciting part of the whole process for me turned out to be watching bright people thinking about these things. Beyond that privilege, the great gift that I received from being there, with this crosscurrent of archaeology and photography, was finding lasting friendships with a corps of archaeologists whose explanations—based on the hard work of digging evidence out of the ground—are the most fascinating stories I have ever heard.

Artist in the Trenches

For my part, I hoped that my own views as an artist experiencing ancient Maya aesthetics would rub off on my colleagues. I do not know that the influence was direct, but I believe that the presence of an artist's temperament had an atmospheric effect on their scientific ruminations. I hoped that they imagined the visions and conceptual universe of ancient creativity as they unearthed the artifacts in the old graves and as they beheld the sculptures of the ancient people. Perhaps the main effect was that I brought different eyes to the analysis, an affirmation of the notion that artists played a central role in creating ancient Maya culture.

Archaeological projects often engage artists to document and record their findings. They carefully draw or photograph the artifacts, the bones, the excavation trenches themselves. I came to Yucatán not to do that, but to portray the archaeologists themselves as well as the processes of their work and discoveries. As an artist embedded in the research of an archaeological excavation project I stood somewhat apart from the work of the others. Their daily rhythm was to consider where to remove earth and rock, and then record meticulously what they found. In the evening they would contemplate their experiences of the day and find some rational stance they could relate to everything else that science knew about their potential discovery, however small or large it may turn out to be. I strongly believed in the science of their work. I had trained once to be a scientist, so the process and mind-set were completely familiar. But my stance and rhythm took on other possibilities. I needed to think about the meaning of their activities, and record and portray those meanings.

I tried to strike a balance between science and everything else not so constrained by its methodology and outlook. An example that springs to mind is a contemplation of the ghosts in the landscape. I do not believe in ghosts (although I must confess to having seen one,

an elderly woman ghost during a very strong earthquake on the north coast of California), but I do believe in the otherworldly power that the ancient people encased in their works, in the power of mind manifest in their buildings and homes, and the spiritual landscape that they sought to shape by their labors. In the setting of an archaeological project, all those ancient energies are concentrated in the buried homes, palaces, and temples. This artist, in contemplating these places, looked for the balance between the rationality of the scientific quest and the beckoning call of the ancient people's spiritual energy. It was the sensation of this energy, balanced by the knowledge that precipitates from scientific discourse, that informed, and still informs, all of my creative work.

Creative Process

For me, the creative process is a meditation. To create I have always relied on daydreaming to discover new ideas, and in fact I daydream while I work. To do that I look inward, and in the best moments, two or more visions or ideas float around. They drift and tumble, and then suddenly, like picture puzzle pieces, they fit together somehow. This fitting sometimes is good, even sensational. More often, it turns out to be mundane. But the process is one of relying upon and expecting this coincidence to create new beauty in the world, to recognize a new harmony, to find perhaps something new under the sun.

Hand in hand with daydreaming new ideas, what I learned to do, as an artist in Yucatán and other places, was to WAIT and watch the unfolding of events, all in order to give time for coincidence to appear. For example, to take the photograph of the Temple of Inscriptions at Palenque I waited and watched for three days. I wanted to capture it with the late sun slanting in from the west, so for three days, just

before closing time, I trekked to the ruins, climbed the Palace Tower, and watched Pacal's great mortuary temple. For the first two days, just as the site guards were blowing their whistles to announce the closing and force me from the ruins, I shot a few frames. Descending the escarpment from the Palenque ruins, I visualized the pictures I just took, and I knew in my heart that those frames were not quite right. On the third day though, big beautiful clouds spilled out over the mountains and looked down on the ruins. I kept watching and waiting, and just as the guards began calling out again, the sun broke down below the cloud line, and light raked across the face of the iconic pyramid. Coincidentally, at that moment Floyd Lounsbury sat down in the shade of the great temple. Dr. Lounsbury, arguably the finest linguist of his generation, had participated twenty years earlier at this exact spot in breaking the Maya hieroglyphic code. What an astounding confluence! All the pieces floated into place and fit together, and the result was one of my all-time favorite photographs. Was it luck borne out from persistence? Yes, certainly. But I like to think it was daydreaming the elements and having them fall into place. The universe works that way sometimes, perhaps more often than we rational folks wish to allow.

All through my work in the Maya area I learned, therefore, to watch and wait. I could not communicate well with the people that I met, but I could always watch and contemplate. I learned to use that contemplation to create new images to express my understanding of a spiritual place. Yucatán always took me out of myself. It always afforded me an atmosphere to dream, to meditate, and to create new meaning.

I believe in this creative process. In it you must first know your culture and your universe, then you wait to see what wells up from

the scene in front of you as well as from the recesses of the mind and the wellspring of human archetypes. For their part, the ancient Maya artists were necessarily well versed in the symbolic systems of their culture; all their creative works are steeped in the Maya genesis story and cosmology. But what is almost fearsome to me is the clarity of their handiwork, particularly in the alfresco paintings on their ceremonial ceramic vessels. I know that the quality of my own work depends upon the use of modern technology: glass optics, precision shutters, electronic recordings, and digital miracles. Looking closely at their artworks, in contrast, I see clearly their reliance upon long apprenticeship training and intensive practice with paintbrush and inkpot. Finally, almost all of their artistic expression relied upon a deep study of the tenets of their cultural belief that led to astonishing works of art, intimately tied to the depths of their consciousness.

Map of the archaeology projects. Created by the author.

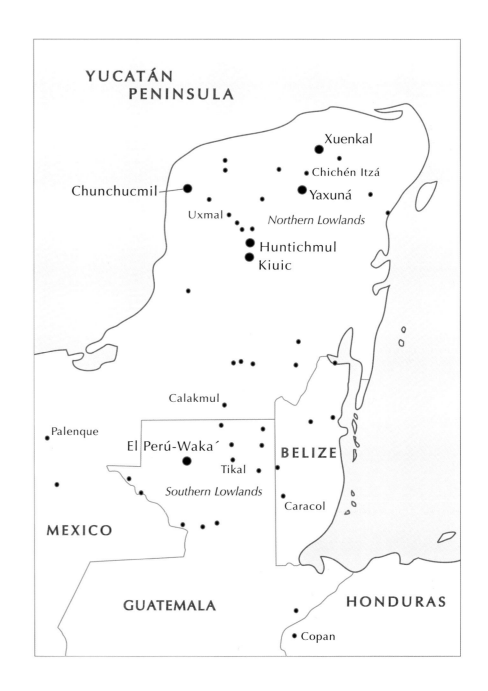

The Archaeological Projects

The four archaeological projects with which I had the privilege to work as a videographer and artist were sponsored by North American universities and foundations with research permits issued by INAH. The projects are all situated in representative regions of the northern peninsula.

Yaxuná rests in the heart of the Yucatán and was established at the ancient crossroads for the east-west as well as the north-south passage of goods. Founded close to the large "Lol Ha" cenote, the ancient city connected to the imperial domains on all sides, as well as directly to the distant great cities of the Southern Lowlands. Yaxuná came to know—to its sorrow—that other cites found the crossroads a good place to dominate.

Chunchucmil, situated on the western frontier and the Gulf Coast, served in ancient times as the commercial gateway to and from the maritime trade route of the western coast. Adding value to trade goods passing through, or directly manufacturing those trade goods, it served as a broker between the sea and the interior.

Kiuic is an old town deep in the famous Puuc Hills and lies on the border of the Puuc zone and the Chenes zone to the south. It was probably an important portal for trade in that direction. A founding member of the ancient Puuc Hills confederacy, it existed from Preclassic times until its florescence and fade-out in the Terminal Classic.

Xuenkal stands somewhat lonely in the northern plains with enticing hints of complex relations with the imperial cities of Cobá and Chichén Itzá during different time periods that span several hundred years.

Although widely separated geographically, these projects resemble each other in the relationship that they had (or have still) with their Maya workers. In various degrees, each was embedded in the life of the communities that surround them and had direct and close connection to the local people who live closest to these ancient ruins. In the case of the Yaxuná Project, townsmen constructed the field camp following traditional Maya house design. The camp became part of the village, and the village itself, and its ejido lands, stood directly upon a section of the ancient ruins that were the target of the excavations.

Excavation at the Popul Na, Yaxuná.

The Popol Na—War Council House—Yaxuná.

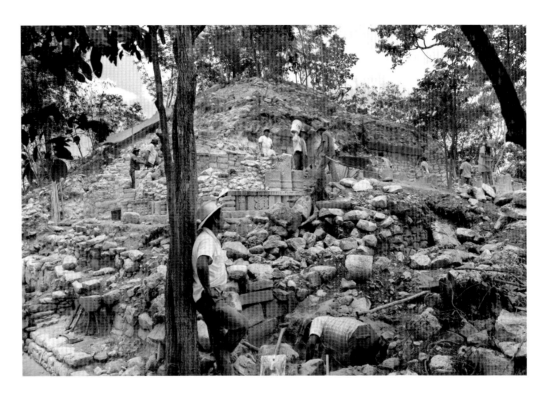

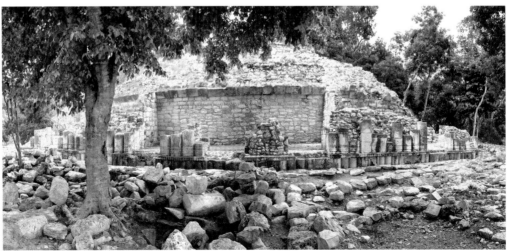

The Yaxuná Archaeological Project

"The place had a serene, majestic quality."

—David Freidel

In May 1991, I took up David Freidel's invitation to visit his archaeology project at Yaxuná. It was my second visit to Yucatán, so I was getting used to the *topes*, the speed bumps that every village puts in the street to slow down traffic. This was in the days before the four-lane toll highway, the *supercarretera*, sped across the countryside, and the only road across the peninsula was the old, dangerously narrow two-lane highway that passed through the traditional Maya villages of the northern limestone plain. Landing in Cancún, we drove three hours through all those small Maya towns, through Valladolid, to reach famous Chichén Itzá in the center of Yucatán.

Pisté is the town that services the renowned Chichén Itzá ruins. At the western edge of town a dirt road heads off to the south. In those days this road wasn't on the map, but David Freidel had said it would bring us to Yaxuná and that he would meet us there late that morning. Halfway down the road at the little hamlet of Popolá we picked up a child, perhaps eleven years old, who confirmed vaguely with a wave of his hand that this road did indeed go to Yaxuná. I remember being concerned about the tough bunchgrass growing in the high center of the dirt road, and in fact it wire-brushed the bottom of our VW Bug to a high Florentine polish. I also noted that Yaxuná lay only fifteen miles, that is, twenty kilometers, from Chichén Itzá. That seemed dangerous to me—I hoped that Yaxuná would be allied to the great power. Later my thoughts on that danger were corroborated by David. Tragedy lived in that proximity, for Chichén Itzá overshadowed ancient Yaxuná in the last years of its career and eventually destroyed its neighbor.

Arriving finally, I felt right at home in this sleepy backcountry Yucatán pueblo. In fact every time I arrived in the village in the years to come I was awash in this feeling of homecoming. Even so, the street as we entered town actually became rougher with bare-rock laja sticking up dangerously in the high spots. We pulled up to the zocalo, the main square plaza, with its semiruined church on the eastern side and the community buildings facing it on the western edge. Taking up most of the zocalo was a grassy/rocky baseball field, and right in front of the church was the concrete basketball court. We spotted a gringo dressed in black under the intense morning sun and playing basketball with the Maya youths. He was Robin Polseno, an accomplished classical guitarist. He was waiting also to meet David Freidel, who eventually showed up. For the next three days we ran around the excavation site with Robin and David and the project archaeologists, who were not exactly sure who this guy with the video camera was or what he wanted.

What I wanted was to walk around the ruins and have them explain on-camera what they were finding and what they were thinking. So for three or four hours under a broiling sun—this was late May and the rainy season had not arrived, and that meant no clouds to shade us—we went around to all the excavation pits and exposures and talked about what they were uncovering. It was my beginning with the people and work of the project, a beginning that would lead to a six-year-long documentary project at Yaxuná. As it turned out, I'm still involved with the Yaxuná archaeologists almost twenty years later as I've trailed them around their excavations, far west, in the Puuc Hills, and to the northern plain.

The Yaxuná Archaeological Project spent ten field seasons at the ruins, and they came to this site for several compelling reasons. When

Hacienda Ketalak,
Yaxuná.

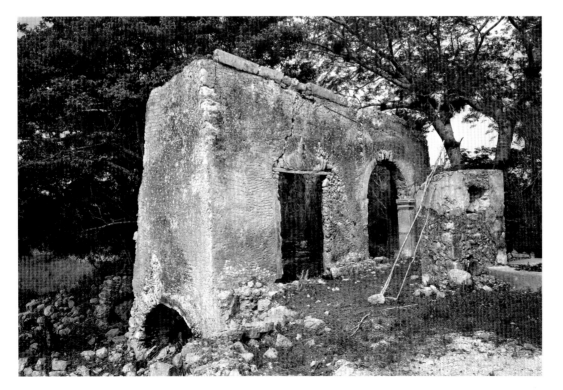

Hacienda Ketalak,
Yaxuná.

David Freidel made his first reconnaissance of the site he saw that it was a large city that boasted two extensive platform acropoli with triads of pyramid-temples and hosts of smaller temples. He noted the large central acropolis with a pyramid as large as the famous El Castillo at Chichén Itzá as well as a group of pyramids on the south that would turn out to be old temples of the Preclassic period, erected circa 500 BC. He also sensed the presence of internal raised causeways (*sacbé*, plural: *sacbeob*) and a ballcourt. But the most interesting feature was the sixty-mile (one-hundred-kilometer) sacbé, an external causeway that ran straight and direct from the eastern imperial city of Cobá and ended in Yaxuná's central plaza, the focus of three large pyramid platforms towering above it. This long sacbé, by volume the largest construction in ancient Mesoamerica, was smoothed on top for travel, procession, or military communication and was probably plastered at the terminal ends. This stupendous construction was an unmistakable sign of Yaxuná's importance to the geopolitics of the Classic period in Yucatán and therefore posed tantalizing questions about raw power politics in the peninsula. With all these attributes, Yaxuná presented many intriguing questions for research.

Maya City and Maya Village

Yaxuná did not survive the Terminal Classic as a major ceremonial center. In the Postclassic period, a much reduced number of people may have lived here. According to the Chilam Balam of Chumayel, Yaxuná seems to have been known as Cetelac.[1] It is noted as a place where the wandering Itzá had arrived and with the inhabitants there, "agreed in their opinions," that is, conquered the community at an early stage in the career of Chichén Itzá.

Almost wiped out in the tenth century by the Itzá, this area showed no civilized life for half a millennium until another active people, the friars of the Franciscan order, came to the area to build a small mission church as an extension of the Yaxcabá Parish. A small village seems to have existed around this church when the Hacienda Ketelak was established in 1773 as a cattle operation. The present church was built in 1817. Both the hacienda and village were destroyed and abandoned in 1847 during the fierce fighting of the Caste War. In this region, the main battles engulfed the large, nearby mission at Yaxcabá. This fortified church, with its pillboxes and rifle slits in the bell towers, changed hands several times during some of the most desperate fighting of the war. The first census in 1860, after the fighting ceased, suggests that Yaxcabá Parish lost roughly 90 percent of its population to combat, disease, and migration.

After this depopulation, some ninety years later, Yaxuná village was resettled in 1937 under the ejido land reforms after the Revolution of 1919. Several of the elders in the village remember the immigration to and colonization of Yaxuná by their parents. This resettlement was part of the ejido land programs of the PRI (Partido Revolucionario Institucional—in power for eighty years after the revolution). The ejido is an ownership system of land held in common and governed by the community. It echoes the communal arrangements of land ownership and management of the pre-Hispanic era. Besides community governance, other folkways and beliefs have come down from pre-Hispanic times and survived through the conquest–colonial period. Village Maya have kept some of their ancient culture, and these ways are expressed in the role of don Pablo, the village shaman (h-men in Yucatecan Mayan), who lived next door to us in our field camp.

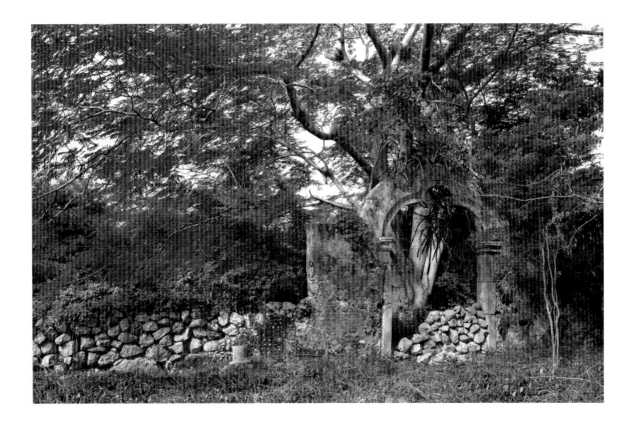

Shaman's Ch'a Chaak

I met don Pablo on that first visit to Yaxuná. I was very fortunate to visit on those specific days, for he was concluding a three-day ritual called the Ch'a Chaak, the "Bring-Rain" ceremony. This ceremony is an appeal to Chac, the ancient god of rain, thunder, and lightning. The celebrant, or h-men (don Pablo), makes an appeal at the Portal of Heaven. This portal is created over the altar, the design of which is unchanged at least from Postclassic times, when we have a depiction of an altar in the *Dresden Codex*, one of four surviving Maya books.

This was a very rare opportunity to record a shaman ceremony of the old tradition, so I asked don Pablo's permission to record the ceremony. In order to participate in the ceremony I had to enter the sacred space, stand in front of the altar, and be spiritually cleansed by the chief associate to the shaman. He brushed my back several times with a thin-branch bundle of tree leaves to initiate, purify, and welcome me to the sacred precinct.

At this event don Pablo and his acolytes built the altar by tying stakes together to form a table in a natural, usually wooded, place.

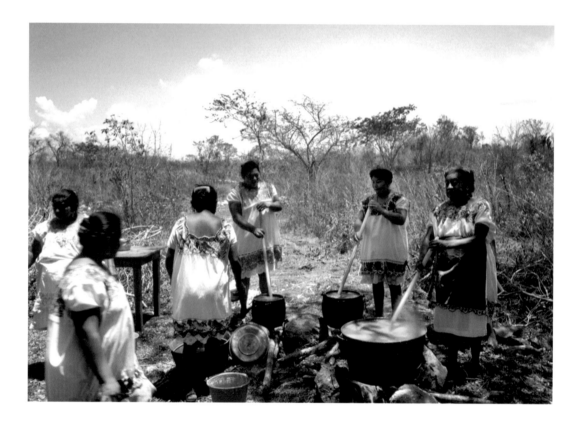

Four saplings with their foliage still clinging are bent over from the four corners and tied together over the center of the altar table above which they form an arbor space. They fixed a small hanging shelf with ritual objects hung from the crossed saplings, and in this interior space the portal of heaven is opened and the appeal made for consistent rainfall during the growing season.

Off to the side, the Maya men were making cornbread loaves from an impressive mound of moistened corn masa. They patted them up into a round loaf, cut a cross on the top, sprinkled *sikil* (a roasted,

brown, powdered squash seed) into the cross cut, wrapped the loaf in two layers of banana leaf, and tied it together with bark strips.

Meanwhile others had built up a trench fire, with large branches that covered big rocks in the trench. After the fire had burned down into a mound of fiery white coals, they covered this intense heat with dirt, laid more long sapling branches down, laid the wrapped loaves on top of that, and covered the whole assemblage with a foot of dirt.

At the same time nearby, some of the village women were stirring large cauldrons of chicken and corn porridge, the *sopa* a bright

vermillion red from the ground herbs and flavorings they had put in. When ready this sopa was poured out into pails and pots and set underneath the altar. The chicken feet placed in the thin porridge stuck out of the top surface just as they were depicted in the *Dresden Codex* from eight hundred years before. This tradition probably extended back to the Classic period, just as many of the cultural manifestations of the Yucatec Maya were carried forward from a genesis probably two thousand years before.

At a certain point the men agreed that the loaves in the *pibil* were baked, and they shoveled off the dirt and gingerly pulled out the blackened ovals. Relieving the loaves of their burned banana-leaf wrappers, they carefully distributed them on the surface of the altar.

Don Pablo instructed that the three cross candles be lighted on the far side of the altar. The adult attendants, the Chac warriors, took their positions at the corners. Underneath the edge of the altar, youths bearing roughly carved wooden swords, pistols, and muskets began dragging these instruments against the underside of the pickets that formed the altar table. This was to simulate the sound of thunder made by the gunpowder implements of their conquerors. The conquest-era Maya people equated thunderstorms with these arms, the roaring guns that belched clouds of smoke and fire and slashing steel swords that struck like their Rain God, Chac.

Accompanying the thunderstorm symbolism the younger boys broke out in the "whoa-ah whoa-ah" sound that simulates the low pulsing sound of the monte frogs across the countryside after a heavy rain.

I forget how long it was, for the chanting of don Pablo and the whoa-ah-ing of the kids under the altar put me in a hypnagogic state. Suddenly, though, the officiating men, stationed at the corners, pulled the kids from under the table, and they formed a circle around the altar

area. Still chanting in time with the shaman they circled the altar once around and then they exited, followed on the tail end of the procession by don Pablo. From the edge of the clearing he signaled that the liturgical part of the ceremony was finished. The men began pulling the sacred corn loaves from the altar and passed them around. They hauled out the red-orange corn-gruel-and-chicken-stew from under the altar, ladled it out into bowls, and sitting down and eating these, we celebrated with the ancient ritual meal.

In other years I was fortunate to witness other significant events in Yaxuná pueblo. In 1994 I was present in the village polling place during the election in which Ernesto Zedillo came to power. At night, in the community hall, I watched the Maya village women surge to the ballot box. I did not know why they would have gathered all at once to vote, but this was a powerful moment. This, they knew, was one of their few powers, and they wanted to exercise it. During that same election cycle, in neighboring Kancabdznot, the army was called in to restore order after a PAN (Partido Acción Nacional) delegation arrived to campaign. The PRIista folks (the peasantry tend to be PRI stalwarts) evidently assaulted the campaign workers and ran them out of town. It took a show of federal force to convince the town that in an election all sides must be heard. The PAN, nevertheless, won governorships for the first time in Yucatán and in Baja California Norte. This was a prelude to the historic victory of Vicente Fox in the presidential race on the national level in 2000.

In its relations with the village, the project adapted to the old consensus form of Maya government and met regularly with the many village representatives. Much like a town hall meeting, everyone has a right to speak. Much conversation was required to agree on work and other arrangements and smooth out occasional problems or anxieties

that arose. Although not convened so frequently, I still spent many hours observing the conversations and actions of these typical Maya meetings, whose antecedents in North America inspired town hall democracy in the English colonies, which survives directly today in the governance meetings in New Hampshire and is echoed in the democracy of the North American nations.

Archaeological Discoveries and History of the Project

I was surprised at the size of ancient Yaxuná. My first impression as I entered the ruins from the road was the Central Acropolis, which is practically as tall as the famous El Castillo at Chichén Itzá, but it is larger in volume for it is actually two buildings, the original temple bulk and a substantial, perhaps added, building on the back.

This building is Preclassic, that is, more than two thousand years old. The ancient Yaxuneros may not have maintained it during the Classic period. In fact, twelve hundred years ago it could have looked much as it appears today, an enormous, tree-clad mound. Eight hundred years earlier, however, it was magnificent. In that earlier period this pyramid-temple stood as the largest building in the Northern Lowlands, perhaps tied politically and ideologically to the huge pyramids far to the south at El Mirador, the premier city of all Mesoamerica in the Preclassic.

In the following Classic period (AD 250–900), Yaxuná was an important chess piece, again due to its position in the center, in the struggles for alliance and imperial control from other cities. It suffered at least three phases of destruction or dynastic regicide. One of the most important research findings of the Yaxuná Project was the evidence unearthed about the final destruction of the city, evidence that led to a major substantiation of the theory for "termination ritual."

The principal testimony arose out of the excavations of a ritually destroyed civic building, Structure 6F-68—the Popol Na, on the North Acropolis. The Yaxuná research made a strong case for this complex of ritual behavior upon the conquest of a city. With the evidence from the excavations, "termination ritual" has became a generally accepted if not mainstream theory in Maya studies.

Termination Ritual Deposits at Yaxuná

The ancient Maya believed that buildings were charged and animated by supernatural powers. At the conquest of a city, therefore, the buildings and temples dedicated to the present ruling family or elite must be decommissioned and the spiritual power neutralized or killed. The technique for this termination of power evidently was a careful and symbolic destruction of the tools, spiritually invested implements, and spiritually inhabited buildings important to the defeated owners. To fail to release the spirits of these buildings and terminate the power invested in them was to run the risk that they would rise up again and defeat you in the future. This was deadly serious business.

From the ceramic evidence we know that the final destruction of the city came at the hands of warriors from Chichén Itzá. The rulers of Yaxuná at that time seem to have been Maya people from the Puuc Hills region in the vicinity of Uxmal or their local surrogates. In the event, the building picked out to be ritually terminated was a Puuc-designed and Puuc-emblazoned palace structure, 6F-68, more commonly called the Popol Na, or the War Council House. At this building project, archaeologists Charles Suhler and Jim Ambrosino found massive evidence of termination ritual that included the scattering of stone tools, jade and shell ornaments, smashed ceramic

vessels—mostly pieces of large water vessels—and an abundance of stone metates, or grinding stones, also scattered about.

After the tools and implements and water vessels were placed, the conquerors cut the columns that supported the front of the building; they set great fires in the rooms and among the sacrificial objects; they dug into a burial crypt in one of the room floors, removed some of the bones, and mixed up the rest; and then they pulled the roof down, crashing it onto the floor, onto the ritual objects, and the building fell forward to smash all the ceramic vessels placed out in front of this War Council House, probably the signature building of the political overlords of the city.

David Freidel had proposed the hypothesis of termination ritual following his research at Cerros in the mid-1980s. At Yaxuná the excavations at the Popol Na confirmed the essential substance of his proposal, and the Yaxuná evidence stands out as the textbook example of what termination ritual looks like. Controversial before the 1990s, more researchers, once they knew what they were seeing in their own excavations, began to accept termination ritual complex as a fundamental explanation for this sort of evidence. Looking back through the field notes of previous excavations, archaeologists can now understand that which was unexplained before. Termination ritual has been increasingly uncovered, or rediscovered, at numerous sites throughout Mesoamerican archaeology, and it has become a central idea in the research of ancient Maya warfare and the destruction of cities and their dynasties.

The Great Sacbé

Apart from imagining the ancient people in the ceremonial precincts of the big temple acropoli, my favorite visualization had to do with imagining the battalions of Cobá warriors as they advanced up the sacbé to defend Yaxuná. Ancient Cobá was nestled among a group of lakes not far from the Caribbean coastline. This city conceived and built the sacbé to Yaxuná, a truly dazzling construction. Essentially a roadway slightly elevated above the countryside, the Cobá–Yaxuná sacbé is the largest construction by volume in ancient Mesoamerica. The last time I visited Cobá I went expressly to find the eastern terminus, that is, the platform or building at the origin of the great sacbé. Close to Nohoch Mul, the signature pyramid of the city, I thrashed around in the jungle undergrowth for a while and may have found that terminus. But the amazing discovery I made for myself that day was the enormous and striking acropolis nearby, completely shrouded in dense jungle, and looming in a great mass just to the west of the Nohoch Mul. It is almost as high as that pyramid, covers much more area, and houses several levels. I and my companions that day explored this complex of palaces, climbing up platforms and peering into vegetation-choked rooms, to contemplate the ruin of a people and their elite residences of fifteen hundred years ago.

Back at Yaxuná, one morning before dawn, Tony Idarola and I climbed the big pyramid in the North Acropolis. Tony was our team's sound man, and he wanted to record the birds on the summit at the moments of sunrise when they were always loud and wild with song. Around us stood the great forested acropoli of Yaxuná with the village milpas growing between them. Down below we spied villagers walking beside the great sacbé and could see in the distance the first farmers out to their milpas or returning from their nighttime vigil. Here where the sacbé approaches its western terminus it looks like a low, linear jumble of rocks. In ancient times it would have been filled and smoothed, probably with *sascab* or even with plaster stucco.

As we began recording the birdsong on the pyramid summit, we turned our sights to the northern horizon, and there! with the aid of binoculars and the first rays of the sun we caught sight of the famous El Castillo pyramid at Chichén Itzá. Although quite small on the horizon, we realized that both Chichén Itzá and Yaxuná could have witnessed the ceremonial fires on each other's Sacred Mountain Portals. During most of Yaxuná's existence, Chichén Itzá did not pose as a great power. But after the arrival of the Itzá, the danger to the Puuc-controlled Yaxuná became clear. During the 1996 summer field season, Jim "Bobo" Ambrosino completed a series of survey excavations around the perimeter of the North Acropolis platform. What he found tells the story of the last days of Yaxuná. It seems likely that Chichén Itzá warriors invested Yaxuná and forced the defenders back to the acropolis platforms. Around the perimeters the defenders built crude defensive walls, perhaps with palisades on top and stakes out front. Into the palisaded fortress walls, the defenders had the time to construct sally ports, and they enclosed killing zones behind that.

A desperate siege seems to have ensued on the North Acropolis. Sorties were made to drive the attackers off. And, although the project did not make excavations to prove it, perhaps some archaeologist in the future will find siege works and bastions on the neighboring platforms of the East Acropolis, the other great triad pyramid complex. In all of these battles the combatants would have felt the mythic battle beasts of Maya warfare flying over the field and the combatants. We may speculate that perhaps the king in his battle palanquin was captured when the enemy's battle beast conquered Yaxuná's.

After this battle and siege, the Itzá warriors raised a number of small buildings in front of the North Acropolis, seemingly in order to camp out and take the time to terminate the spiritual power that

resided in the portal mountain pyramids of that acropolis.

The mural in the Upper Temple of the Jaguar that overlooks the Great Ballcourt of Chichén Itzá depicts the attack and sack of a city. This depiction could be historical, and it may depict the destruction of Yaxuná. Scrutinizing the murals in Chichén Itzá, I have visualized the ancient artist perhaps climbing, during the climactic battle, to the summit of the Central Acropolis of Yaxuná. I see him as he recorded in his memory the drama of the fall and sack of Yaxuná. We do not know precisely what event the murals were memorializing, but in Yaxuná we know that the Itzá warriors stayed for a while, primarily to make a prolonged victory dance, but they did not seem to remain long.

The Benedictions

After witnessing two Ch'a Chaak rituals, Traci Ardren, codirector of the project, came up with the idea to ask the shaman don Pablo if he would conduct a benediction ceremony of his own design. The idea was to bless the work, bless the site, and bless all the people working there; to pray for good fortune in our researches, to pray for good outcomes, and especially to pray that no one be injured on the stairs nor in the deep trenches, the small tombs, or under the walls of stone; to pray that no one was hurt in moving all the dirt and large rocks, that no one was hurt wielding the dangerous tools used in the excavation process. That was the benediction at the beginning. The purpose of the ritual benediction at the end of the season was to give thanks and farewell.

The first of these benedictions, held among the ancient ruined temples in the site center, was the most beautiful performance I ever witnessed.

Don Pablo's first task was to pick a place, and he chose a spot at the base of a small pyramid just in front of the looming Central

Acropolis. Miraculously he spotted the altar just two paces from the original center point for the project survey of the site, something that he did not know, but which makes sense if he's doing his job right. He, through some agency that shamans use, picked the exact center of the ancient ruins to hold his benediction ritual.

That afternoon don Pablo's assistants prepared food as they did for a Ch'a Chaak ceremony. They did not, however, carry out the role-playing hunt for deer. This would be a one-day ritual, instead of the three-day rain ceremony, but it had several similarities. The men dug out a pibil, an underground roasting pit, to cook the corn loaves. They stewed chickens in the red seasoned corn gruel. The chicken claws stuck out of the tops of the serving pails just like in the Ch'a Chaak procedure. The design of the altar also resembled that of the longer ritual, but without the bent over saplings to form the tree bower over the altar. In this instance the altar was clear to the sky. Long, small crosses made on the spot from sapling boughs were lashed together and stuck into the ground behind the altar and candles placed upon them and also on the altar itself. Don Pablo placed some small bowls with small objects and water half filling them. These were for gazing and divining. During the ceremony, he would stop chanting and gesturing and take up one of these bowls. He would stare into the water in the dark of the night, and I imagined the images and portents that might appear to his sight.

It was dark night, perhaps ten o'clock, when he started his chanting, again some words in Latin mixed with his mother tongue. In this case there was no whoa-ah-whoa-ing by young boys in simulation of the frogs of the monte. Don Pablo would chant in a low voice, sometimes in a loud voice, punctuated by his gazing into the water bowls or staring into the candlelight.

We archaeology folks had gathered above him on the steps and platforms of the small pyramid. This scene and ceremony were a magical sight. The Yaxuneros themselves took it both seriously and also not. Sort of like the Kabuki plays in Japan where the audience talks a bit, or eats or sleeps, but then at a crucial moment in the old play, everyone sits up in rapt attention. The main character makes a highly stylized gesture or utterance, everyone recognizes with deep appreciation this moment of extreme drama or catharsis, then the audience goes back to what they were doing before. Don Pablo's benediction had that sort of dynamic. The guys by the pibil pit would roust around, try to scare people who were arriving late, crack jokes, and poke at the fire they kept going beyond the altar area. Once in a while I would be startled by the imitation of a jaguar growl and realize the guys over by the pibil were joking again. Later on when the loaves were done and brought out, they came over closer to the altar and began to play cards and quietly horse around. Some of them curled up and slept.

After some time of watching don Pablo chant his liturgy, sleeping seemed like a great idea. I rolled up in a blanket that someone had brought and stretched out on the narrow pyramid step, against one of the megalithic stones that dated this temple to the Early Classic period. My little pyramid step was the most precious seat in the world just then as I watched this scene: don Pablo speaking in low tones, lit by the candles; a small fire somewhere off in the brush, lighting some tree over there; the Maya townsmen also talking quietly or sleeping around the stage; and my friends and colleagues also gathered around this stage. Like me, they were sitting or lying on the steps of the pyramid, like box seats in this opera house under the starry sky.

Every half hour or so, don Pablo's deputy would circulate among all the observers and offer a ritual puff on a cigar or cigarette and a gulp of

the white lightning cane liquor that don Pablo had requested we bring from Pisté. I had heard rumors about the fieriness on the palate and the nasty potency—actually of its next-morning effect—of this particular liquor, so I was hesitant. But I found it quite pleasant to drink and was without much pain the next day. Perhaps it was the beauty of that night and that scene that made the experience turn out fine.

In the event, don Pablo's deputy made certain everyone participated in the ritual. He insisted—we must all puff on the sacramental cigar and drink the clear sacramental liquor. He also had the responsibility to cleanse with large sprigs of leaves everyone who entered and exited the sacred precinct.

The night was dark and beautiful, with Scorpio and Sagittarius standing overhead, straddling the Milky Way as that starry band stood upright in the sky. About three in the morning don Pablo stopped chanting and gesturing and with two trusted associates went out to each of the future excavation sites to sprinkle holy water. They even trekked out in the dark to bless Traci Ardren's excavations at Xcan Ha, the citadel outpost that was two kilometers north of the central ruins.

On the way home, perhaps four o'clock in the morning, I walked the *camino blanco* from the central acropolis to our field camp. Along the way I heard the *aluxes*[2] and *dueños* keeping pace with me in the monte. Sometimes they were near and sometimes far, but they kept up with me, and even more thrilling in the still of the night, I could hear their breathing.

The aluxes are the little spirits of the Maya woods. They can, by turns, be benign or pesky, sometimes to the point of trouble, sort of like gremlins, fairies, or leprechauns. Dueños are more like witches or elves. I always thought that one could speak with a dueño but not to an alux. Anytime I was alone in the ruins, or in the woods alone, I could

sense these creatures. But this sensation only arose in Yucatán and the Petén of Guatemala, not anywhere else in my travels.

Yaxuná Pueblo

Yaxuná is the classic sleepy central Yucatán pueblo. Maya people have lived in this place for twenty-five centuries, except the ninety years following 1848 when the area was almost completely depopulated in the aftermath of the Caste War. In 1937 during the "Crusade of the Mayab," native farmers returned and reclaimed the land. Even during that hiatus, some isolated Maya folk most likely made milpa in the area around the old ruins. This reminds me that in the practically uninhabited stretch on the old carriage road that existed when Stephens and Catherwood traveled the countryside in 1841, the Kiuic Project reports that, between Kiuic and Huntichmul, a very old woman and her elder son still grow maize and grind in metates. They may be the only people in the hundred square miles south of the ancient sites of Sayil and Labná on the Puuc Route. (When I returned in 2008, a handful more folks had moved into the area to make milpa.)

The Maya people returning to Yaxuná came back to a small destroyed church and ruined colonial era buildings around the square plaza. In the fifties the government put up a few community buildings facing the church for town meetings and for a small *tienda* (shop) just as you see in every small town and village in Yucatán.

In the excavations something exciting was always going on. In the village, though, big developments sometimes took years. I was happy to see the progress and witness the daily life of the town. In 1993 Yaxuná coordinated with the hamlet of Popolá, and they cleared the right of way on the side of the Pisté road so that the government could set the concrete pylons, string copper wire, and bring the electrical grid

to town. In 1996, following up on this breakthrough, an electrical-powered well was established in the zocalo. When I visited the pueblo in 2008, some large statuary decorated the central plaza. These were similar to those you see in Ticul, oversized figures of ancient Maya warriors, the moon goddess Ixchel, gods, kings. Probably because I am nostalgic for the "old days" when I lived in Yaxuná, I liked the zocalo better when it contained only the concrete basketball court right in front of the churchyard, and the only other part was mostly a baseball field that grew some patches of grass but was mostly strewn with small dangerous rocks, that is, dangerous to baseball play.

One time I watched our baseball team play a game with the neighboring town's nine from Kancabdznot. This was, by an order of magnitude, the roughest baseball I ever saw, almost like a sacrifice ritual, or the bloody re-creation of the birth of the cosmos as played in the Mesoamerican ballgame. This was a high contact sport on a rocky field. Some of the players were barefoot, and the play was spirited and competent, aggressive and devil-may-care. Both during and after the game I noticed streaks of blood on the players.

That season a delegation of our young workers approached the project to ask if we would sponsor some baseball uniforms—Irish green V-necked T-shirts that sported the town's team name: The YAXUNÁ ARQUEÓLOGOS. They were proud to be called archaeologists. We were proud they wanted to be called archaeologists. I still have my team shirt hanging in the closet.

The Field Camp

In 1989 the pueblo council gave over a plot of land, perhaps an acre, to the archaeology project in order to establish a field camp. The Yaxuná Project commissioned the village house builders to erect traditional Maya houses of round-cornered rectangular space. Low courses of stone surmounted with lashed-together wooden staves defined this space, all forming a low wall from which a superstructure of poles projected up to a lashed-together roof truss, all of an ancient and well-tested design. Upon that roof structure a guano palm-thatch—brought in from afar, thus relatively expensive—was hooked and woven to provide a mostly rain-proof layer above.

The men built a beautiful terrazzo upon which they set up a *cocina* (kitchen) attached to a *comedor* (dining room), which also served as commons and a bedroom for Charles Suhler, the project codirector. Three standard-sized Maya houses served as sleeping/living quarters. They normally housed three or four team members. One of these was doubled in size, and a concrete floor was smoothed in 1995.

When Tony Idarola (the sound recordist) and I were in camp we slung our hammocks in the field laboratory, which was the largest building in camp, about three times the size of the sleeping huts. All the ceramic and artifact finds as well as all the burial skeletal remains were kept in the field lab. I would pull down my hammock every night with bones and skulls all around me on the shelves. In the morning Sharon Bennett, the project osteologist, would set out some tables, haul out the boxes, and place the bones carefully for inspection and analysis.

Sascab

The floors of our huts were white sascab, a material used by the ancients as well as the contemporary Maya villagers for some of their floors. Very conveniently—since *sascaberos* are not common—we mined our sascab from a small cave, excavated by modern and ancient villagers alike, about ten yards outside our camp perimeter.

At first glance, sascab might seem dusty, since it is after all dirt. But it is a pure, soft carbonate, a sort of nonburning, noncaustic white lime. It discourages insects and is easy to keep clean. It does seem, however, to deteriorate cotton hammocks. For the first two years I was at the Yaxuná Project I could not miss this sort of cotton hammock snobbery. "Natural is good" was the saying. I thought it was a shame that the cotton hammocks gave out so regularly. Then I heard about Ebtún Prison, just to the west of Valladolid on the old highway to Chichén Itzá. They are famous there for making the finest hammocks in Yucatán and, therefore, the finest in the world. In subsequent years I accompanied several of my friends to help them buy these famous hammocks.

The first time, though, I went with Charles Suhler. The prison guards let us into the front waiting room, where we announced our intention to see hammocks. Wearing their boredom like badges of honor, the guards called out the prisoners who made hammocks and assembled them in a small courtyard. It was a raucous affair, with the prisoners shouting out prices and showing their wares. I picked out a red-and-blue-threaded hammock, whose colors combined gave me an impression of deep purple. The end strings were a neon baby blue color, and so fetching were they to the eye that when we returned to camp it immediately won over some members of the cotton hammock gang. The ringleaders of the gang resisted at first, but as time wore on, and they found my nylon string hammock more comfortable, more durable, and better looking, they relented and came over to the dark side of the force. They began to sleep in synthetic fiber hammocks themselves.

Sleeping in the traditional Maya house design posed some special considerations. Foremost for me was protection from the assassin bug, also known as the kissing bug, or *pik* (peek) bug in Mayan. This is a needle-nosed beetle who favors sneaking up on you in the night,

sometimes by falling out of the thatch roof. They are called kissing bugs because of their disgusting habit of biting you on the lip if they get the chance. I won't go into details here, but let's just mention Chagas' disease or heartworm and leave it at that. Usually hits you years later.

Perhaps I should not dwell on this, since in all the years that I was in the field with dozens of people, I only heard of one person being bitten. And in that case, we nipped the disease in the bud because it is easy to recognize and easily treated if diagnosed at the proper time.

I was known in camp for my heightened fear of pik bugs. It was a fake, theatrical fear. But that's because I solved the problem by stretching fine netting above my hammock, a netting that would catch any beetle that fell from the thatch roof. Over the years that netting caught a legion of bugs, lizards, and other (larger!) critters who lost their footing at night.

The other place in camp where we spotted nighttime pik bugs was our terrazzo. After dinner, we would gather on the terrazzo to talk over the discoveries in the excavations that day. A few times over the years I would give impromptu astronomy lessons, pointing out constellations with my flashlight and bringing attention to Scorpius and Sagittarius, which straddle that part of the Milky Way that is the center of our galaxy. Of course, that is the portion of the sky so important to the creation story of the ancient Maya.

On one special night, August 12, 1993, I gave advanced notice to my colleagues for the appearance of the annual Perseid meteor shower. We lay down on the concrete playground of the school across from our field camp, where the Maya schoolchildren played, and a soft, dark night came over us so we could watch these wondrous meteors run the sky. For two hours, enormous fireball meteors flashed up from the

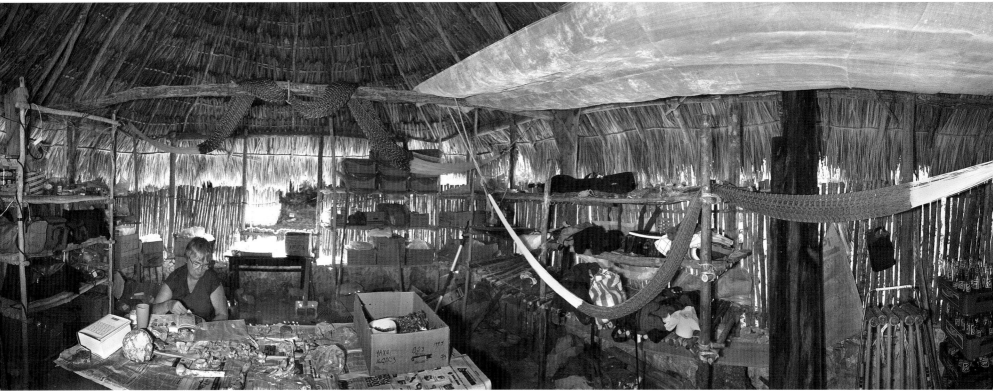

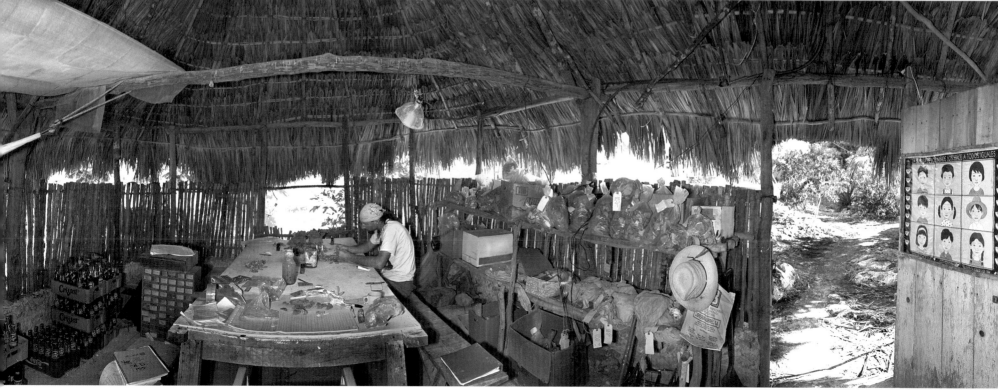

Top: Panorama of the field camp at the Yaxuná Project. Bottom: Panorama inside the field laboratory, Yaxuná.

dark and cloudy northern horizon. Streaming long, fiery tails, they drove slowly up the dome of the sky then ran down the Milky Way, fireball after fireball, all over the sky, to the west and east as well. They all streaked through to the southern horizon and burning still, disappeared from view.

In Yucatán other sky phenomena fascinated me as well. One evening near sunset in 1994 from the field camp we spied a double rainbow to the east, and to the west a large thunderhead formed and began an arresting show with sheet lightning shooting and crackling throughout its massive body. It was a continuous display with no moment without a bolt or sheet of electricity. We stood transfixed for half an hour as the sun set behind this storm. The sky took on its sunset colors, and the thunderhead continued its display. Only after dark descended upon the peninsula did the lightning bolts fade and the huge cloud drift away over the northern horizon, obscuring Polaris on its way to the gulf.

Two years later I was with my friend Tony Idarola just outside camp on the dirt road leading to the ruins. Tony wandered off as I set my large camera on its tripod to photograph the darkening clouds. I was calculating an exposure when a lightning bolt seemed to come from nowhere and exploded atop the Central Acropolis about a half mile distant in the ruins of Yaxuná. This strike sent up large, alarming chunks of debris, and a strand of electricity shot up the power lines that were strung just overhead, snapping and crackling like a bullwhip going supersonic just beside my head.

I stared at my hands on the metal tripod and decided instantly that I was finished with being outside, standing on wet ground. I yelled at Tony that we should pack it and retreat with all deliberate speed (get the hell out) to the field camp, one hundred meters away. Sprinting

into the laboratory without any shame, we put our gear down just as I noticed that Tony's long hair was sticking straight out with a static charge. I thought for certain that a lightning bolt was going to come down on us. Before I could point this out to him a massive bolt struck close by and rocked the field lab. I saw Tony jump two feet in the air and float there for a moment with fright, this sight being funny enough that I burst out laughing, so hard that I fell on the floor, forgetting my fright. Tony did not think any of this was all that amusing.

That storm passed quickly, and I stepped outside in time to see another ominous thunderhead approach from the east. Everyone gathered in the comedor, and this storm silently covered us and began to shoot sheet lightning all around. It surprised us, for it made hardly any sound and dropped no rain. However, this black storm cloud stood over us for an hour and strobed lightning at us so continuously that the night that had fallen now seemed almost like day.

During that long lightning storm, 'Ceno—Nacioceno Poot, our camp cook—told us his experiences with a *chupacabras* that was harassing him. Chupacabras are mythic folk creatures whose existence brought real terror to some communities in the previous year. This chupacabras story had sprung up in the Caribbean and spread to South and Central America, extending into the American Southwest. I even heard the story, at that time, in the Hispanic communities of the Bay Area. Of course, the story has now passed into popular culture, but at the time this creature story frightened many villagers and even urban folks throughout Latin America.

The chupacabras creature in most of these descriptions is a small, winged, humanoid vampire with vicious teeth and a pointed animal's snout and feral eyes. In most descriptions that I have heard or seen, it is covered with coarse hair. Its main prey are goats and cattle, which

The road from the field camp to the Central Acropolis.

it attacks usually at night. It sucks the blood completely out of the animal, which is the vampire part of the story when it first arose in the islands. The other behavior noted is of harassments during the day. In this version the chupacabras is a slippery vampire creature that behaves like a poltergeist of the fields. It hides in the wooded margin of paths or roadways and makes noises or throws objects at passersby.

We asked 'Ceno to tell about his chupacabras run-in because he had spread the story around the village. Other people began to experience strange occurrences that could be attributed to the chupacabras, the most common of which was that the creature would hide behind one of the ubiquitous white stone walls and throw stones and garbage at passersby. This became so aggravating and frightening that the villagers appealed to the constables of Kancabdznot—Yaxuná had no police—who called up a posse. They formed a dragnet line of men across the stone-enclosed fields to search for the garbage-throwing culprit. They never snagged nor even set eyes on a chupacabras, nor anyone else for that matter. The scare died down some time later.

The original Yaxuná Project ended in 1997. It had broken new ground in showing the termination ritual complex of the Maya. Since then many researchers began recognizing this complex of behavior in other excavations, and major episodes of termination, the proponents say, could be found at the imperial sites of Chichén Itzá and Uxmal. The first papers, using the field notes of careful archaeologists, have pointed out this complex at other sites where it was not recognized before, but careful examination of similar evidence from these earlier excavations shows clearly the same evidence as was found at and reported from Yaxuná.

In 1998 I visited Yaxuná to deliver a framed photograph for the small museum room that the villagers had built. The picture showed Yaxuná men excavating in the War Council House, the Popol Na where the project had uncovered so much evidence for termination ritual. I was bringing it to the pueblo for their fiesta celebrating the opening of the museum and the dedication of the new pathway that opened up the Lol Ha (Flower Water) cenote to visitors. A typically lovely, serene, and mysterious place, the cenote now became more accessible to casual visitors with new stairs and terraces and benches. I never swam in this cenote. It looked too far down to climb out easily, and I did hear of some tourists who thought they were fit enough to climb hand-over-hand up the rope that the village kids had hung down. But they were not so fit, and a rope ladder had to be found to fetch them out.

The ruins still hold most of their secrets. Perhaps only 20 percent of the site has been investigated. Two large acropoli, including one of the largest ancient pyramids of the peninsula, as well as an imposing E-group pyramid, are still silent. The ancient stones there will eventually give up important evidence of the geopolitical and trade connections that run through the ancient landscapes of Yucatán, and in the decades to come, important discoveries of the lives of kings and royalty, as well as the lives of the common people of ancient Yaxuná, will come to light as archaeologists of the future reveal more of this extraordinary city.

After the project ended there was some hope that the Yaxuná Project would revive in the future. In the meantime, I had followed Traci Ardren and Travis Stanton to the Chunchucmil Project, but they and I still yearn for the promised land of Yaxuná.[3]

The field camp at the Pakbeh Project, Chunchucmil.

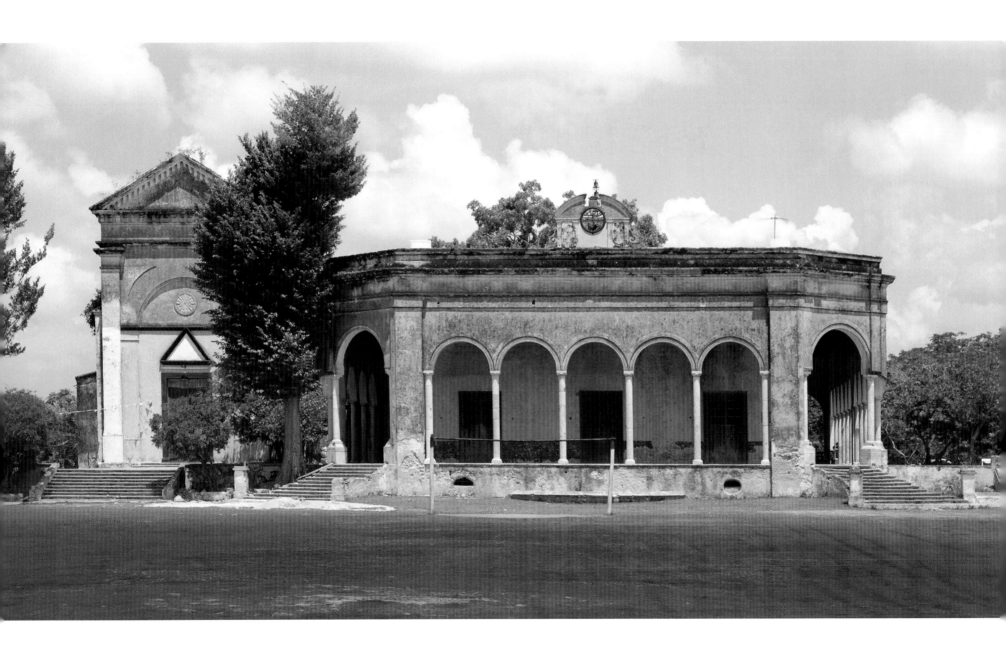

CHAPTER SEVEN # The Pakbeh Regional Economy Project at Chunchucmil

My involvement with the archaeologists of Chunchucmil grew out of my time at the Yaxuná Project. Two of the Yaxuná team, Traci Ardren and Travis Stanton, went on to work at the Pakbeh Regional Economy Project, located on the ruins of Chunchucmil, and I trailed them to this western Yucatán site.[1]

As soon as I pulled up to the headquarters of the Pakbeh Project at the Hacienda Chunchucmil I knew immediately that my experience here would be very different from Yaxuná. The hacienda casa principal, in its place at the head of the big plaza and facing the big buildings of the henequen factory, featured grand colonnaded and arched porticos. Inside, the bella época–painted décor of the thick walls faded under the twenty-foot-high ceilings in every room. In fact this was not really a field camp so much as a field palace with hammocks. That first year the project folks put me up in the big dormitory of hammocks, and this was the first time I had to string a lovely *mosquitero*, a box of netting designed to hang securely around and swing nicely with my hammock.

Out in the ruins where my friends prevailed, or at least survived, for several years of excavations, the enduring memory of Chunchucmil is that feeling of being in a frying pan set in a broiler oven. This intense heat met my expectation of fieldwork in Yucatán, although I admit that without as much tree cover (practically none) this western zone seemed hotter than anywhere else I worked. (I'm leaving Guatemala outside the competition here. The heat in the Petén is kicked up a notch and is in a league of its own.)

In comparison to the Yaxuná Project, what was quite the same at Chunchucmil was the friendship of the archaeologists. This project featured an interesting mix of veterans and students, an energetic and hard-working set of field researchers. The grand dining table—actually not grand so much as long, up to twenty-four feet long in some seasons

I was there—seemed always filled with interesting folks, often visiting scientists who were studying the various angles to the questions that the archaeology of ancient Chunchucmil posed.

Perhaps the most important question that occupied the Chunchucmil researchers was how could such a large city have sustained itself in one of the poorest, most improbable regions for agriculture? It is a puzzle since this ancient place is set in a strange territory on the borderlands of the wilderness zone of the coast. This ecological or geographical zone, known as seasonally inundated savanna, features a bedrock landscape that settles under several inches of water during the rainy season. At Chunchucmil itself the water table is just below the surface. In the lands to the west of town, therefore, no crops can be cultivated, so it is almost completely uninhabited. You must go to the coast before you find people again, and on this coast few people live except in the fishing port of Celestún.

The wilderness on the west coast is about twelve to fifteen miles wide and stretches more than one hundred miles from Campeche City on the west coast to Progreso on the north coast above Mérida. Punctuated only by the fishing and resort town of Celestún and the small isolated port of Sisal, very few people live on this austere coast, save perhaps a fishing rancho or two. And judging from the number of ancient sites that have been found in this zone (almost none), it seems to have been uninhabited in ancient times as well. So the question remained: why was this city here, since it could not have grown its own food in ancient times. The answer to that question guided much of the research and provided much of the explanation for the city's ancient existence.

The Pakbeh Regional Economy Project, led by veteran archaeologist Bruce Dahlin, was conceived as a grand research project that

would encompass wide-ranging studies in support of the archaeological research. Studies of soil, both ancient and contemporary, cenote sediment analysis, flora and fauna surveys, and investigation into the agricultural capacity of the region in ancient and modern times would bring wider research data to the questions raised in this paradoxical city.

Apart from the poor farming conditions, Chunchucmil is anomalous in other ways. It may be the largest site by area in Yucatán, and the burials contain very rich grave goods, even on the perimeter of the site. Soil and agricultural yield studies show that this part of the peninsula is an extremely poor crop producer. So why then is a large, rich city located here? The answer may come from the evidence unearthed and a contemplation of the anomalous structure of the city.

First, a city of this size should include monumental architecture. Instead it presents only a middling-size pyramid complex in the site center, and those buildings are not striking or tall. A proliferation of platform groups challenges these putative royal buildings by showing off their triads of small pyramid-temples. This pattern is contrary to most other royal Maya capitals where strong centers display the tall pyramid-temples and official buildings of the ruling dynasty.

Second, while at other sites the richness of grave goods in burial crypts declines as their location grows further from the center, in Chunchucmil common burial crypts feature luxurious grave goods at a distance from the center zone. Polychrome and carved ceramic vessels, flints, jewels, carvings, and jade are found outside of the ceremonial central zone of ancient Chunchucmil.

Third, Scott Hutson unearthed a seemingly simple house mound complex that nevertheless revealed hundreds of broken flint and obsidian blades in the ground surrounding the house structure, indicating it may have served as a small factory for blade and tool making.

The explanation that most likely connects all this evidence is that Chunchucmil was the preeminent commercial city of its age. A close-by sheltered lagoon provides it with a seaport and a canal reached out across the empty savannah. Some of the best salt in ancient Mesoamerica was harvested in the shallow tidal ponds of the Celestún estuary, where some harvesting of salt continued into the twentieth century. It seems, then, that Chunchucmil added value to the trade goods that proceeded to and from the interior, a place where goods were prepared for transport to the interior or prepared for transport by sea, connecting to the vast trade to Mexico, southward to the Usumacinta basin, and the northern route over the peninsula and thence to points east.

This was a great city of commerce in ancient times, all through the Classic period, perhaps for several hundred years. Because of the wealth and substance of the merchants of the city, the ruler was probably only first among equals. The king could erect a modest pyramid, perhaps a bit larger than the others, but they were free to erect their own family ceremonial temples all over Chunchucmil. Judging from the number of small pyramid-temple complexes scattered around the ancient ruins, perhaps twenty families served as the oligarchic ruling elite in ancient Chunchucmil.

Two other distinctive features set Chunchucmil apart. At the site center a low wall almost a meter high in some places stretches around three-quarters of a circle. To explain the existence of this wall, Bruce Dahlin tells this dramatic narrative. He maintains that this was a defense wall, thrown up in desperate haste during the final hours of the city. But it failed to stop Itzá warriors from overwhelming the city's defenses. Other archaeologists at the site, however, may have discovered ceramic sherds that predate the projected end of the city. Clearly,

Aline Magnoni's excavation in the Kaab' Group.

Scott Hutson at the 'Aak Group.

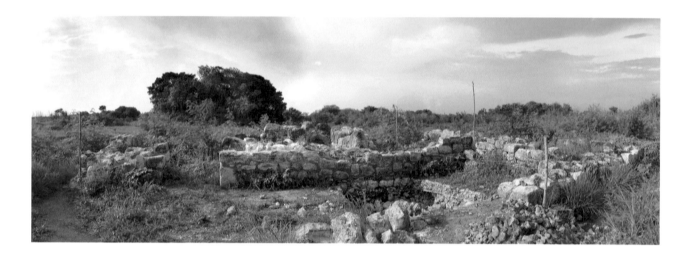

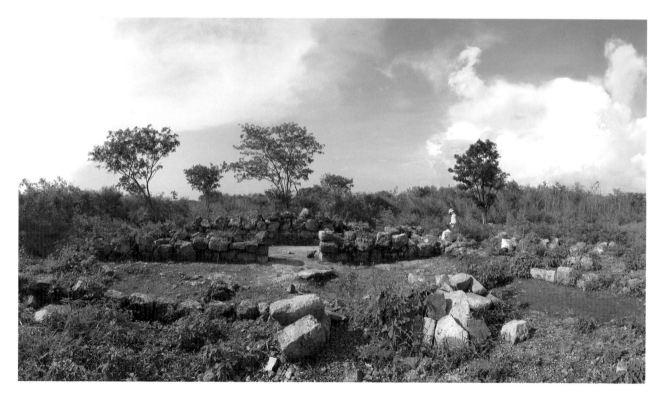

Traci Ardren's excavation in the Lool Group.

Travis Stanton and Scott Hutson's excavation at the Muuch Group.

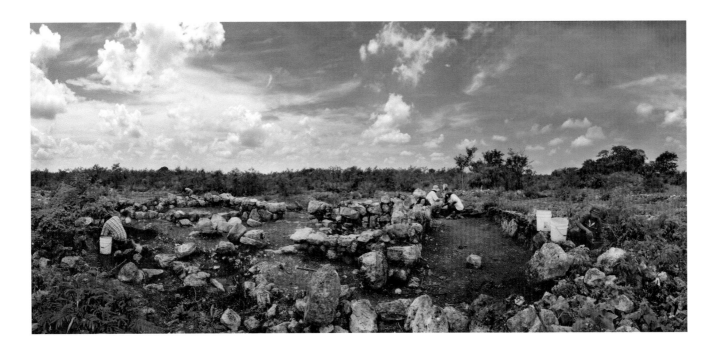

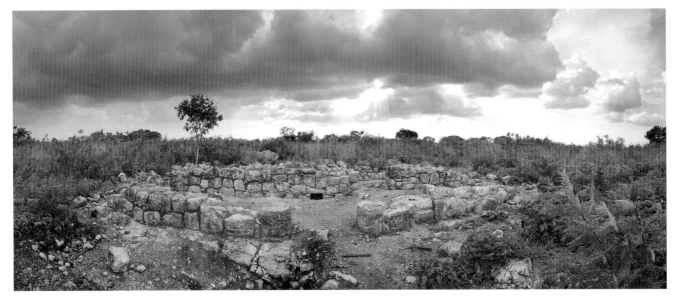

further research is required to find a satisfactory end to this story.

Another interesting characteristic is the number of *albarrada* walls that wind all through the city. These are low walls of one or two courses that seem to define private space and even perhaps walkways and alleys in the ancient city. These interesting, unique features are the subjects of special study and reporting by the Chunchucmil archaeologists. Bruce Dahlin himself is concentrating on finding possible marketplace locations in the ancient precincts.

The principal excavations of the Pakbeh Project centered on the residential compounds and the archaeologists named them after characteristic flora and fauna of the Maya world: Lool (flower), Muuch (toad), Aak (sea turtle), and Pich (*pich* tree), for example. Archaeologist Aline Magnoni named her residential mound site Kaab, the Maya name for honeybee. Her excavation site—located close to the site center—embodied all the distinguishing features of ancient Chunchucmil: it was an Early Classic residence, when the city was at its largest; the albarrada walls and the *callejuela* pathways ran all around its vicinity; and the defensive wall ran right over the top of it. Added to this was the uncovering of a termination ritual with human remains and with intact as well as purposely broken ceramic vessels in ritual placements. In all, Aline devoted years of research to a focused examination of this residential complex and its surrounding areas; this concentrated analysis revealed the long, several-hundred-year occupation of this residence, some details of the daily life of its people, and an intriguing glimpse into its final abandonment.

Alongside the focused examination of the residential mound complexes, the map surveyors of the Pakbeh Project had worked for several years to gauge the size of the ancient site and to place those residential mounds within the context of the larger city. While they

Soccer fans and the old henequen factory at Hacienda Chunchucmil.

have determined the western limit of ancient Chunchucmil, the eastern limit is still unknown. What is known to the east and south is that many small towns are situated on the approach to Chunchucmil, and there you can see evidence of the former inhabitants. Searching for these, Bruce Dahlin and I drove around the nearby village of Kochol, looking for ancient sculpture. We spotted many carved stones in backyards and set into walls in Kochol, as well as in Santo Domingo. At the casa principal of Grenada, two carved Atlantean figures serve as balustrade guardians to the main house, and at Kochol two heavy carved figures are reclining on the hacienda grounds.

The Satellite Sites: Paraíso and Santa Bárbara

In 2002 Travis Stanton was working at Santa Bárbara and told me about the Paraíso pueblo where we could see other carved monuments. I drove with him, and my colleague Michael Henninger, to this small village on a back road near Chunchucmil. Travis was surveying nearby at the small ancient city of Santa Bárbara, that is, he was sinking some test pits and looking for ceramic markers for determining its age and affiliations. He came up with some interesting deviations from the local norm, namely a definitive Puuc-style architecture and ceramics more commonly found much further to the southeast in the Puuc Hills zone. Perhaps this small city became the stronger of the two cities in the Terminal Classic.

The local people in Paraíso had found a number of carved figures in the Santa Bárbara ruins, and they set them into the exterior walls of their small church and the entrance stair to the churchyard in order to forestall their theft by looters. Sometimes the local people are better at preservation of the heritage than the authorities, who do not have the resources to find, collect, and store the myriad artworks that the ancient people produced.

The House of Diamonds, Kiuic. Ancient Puuc cities used good cement. At Kiuic and other Puuc sites, buildings had a excellent chance of standing. They often do not crumble into heaps of debris, but break apart in big pieces. For one thousand years they have stood under the strain of tree roots and vegetation growing from their tops. The artist Frederick Catherwood visited the hamlet of Kiuic in 1841 and drew the trees growing from the summit of the House of Diamonds.

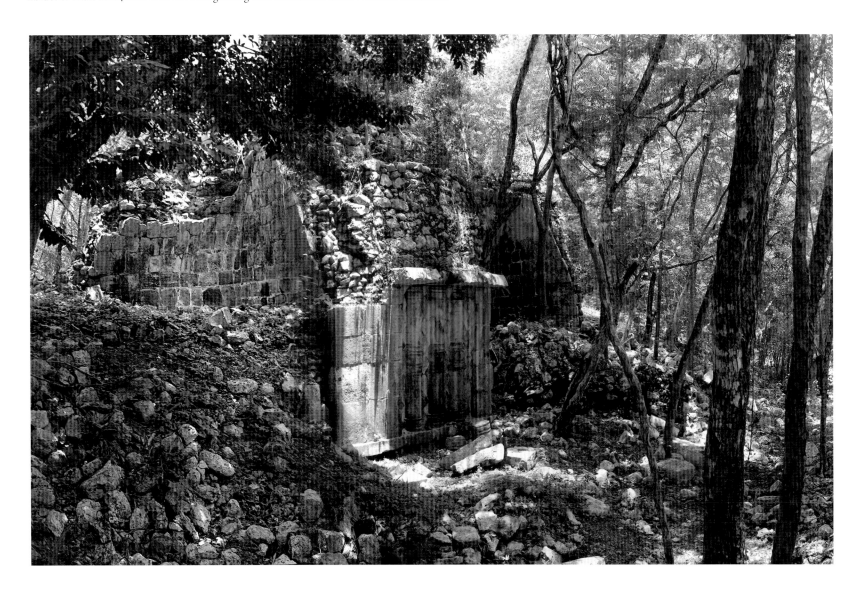

The Kiuic Archaeological Project

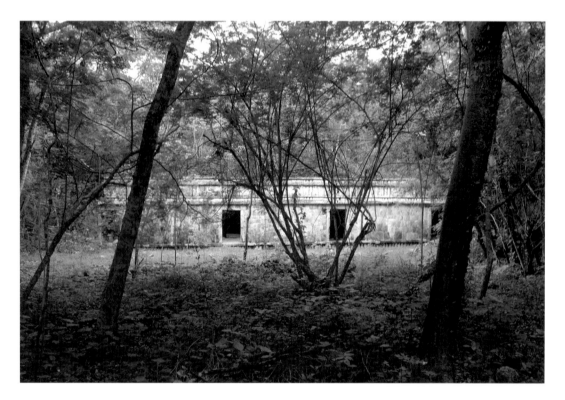

A hidden palace
at Kiuic.

I had finally found my beautiful hills in Yucatán. The ancient city and the modern archaeological project of Kiuic is located in an uninhabited region of the Puuc Sierra, a low range of hills stretching from Maxcanú, an important modern Maya town in the northwest, down one hundred miles to its anchor at Peto, another historic Maya town to the southeast. Kiuic is nestled into this hilly region, and at the same time I was working at Chunchucmil I joined the new project in that ancient cultural area called the Puuc (pook). Being involved with the Kiuic Project held many side benefits, mostly the advantage of being close to Uxmal, visiting the old towns of the Mani and Convent Trails, and roaming all over the hill country. This area is densely populated with ancient ruined cities and, on the eastern flank of the hill range, with a vibrant modern Maya culture.

In 2001 I was traveling with my colleague Michael Henninger. After visiting several Puuc sites on the way, we arrived in Oxkutzcab looking for George Bey and the Kiuic Project house. It took some asking around and a couple of false leads knocking on likely doors, but finally we saw the faded black Jeep Cherokee with a cow's skull stuck

The South Temple at the Ulum Group, Kiuic.

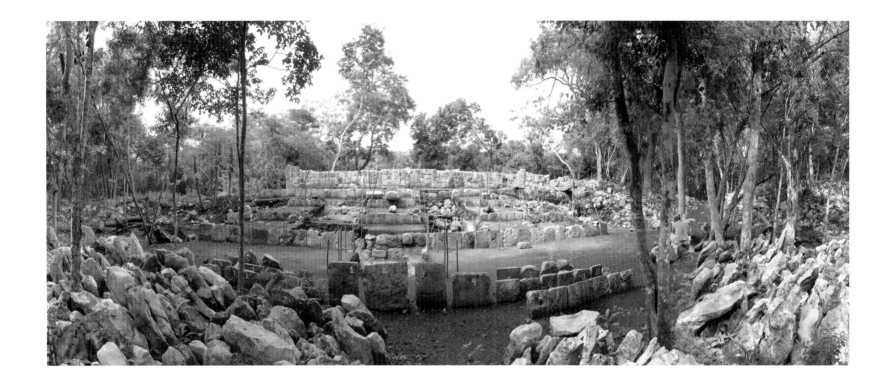

to the front grill. George had told us to keep an eye out for it, since it belonged to Tomás Gallareta, the INAH archaeologist who was one of the codirectors of the Kiuic Project. The next day we were on the narrow Puuc road that wound down from the rich fruit orchards that begin near the Loltun Caverns and fill up the pockets of good soil in the hill valleys in that neighborhood.

This road reminded me about how pleased I am to drive down an unfamiliar road. We pulled into Xul (shool), a strictly Maya town whose name I recognized from Stephens and Catherwood's book. They

had visited Kiuic and this region in 1841. I was still a bit unsure of the right bearing, but in downtown Xul I turned down a paved road that seemed promising. The maps of these areas are mostly noncommittal about locations of towns, so we passed through one little hamlet and we looked for the dirt road turnoff that George had told us about. Just when we thought we had gone too far, a little sign with an arrow pointing said: Kiwic.[1] George or someone had left the gate unlocked for us, so after a mere three more miles on the dirt road, and passing gingerly over some substantial bedrock protrusions, we came down into the ruins.

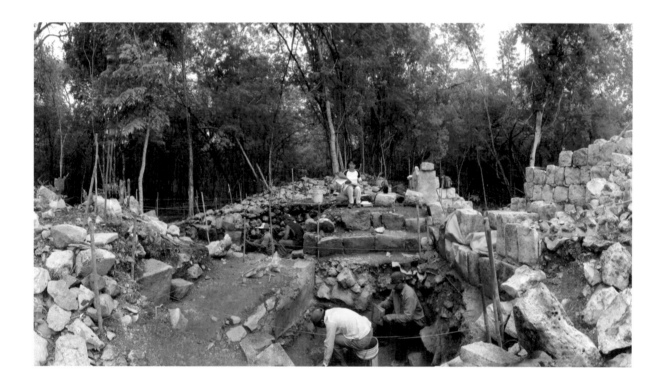

Earlier that year George Bey had invited me to visit his new project at Kiuic. I knew that he and Bill Ringle had always worked together on excavation research, and here they had teamed up with Tomás Gallareta Negrón of INAH to initiate a new integrated research program at the ancient ruins. Their idea was to purchase the four thousand acres of uninhabited land that surrounded the ruins and bring in researchers from other disciplines, such as zoologists, botanists, and ecologists, geologists, and geographers, to conduct a thoroughgoing examination of the site and the local region. Along with the scientific research, they have established the land as a nature preserve and built up an educational component that brings students from the state and the nation as well as from the wider world to live and study in the preserve. To this end they have constructed a number of Maya-inspired buildings to house the institute and research facilities. This research preserve, now called Kaxil Kiuic, stands peacefully in a midcanopy, climax forest that has been out of cultivation since the 1840s.

Unlike at Yaxuná and Chunchucmil, the connection between the Kiuic Project and the village Maya is somewhat more distant as the

Maya excavators.

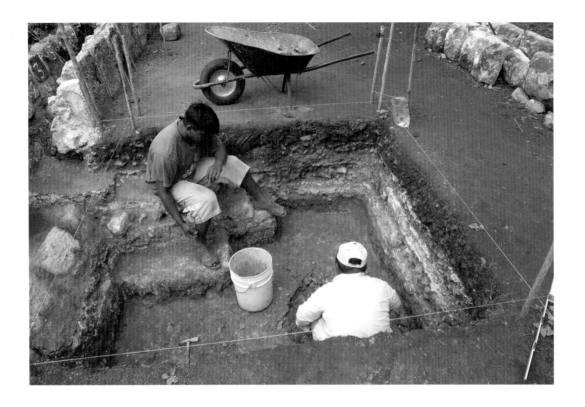

villages are not in direct physical contact with the ruins. The closest villages contribute men to the excavations, but the ruins themselves are in an uninhabited region. It is typical of the contemporary Puuc to be lightly inhabited, in contrast to its much denser populations in ancient and colonial times. The demographics dropped severely in the Caste War period, and a good example of the effects is isolation of the beautiful mission church at nearby Tabí. It essentially stands alone where a community existed before. After the Caste War, the people of this town never came back.

As an example of the population densities in the Puuc, Tomás Gallareta ran a survey for sites on the line from Kiuic north overland to Labná, generally following the ancient sacbé as well as the colonial carriage road that traversed the same ground. He found 128 ancient settlements on that route. He believes that other areas of the Puuc Hills in the region all around Kabah, Sayil, Labná, and Kiuic held similar population densities in ancient times.

Today people are repopulating the Puuc Hills. I have noticed the difference from the first times I wandered there in the early nineties.

The Puuc Hills and the area surrounding the cities that fringe the northeast slope have good soils relative to other regions of Yucatán. Fruit orchards and truck crops can grow there. The small hill valleys at the top of the Puuc Range harbor fruit trees near the location of the Loltún Caves.

Yucatán 2005 Diary Excerpts—Kiuic Project
Monday, June 20: Mérida, Hotel Caribe, to Uxmal and the Hacienda Uxmal, Heavy Rain

The streets were underwater—seven or eight inches of water sloshing around in the streets. Driving, we all waded through, and I made my way to Avenida Itzaes and out of town, the downpour continuing. It lightened to a solid rain on the main Campeche highway, but when I approached Muna it strengthened again. I saw the Muna schoolgirls in their uniforms standing stoically, soaking wet.

Approaching Muna I smiled out loud when I glimpsed the Puuc Hills standing on the south side of town. They are widening the highway about halfway down to Uxmal, the heavy earth-moving stopping just before I pulled in to the huge entrance *palapa* at the Hacienda Uxmal. The flamboyans are in full bloom, plumeria graces the grounds of the hotel, and mature imperial (or Nile palms) tower over the central court. I changed out of wet clothes and crossed the court to reminisce about other times here, at this bar, drinking *micheladas* with good friends. Seems like a hundred times. All the while mynas and the big black tropical orioles bathed the court and gardens with song. Now dark has fallen and a strong cricket sings as the birds have taken to their night roosts.

Tuesday, June 21: Uxmal, Partly Sunny, Rain P.M.
I did some repacking/organizing and by noon was ready to have lunch at the Villas Arqueológicas, which was deserted. No cars in the lot and one family in the family room. Not another soul there for lunch. I recognized the waiter from previous years.

In the Uxmal ruins I met George Bey unexpectedly on the stair leading to the Adivino Pyramid and then sneaked up on Tomás to surprise him, then I went into the ruins where I spent a thoughtful afternoon. I photographed in the usual places before wandering to previously unexplored sections. INAH is carrying out major restoration work in the court plaza in front of the Las Palomas building. With all the rain lately the mosquitoes were bad in the shady, grassy areas. The iguanas now seem to swarm the place. Did I not notice them as much before?

I climbed the western limb of the South Pyramid up to the summit temple and found that the panorama that I took six years ago was no longer there. The ruined corbel arches in my previous vista were now part of a fine new building. I could not go home again to that previous imagination for it had been restored out of existence. The vegetation had grown thick as well, and the tall agave flower stalks have dried to burnt black. A major bees nest (Africanized?) swarmed out of the eastern summit vault as I approached, and I hastily backed away. The sometimes idealized world of this artist's past truly no longer existed here.

The beauty this day was the afternoon rainstorm that broke over the Nunnery and the Adivino as I sheltered in the doorway of Casa Tortugas. I watched gangs of schoolkids walk through the ballcourt below me and an extremely handsome, Spanish-speaking, white couple with their three young, pretty girls climb the rough stair wall—reprimanded by the guard at the top—right in front of me.

In the evening we had a cocktail party with all the Millsaps College crowd with the students joining us, all cleaned up though, from the field. Nice crowd at dinner, and I talked to Kirk, Melanie, and Jane.

Wednesday, June 22: Uxmal to Oxkutzcab, Partly Cloudy
The Millsaps crowd took off early. They stopped at Labná and were trapped for a little while at Kaxil Kiuic by the afternoon downpour out there. I drove through Santa Elena, stopped to shoot the side of the church, and made my way over the Puuc Range, down into Ticul, along the well-remembered road to Oxkutzcab. Drove through *centro* and by the marketplace, down to Calle 49 and the turnoff back to the Ruta Puuc. The Hotel Puuc has expanded and seems smartly run. Clean, simple, and inexpensive at nineteen dollars per day.

I drove over to the restaurant in Mani and waited for two hours for the party to arrive, but they never did. I figured that they were

caught in the rain in the hill ruins. Instead, back at the project house there was a birthday party for George Bey Jr. and Halley Ringle with an hour-long piñata in the shape of Shrek and then cake. I'm always scared to death of piñatas—equal to trampolines, they're accidents waiting to happen. I watched *Return of the King* at the local cinema and didn't get to sleep, suffering a sore stomach until 5:00 a.m.

Thursday, June 23: Oxkutzcab, Partly Cloudy—Did Not Rain
Arose late and made it out to Kiuic around 10:45 after picking up a big roly-poly white kid who inexplicably spoke almost perfect colloquial American English, inexplicable because he was headed to Yaxachen, the village beyond Kiuic and literally at the end of the road and literally in the middle of nowhere. He claimed to have a wife, age twenty-one, in the village. Inexplicable.

I chanced into James Callaghan as I walked on the road down to the project excavations. He had a group of landscape students from Texas Tech coming through on a tour. He had me say a few words to them. Spent the rest of the morning with George touring the operations and then photographing them. Catesby found a nice cached pot, intact, and the lid sat upside down in the top.

Friday, June 24: Oxkutzcab, Partly Cloudy, Mostly Sunny
I walked on the muddy red road into Kaxil Kiuic and talked with Ruby Callaghan a bit. She administers the place and James, her husband, runs the groups. Magnificent also are the large vermilion flamboyans and the huge ceiba trees festooned with epiphytes. I photographed all the white-walled and high-peaked thatched roof buildings they have constructed there in the past year.

Back at the excavations I began the video interviews. I started with Catesby in her operation in Plaza Ulum. Walked around and shot sequences at Rosanna's and Betsy's operations too. Many parrots squawking in the branches overhead.

Everyone drove in the van to Ticul for pizza, beer, and an ice cream on the main square. A dance troupe was rehearsing on the main stage. On the way home a DUI checkpoint was set up just on the outskirts of Oxkutzcab to catch the drunkards coming home from the corrida.

Saturday, June 25: Oxkutzcab, Partly Cloudy, Mostly Sunny
Arriving at the project house to work, I conversed with Bill Ringle and saw his pictures of the extraordinary stela that they unearthed at Huntichmul. Everyone took off except Chris Gunn. I did laundry at Calcitchen Lavandería and headed over to Yotholin to photograph the village fiesta and corrida there. They had already killed the bull and were butchering it outside the stave coliseum. The smell of adrenaline in the carcass repelled me in a way that the dead carcass by itself did not.

I wandered around attracting not too much attention from the quietly drinking, quietly drunken mass of mostly young Maya men who were surrounding the wooden bullring. The two-story, stick-and-twine bullring itself was packed. Every twenty minutes the caballeros would force a new bull in, it would paw the ground, and the acting toreadors/matadors would bait it with their red capes, run like mad for the safety gates, and the crowd would scream with excitement if the bull would get even remotely close to one of the youths. After a while the men on horses would ride in en masse and a short interlude of comic lassoing and dragging the bull out of the arena would ensue. The old Maya matrons in their best huipiles—the traditional white and embroidered dress of Maya women—seemed most to enjoy

The two-story stave and twine bullring at Yotholin.

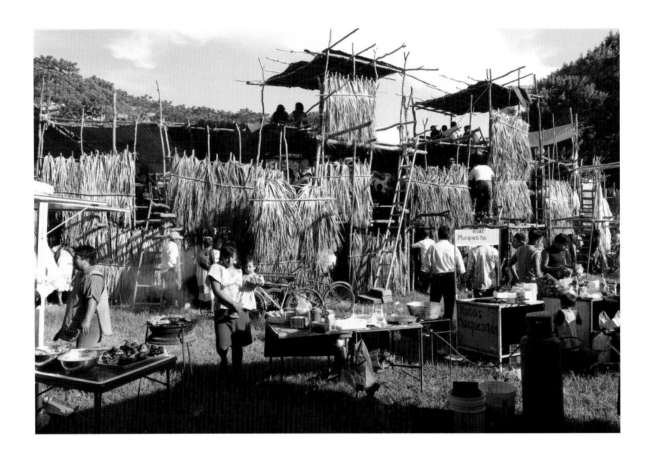

the action. Apart from the bullring, by the side of the main road, a two-man, barefooted, drum machine and keyboard–equipped, mightily amplified *cumbia*/rock group dressed in gray cut-out-sleeve T-shirts and black knee pants belted out songs with the old, momentarily deserted church as a background.

In the evening, Chris, Kristen, and I went for pizzas, beer, and a movie at the Oxkutzcab cinema. Bruce Willis in *Hostage* was the satisfying action pic. I would never go see this film at home.

Sunday, June 26: Oxkutzcab, Partly Sunny, Warm but Pleasant
This morning I ordered *huevos* and *longaniza* with *café con leche* at the Labná Restaurant right outside my hotel door. Somewhat simple conception of service, but okay.

When I went over to the project house, Bill was the only one resident, so I sat down to write as the Baptist church singers next door sang their songs. Reminds me of a much rougher version of the hymns I heard in Polynesian on the north shore of Huahine in 1993–94.

Toro!

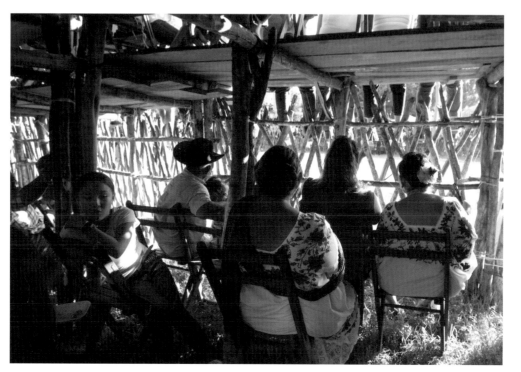

At the corrida,
Yotholin.

I take it back, the voices are pretty good and sweet, it's the drummer that makes it a bit rough.

In the afternoon all of us still left in the house drove over to Mani and the Tutul Xiu Restaurant, which specialized in true Yucateco cuisine. *Poc chuc* is the typical dish, but people ordered *escabeche* and *filete de res*. The other day I had the relleno negro, which is not as good as at the El Mesón in Valladolid. On the way home we drove through a tremendous downpour with water several inches deep on the country road and the road into town. The downspouts were pouring cascades of roof water into the streets, and creeks of water filled the passageways. That night too a loud, muscular rain poured down. This is a tropical depression then.

Monday, June 27: Oxkutzcab, Overcast to Partly Sunny,
Hot and Humid

I drove a little earlier to the site and interviewed Rosana, Betsy, Mike, and Kristen. Also photographed a lot. I stopped for a minute in Xul to shoot the church with a towering thunderhead over the hills. On the ride into town, another downpour blurred the vision, and it followed me into town. Lunch at the project house was *puerco con frijole sopa*.

Tuesday, June 28: Oxkutzcab, Overcast to Partly Sunny

I arose quite early to go to Huntichmul with Bill and George. Bill picked me up in the newly fixed Jeep—it had broken its driveshaft. About halfway up the road from Yaxhom to Labná we started to get a bad vibration. Our first thought was that the driveshaft fix had gone wrong. Turned out, after we had shifted people around cars, that the wheel hubs for the four-wheel drive were out of synch. The eight-kilometer ride into the site was muddy and rough. The Jeep bogged

down three times, but only once did the Maya guys have to get out the rope and pull it out.

The Huntichmul site itself is magnificent with dense platforms and buildings and sacbeob. It sits in a valley or plain between high hills, many of which display palaces and temples. Bill and now George believe that this city may have been the central polity around which both Kiuic and Labná orbited. Some of the temple buildings show strong Chenes design influence with masked buildings and an Earth Monster building on the high pyramid. Bill showed me his map from last year and pointed out a tremendous ramp up one side of a palace-bedecked hilltop. This ramp looked to be one hundred meters long.

When we arrived, they unwrapped the protective tarp from the well-preserved twelve-foot-long stela. It shows a named lord: Ajaw Kan Tok and a stela erection date—looks like AD 894? He stands on a large Pop mat, the only one I've seen like this. He seems to be enacting a deity, and a deity is suspended above his head in a separate panel division. The tentative identification is Chac. Extraordinary quality. The stela was soon afterward shipped to INAH Mérida.

George took me on a tour to a platform with two temple buildings: one with a standing vault end wall and corner, the other with a half a wall with strong jambs and Catherwood flora on the top. Debris slopes showed a cascade of sculpted stone pieces in a jumble. In fact this is a prominent feature of Huntichmul ruined buildings, that these temples and palaces were highly decorated. Perhaps this is in keeping with the Chenes nature of the design here, but also could indicate the relative prosperity of this site over its neighbors. The density of large buildings with their ornamentation suggests such a prosperity.

George and I walked next to a standing palace in the side of a hill overlooking the valley. Later I returned to photograph this palace, but

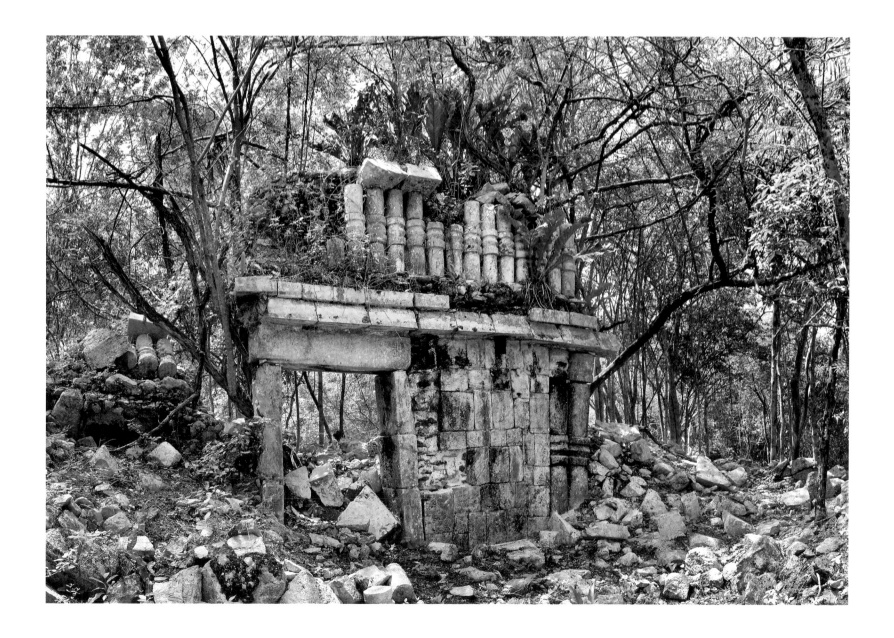

George Bey and Bill Ringle with the recently discovered stela at Huntichmul.

it was difficult to get the good angle. In front of the palace near the roots of a substantial tree I discovered a deep and dark chultun (plural: *chultunob'*). Chultuns are those natural (as well as man-made) bottle-shaped holes in the ground that the Maya used to store food and water. They range in size from perhaps a meter in diameter by a meter high, which is quite small, to some that are room sized or larger. This one in front of the hillside palace was big enough that I could not see its extent, but perhaps my eyes were blinded by the bright noontime sunlight all around me. Finding this chultun certainly was not unexpected. While I have come across chultunob' in many of the ancient ruins across the peninsula, I seem to encounter them more often in the Puuc, and there my impression is that they tend to be larger or deeper, and often seem plastered or sealed in order to serve as cisterns.

When we struck camp for the day, Bill took us on a tour of the hilltop buildings above. The great pyramid structure, twenty-four meters high, has an Earth Monster temple at the summit and one hundred meter plus–wide platforms rising in two steps to the temple-pyramid base. The face of the building had collapsed, leaving two towers surviving, one just a wall towering over the collapse. Sculptured stone designs and beautifully cut vault stones covered the scree slope. A beautiful, wild, and romantic place above the lacy canopy of the dry tropical forest.

The ride back out from remote Huntichmul was not so bad. We only bogged down once, and some snapped-off brush and sticks, and some pushing, sufficed to get us out. We stopped at the entrance gate of Labná ruins for a Coke before heading home. Back at the project house, Bill left to drive some of the students to Mérida for their plane flights home, and I said my good-byes to the Kiuic Project for the year. On the way out Tomás, with humor, said that I was the "Phil." I think he was making a pun about excavation dirt.

Hacienda and pyramid at Xuenkal.

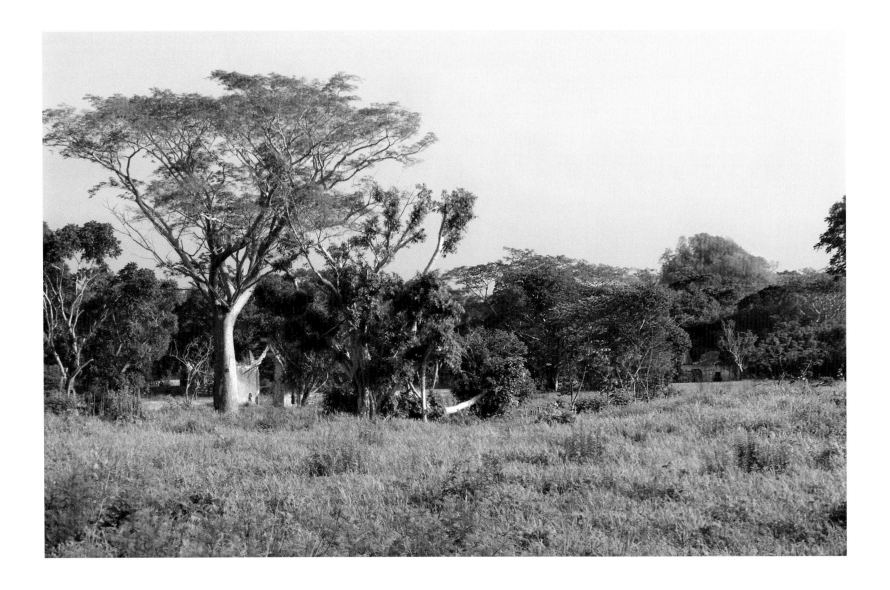

The Xuenkal Archaeological Project

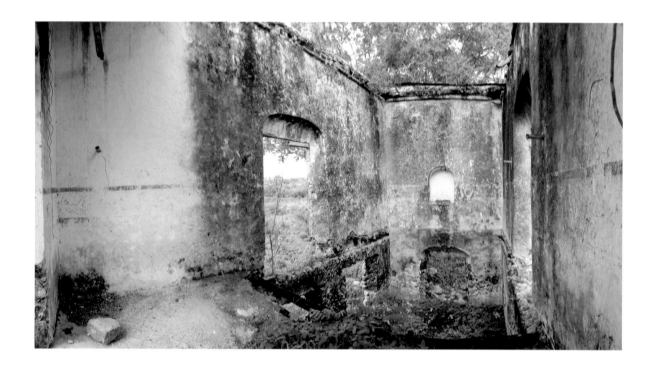

Ruined hacienda at Xuenkal.

During the summer 2005 field season I finally made it to the Xuenkal Project, which was in its second season. Traci Ardren and Kam Manahan, old friends from the Yaxuná Project, began this research project in 2004 with surveys, mapping, and test pits, the usual first steps in any excavation design.

The ruins of ancient Xuenkal (shuuwen-KAL) lie a short distance to the west of Espita, a small city in the less populated northern plains. The restored sites of Ek Balam twenty-five kilometers to the east and Chichén Itzá forty kilometers off to the southwest are the obvious places to consider ancient geopolitical interactions. The main thrust of the project's research has been to determine the relationships that ancient Xuenkal may have had to these larger sites, particularly to Chichén Itzá, whose early dominance extended to the coast north of Xuenkal's location. Their early findings through the 2007

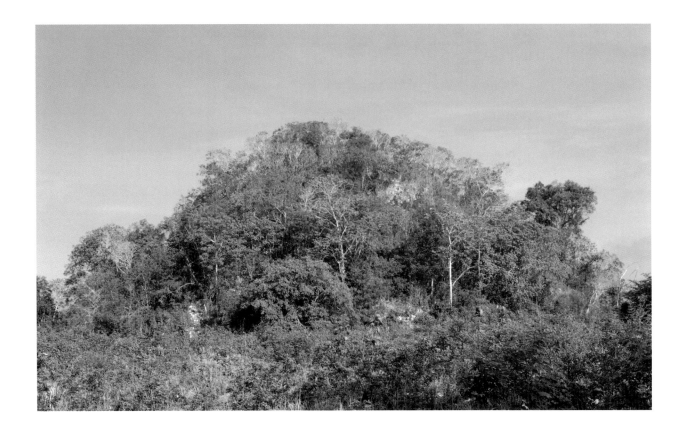

season point firmly toward a Chichén Itzá–influenced settlement in the site center during the Terminal Classic and a wealthy Late Classic population—judging from the numerous rich burials and artifacts of that period. The project remains focused on this cultural transition in the region north of the Chichén Itzá polity, keeping in mind the key midposition of Xuenkal on the salt trade route from the north coast and the number of fertile rejolladas with their crops of cacao and other highly prized produce.

The Xuenkal Project lives in town, which does not take much notice of the archaeology project based in one of its houses. Espita was once one of the largest and most important towns in Yucatán. Its heyday was during the eighteenth and nineteenth centuries when it was surrounded by a number of cattle haciendas and produced truck crops besides the ubiquitous corn and beans. In the

Ruined church on the road to Tizimín.

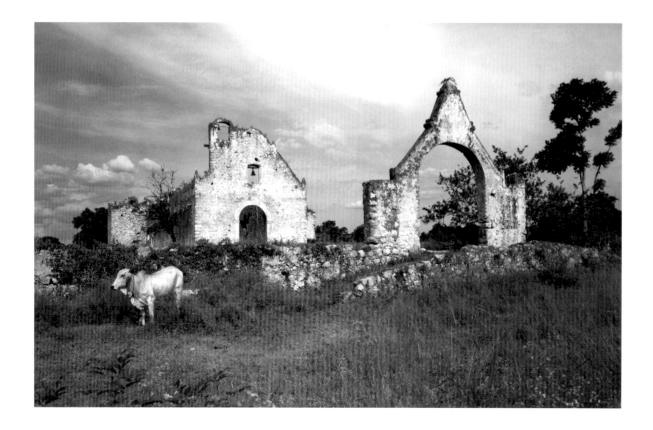

late twentieth century, the city of Tizimín, larger and a short distance to the northeast, overtook Espita as a cattle center as it was closer to the great pastures carved from the jungle forests. Its influence spread from there to the coast and further out to the sparsely populated eastern corner of the peninsula.

Espita remains a stubbornly traditional Maya place. It is off the beaten tourist path and appears somewhat sleepy, especially in that afternoon time when the sun is still hot and the clouds have not released rain yet. Although the buildings of the central town have fallen into melancholy disrepair, the habits of the past three centuries remain strong except, perhaps, strict adherence to the church.

One night they began the high school graduation party in the town plaza, and although they were about four blocks from our house, the dance music kept me up until about four in the morning. I noted

with interest that they played the Numa Numa Dance, that Romanian disco tune that became an international hit. I had never heard the long version before.

2005 Xuenkal Field Season Diary Excerpts

Wednesday, June 29: Oxkutzcab, Muna, Mérida, Light Overcast
I left Oxkutzcab for good in midmorning, shaking hands with the proprietor of the Hotel Puuc on the way out. At Muna I missed Travis by an hour. He had gone off with Pipo and Rodrigo Morales to Uxmal, eventually back to Oxkutzcab to search for ancient clay sources.[1] Arrived at the Hotel Trinidad after noon, my bohemian hangout in Mérida, then to lunch at the Portico del Peregrino.

Thursday, June 30: Mérida to Espita, Partly Cloudy to Sunny to Downpour
On the way to Espita I stopped in Motul to photograph the church there. Motul is another big Maya town, perhaps twenty thousand people. This is the first time I've driven this road. The northern tier is more empty and open, the road almost deserted with less topes along the way. Along the road from Motul to Buctzotz some acres of henequen are growing. The road from Buctzotz to Sucila shows the vast cleared lands of the cattle ranchers. Highway signs warn of fog. The road from Sucila to Espita is a back road with the vegetation crowding the margin. Espita is a profoundly Maya Yucatán town with a beautiful church. I found the project house without a hitch and joined the project members at lunch. Met Andy, Eric, Evan, Araceli from UADY (Universidad Autónoma de Yucatán). Also Don and Loren on loan from the Chunchucmil Project. We left at 1:30 p.m. back to the Xuenkal site, eight kilometers due west of town. Kam

and I set off to climb the big mound, but we turned back when a huge rain approached and hid in a nearby sascabero cave until it stopped. (Later, near this cave, Traci would point out a wild cotton plant, source of one of the most important goods of ancient Mesoamerican trade. In the wild, it looks modest and unprepossessing, a skinny undistinguished bush.)

After the rain, we began our ascent up the pyramid, but only reached halfway before a second deluge came upon us, and I began thinking of the danger of lightning as we stood atop the twenty-nine-meter-high temple. The rain continued and soaked us through. Kam called off the excavation work, piled into the project cars, and arrived in a dry Espita. At the project house, we hung up our clothes to drip-dry.

Traci and Justin arrived from Cancún about six o'clock as we were beginning a second round of monte croquet. Kam won after I had led the entire way and had become "poison" first. The croquet pitch at the Xuenkal is an excellent mixed course of laja, bushy vegetation, high grass, trees, logs, and rocks. After dinner I showed El Perú-Waka' Project pictures to the interested crowd. The younger team members returned to their lodgings at the other project house, and Kam and Traci talked about the new troubles with the ejido folks. They thought that the season had been going too well not to run into something like this.

Friday, July 1: Espita, Sunny to P.M. T-storm
We drove out to the site of Xuenkal, and Traci and Kam gave me the full tour. We visited the abandoned tiny pueblo site—named San Francisco—that the people had quit when Hurricane Gilbert had wasted the north shore of Yucatán in '88 (the eye passed over this part of Yucatán). An old-man hermit had refused to leave, and his lonely

Maya's hut was still standing with a large ceramic water vessel and a flat low table left behind. I thought this was an excellent example of how a Maya house might have looked when abandoned in ancient times.

Further on, we examined some platforms, skirted the big pyramid, and checked in on all the test pit units. We walked the trail over to the old hacienda and moseyed around looking at the building with mosaic designs on it and the archway entrance. I took a photo of the young kid there named Christian. Then walked over to the Palace and climbed it. Nice view. I conversed with Andy about where he should put some new units.

Back at the project house, lunch was mole. A nice thunderstorm passed over with a nourishing rain about six thirty in the evening. Traci went to Mass for some sort of graduation of one of our cook's daughters.

Saturday, July 2: Espita to Saban, Partly Sunny
After a pleasant morning at our project house in Espita we drove in two cars to Valladolid for lunch at El Mesón and to secure rooms for that overnight. We were headed to Saban in Quintana Roo State to party with our archaeology colleagues from across the peninsula at our traditional Fourth of July get together. On our way south from Valladolid, having missed it, we spun around to inspect the Cobá-Yaxuná sacbé south of Tixcacal. We crossed the state line without a hitch—we had been warned that we might need our passports! Tihosuco has a beautiful open-roofed church and the Caste War Museum. The trees have grown up substantially since Macduff Everton photographed the church in 1971. We sailed into Saban Project house without confusion. Dave Johnstone and Justine Shaw, both alumni of the Yaxuná Project, were hosting this party, and Justine was outside

on the street to greet us. The Yalahau Project folks were already seated and drinking beer. The Chunchucmil Project from across the peninsula arrived with Bruce and Scott, others, and a Finnish young lady in tow. Dave took me back to witness the unearthing of the pig in the pib. I talked with Scott and Bruce, watched the piñata fun for awhile, and returned early with Emily and Exey to Valladolid. We stopped at the turnoff from the Saban road to Tihosuco road at the ghostly beautiful Santa María shrine with candles alight that shine for many minutes as you approach in the profound darkness.

The village of Saban seems like a typical Maya Yucatán town. But the churches in this neck have their roofs gone, and the folks in this region seem to remember the Caste War well. I photographed around the ruined-in-use church for awhile and the plaza square too. The region around is also lightly populated and a bit poorer than Yucatán, although, certainly, poor pueblos we know about in Yucatán.

Sunday, July 3: Valladolid to Espita, Partly Cloudy
The Mesón has added many more upscale rooms, but the restaurant remains the same. Its romantic and beautiful common rooms were first constructed in early colonial times, and this building saw three centuries of frontier Yucatán history. I think with some fascination that it also witnessed some terrible atrocities of the Caste War, but now it is a favorite with knowledgeable tourists, and certainly a favorite of the archaeology community. I've been coming here for fifteen years with my friends from the projects.

I wandered around the Sunday square to photograph. We left after lunch, and on the road north we spied dark nimbus that evidently dumped sixteen hours of rain on Tizimín and parts east of us. In the late afternoon Traci and I drove around town to view rejolladas, most

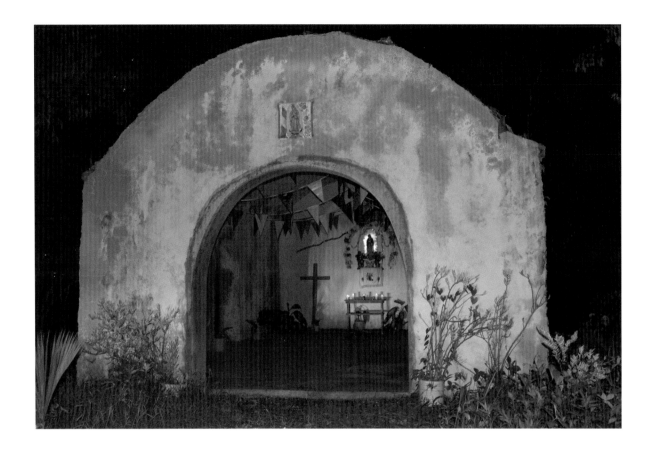

of which were unphotogenic, but I did take some shots at the one where La Virgen María appears on occasion. Great pizza (!) in town, and beginning that evening a school graduation made tremendous noise all night, with the "Numa Numa" song appearing in the wee hours and a mythic Slavic drum-chant piece I'm sure disturbed the psychic foundations of this traditional Maya town.

Monday, July 4: Espita, Tropical Depression
The rain has stopped all fieldwork plans. I've begun videotaping, beginning with the bio fractions that the botanists left. Everyone is washing sherds. After lunch Traci, Kam, and I set off for Río Lagartos and Las Coloradas where the salt mountain is. We stopped at the beach to see the placid sea and talked about the Maya traders who brought their goods around this peninsula. We ran into a walking funeral procession

as we passed into Río Lagartos. Travis called us from Mérida as we drove south from Sucila. All the clothes came back from the laundry, all clean (mostly clean), and fine to start the next day.

Tuesday, July 5: Espita, Partly Sunny, Hot but with Nice Breeze
I drove out with Kam to the site today to interview all the researchers at Xuenkal. Very hot and humid. And now that the detergent perfume has worn off, the true nature of my newly laundered, but mildewed T-shirt becomes apparent.

In the afternoon both Traci and Kam sat for interviews, and I went out to photograph the church. I walked around the interior and noticed again, just as in Saban, that the new decoration takes the form of satin banners with living slogans and somewhat cartoonish figures of the Christ or saints. The modern style and materials seem out of place. But anything more substantial must be out of the reach of the parish. The huge stone heritage of these churches impresses, but the real system is the support and moral participation of the community. That social basis does not seem to be as robust or as encompassing as in the past. It cannot be that these areas are poorer than in the eighteenth or nineteenth century?

In the evening I showed everyone the large prints that I brought along. They were well received. Beautiful night out and the house is very warm. Phoning home I talked to Nina about the airport pickup tomorrow.

Wednesday, July 6: Espita to Puerto Aventuras,
Sunny and Bright, Hot
I drove out to the ruins to catch some pickup shots in the early morning light. A beautiful long shot of the large mound with the

hacienda chapel presented itself. I walked over to the large mound itself to videotape it and then crossed the fence on my belly, getting mighty dirty, almost muddy, I was sweating so much, in fact sopping wet. I shot some of the lonely test pit shots. Perhaps some may prove printable.

Midmorning Kam and Traci were headed into Mérida, and we said our good-byes then. I packed, had lunch with the crew, and left for my two-hour drive to the Cancún airport. I got there three hours early, so I drove up through the abominable hotel zone on the strand. I had stayed once at the Hilton with Tony. They had a different name in those days that I now forget. But the Hilton is in the less densely developed southern zone. As I drove north I became increasingly appalled. I tried to imagine the amount of money that is pouring into this zone. In his house notes, Don Hart later reported that the hotel zone is losing customers to the Maya Riviera zone to the south, the unintended consequence of pushing the four-lane road south to Xcaret. The riviera zone now is developed, with large resorts populating the entire stretch. Playa del Carmen is much more developed than in 1998 when we struggled through the highway construction, trying to get to Cancún airport from the south.

Nina sailed through customs/immigration quickly and on time, and we made our way to Don Hart's beautiful hideaway next door to Puerto Aventuras on the Akumal coast. At first entrance it was very hot inside his place, but lots of art to admire. The image of the Temple of Inscriptions is particularly striking.

Traditional shaman ceremony held by syncretic Catholic Maya.

Maya Yucatán

Living in Yucatán

Late one night at the Yaxuná field camp I heard a strange throbbing sound coming from the far fields. An eerie sound, it seemed like great water engines at work, a deep rhythm in the night. It seemed so electronic, this phasing of the frequencies. For some time I tried to analyze the unearthly sound, but this one fantasy kept sticking in my head: this was the undulation of a space-alien gravity ship, resting in the fields out beyond the pyramids. Of course that was silly, and days later I solved the mystery by thinking it through: this great thrumming in the dark was created by many hundreds of frogs, singing in phasing unison, two or three different species that combined to make the uncanny music. For more than one reason, they were all happy that the rains had arrived that day, and everyone had to sing.

That night I had wanted to go out to the fields and hear them more closely, but this was soon after my nighttime experience—related earlier—with the aluxes and dueños. After these spirits had followed me home at the conclusion of don Pablo's nighttime benediction ceremony, I was more leery of venturing far at night. I could sense the aluxes in the dark line of trees beyond the cleared areas near the ruins. Likewise, after that time, when visiting cenotes I had the sensation that I would see them in broad daylight, peeking out from the hollows and sheer walls of the limestone sinkholes.

I did not really believe in these creatures and other small spirits that dwelled in the woods, but I still thought it was a good idea to bless and spiritually purify, to the best of my ability, the field camp where we lived and slept. To that end I would fashion a little *incensario*, place on it a burning ember from our cooking fire, and set thereon a crystal of copal incense. This combination would smoke up into dense clouds of fragrance, and I would walk waving my incense burner around our comedor and cocina, our sleeping huts, and the corners of our plot of land. I think it was effective, this purification, for I never had nightmares in the field camp.

For this same purpose of purification copal incense was and still is used by Maya shamans in many of their ritual ceremonies and in their everyday practice as well. I procured my copal in Valladolid at one of the small traditional tiendas a door or two off the principal market street. Copal is practically identical to the frankincense of the ancient Mediterranean and Catholic ceremonies, at least to my nose. I looked always for the large crystals of copal, some as big as the palm of my hand.

On these shopping trips I would also look for cacao beans, a currency of ancient Mesoamerican trade. During his fourth journey to America, Columbus noted the use of cacao beans as money when he came across an oceangoing Maya trade canoe in the Bay of Honduras. In my case I often traded money for a small bag of the cacao beans and at night lay in my hammock to chew on my new currency. It was a pure chocolate hit, and of course I would not be able to sleep afterward. I soon quit chewing them at night and switched to an afternoon chocolate routine.

In Yucatán, even if I did not really accept the aluxes, I did believe in certain small spirit creatures, one genera of which were the many butterflies of the peninsula. Every week during the rainy season, a different butterfly species poured forth thousands of individuals, like tree blossoms filling the air. These weekly issuings of different species would overlap each other, and gathering at the margins of mud puddles, they polychromed the ground. Watching them, I wondered from my reading of Maya mythology: are these the reincarnated souls of warriors? Or was that hummingbirds from the Aztecs' myths?

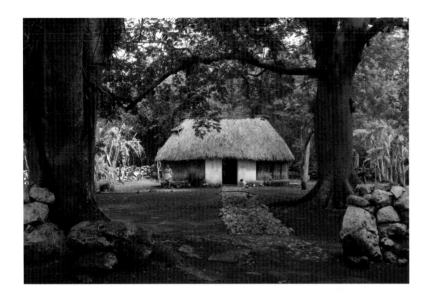

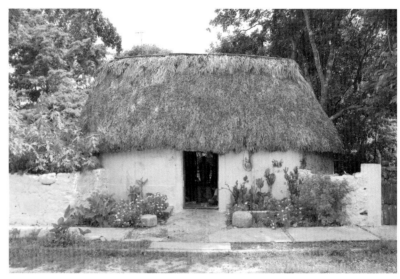

And if that were true, I wondered if the souls of warriors inhabit other gentle species? When I first came to Yucatán, one of the enchanting sights while driving at night was the small nighthawks that sat on the white dirt road that led down from Chichén Itzá–Pisté to Yaxuná. My memory is that we drove that road a lot at night. It was a decent enough road, but on some sections the dirt turned into a red clayey earth that held water and created deep muddy puddles that we called "red death." As we drove we were captivated every few minutes by a succession of bright sparkles, perhaps one hundred yards ahead on the road surface. They always came in pairs, these spots of light, and

grew brighter as we approached. After a few times I realized they were small nighthawks (nightjar or *pauraque*) that liked to sit in the road. Here was a nice cleared space for them to rest, listen, and spot small prey. Like the silver eyes of a spirit-companion *nahual*, their eyes would brightly reflect our headlights on those preternaturally dark nights, and they would spring into the air just as we got to them, sometimes flying directly toward us and skimming the rooftop of our project pickup, which we called La Llorona—the Weeper. We all believed this pickup truck was possessed of a spirit too.

Typical bajareque (stave) siding and low-stone foundation course.

Emblem badges on the South Palace of the Nunnery Quadrangle, Uxmal. The Nunnery was the heart of authority for Puuc imperial rule. The Maya house was the symbol of its responsibility to the people of the realm.

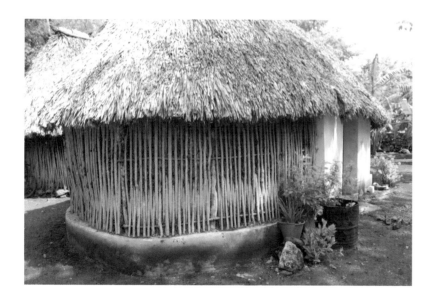

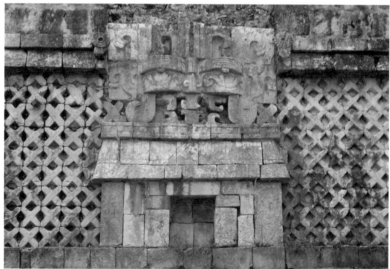

Maya Na

The great houses of the Maya are the temples—the ancient pyramid-temples and the colonial mission churches. But it is the humble house of the commoner that is the true cultural symbol of Maya endurance. For the Maya houses that stand throughout the peninsula have kept their design and construction over thousands of years. To my mind, the definition of Yucatán Maya culture is embodied and made homogenous by this traditional house design.

I believe that Yucatán traditional culture gives way at the banks of the Usumacinta River where the traditional house of Yucatán begins to change to houses of wood board. This transition applies to the Guatemalan and Belizean frontiers as well. In areas where Yucatecan is spoken, the Maya build up their houses using lashed-together wooden staves (*bajareques*). The roof is thatch, and house corners are typically rounded. This traditional design with whitewashed foundation and foundation course, the low white stone walls, and the bare-earth yard (and often bare-earth floor) holds true throughout the peninsula from the northeast coast to the Puuc Hills and the deep interior. The favored location for a Maya house in modern as well as ancient times was atop a small hillock, to avoid flooding and the better to catch small breezes.

A tour group gathers to hear about the echo-call of the quetzal bird from the steps of El Castillo, Chichén Itzá.

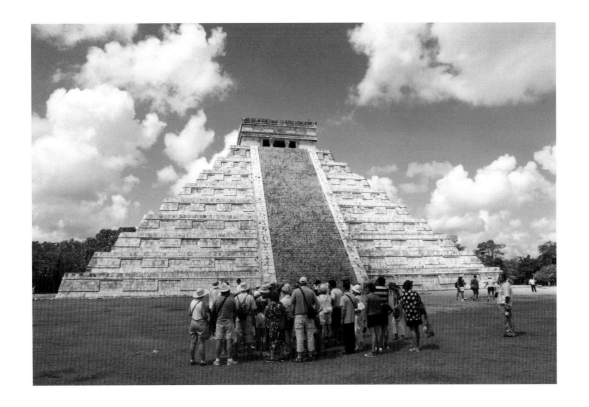

Tourism

2005 Yucatán Diary Excerpts—Thursday, July 7: Puerto Aventuras, Sunny and Bright

At lunch we watched the dolphins playing with the people in the lagoon. Five tourist swimmers at a time at one hundred dollars a pop and many folks lined up for their turn with the dolphins. This is subject matter for a new documentary.

Friday, July 8: Puerto Aventuras, Clouds to P.M. Thunderstorm

The thunderstorm passed in a couple of hours, and we drove down to Tulum, which was not edifying except in a negative way. I was last there in 1998 shooting the Tulum panorama that shows seven UFOs on the horizon. (Don't ask.) This time they had refashioned the entrance gate in order, I suppose, to control the immense crowds that pack the place at peak hours. They also have landscaped the grounds with plantings and walkways—more Disneyland more of the time. It is a shame that most tourists' experience of ancient Maya ruins is of

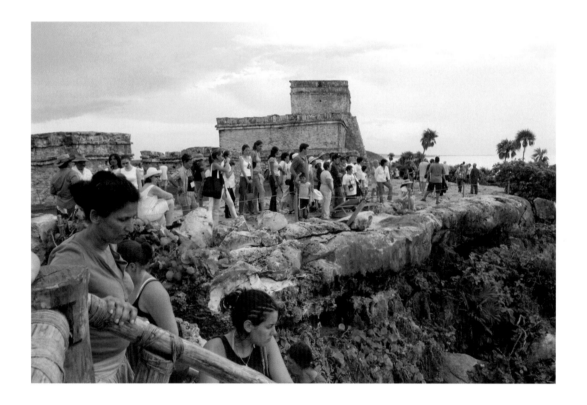

Tulum, a middling Postclassic site. I admit, however, that the sea is beautiful and serene as seen from the cliffs of Tulum.

After the ruins we drove the potholed dirt road to Maria's Cabañas for dinner. We had eaten here in the more rustic palapa back in 1991 when we stayed next door at the Cabañas Tulum. There were only three places on the beach in those days. Now beach hotels and palapas string along the beautiful straight strand for three or four miles. We stayed, enjoying the sight of the aquamarine surf, until the light had faded from the eastern thunderheads.

Thursday, June 14: Puerto Aventuras to Chunchucmil, Sunny Clouds
I dropped Nina off in good time at the Cancún airport and made good time to Chichén Itzá and the Villa Arqueológica for breakfast.

Walking through the Mayaland Hotel I noticed the fountain with the sculpture of Ixchel, the Maya Moon Goddess, pouring from her large water pot. (In Maya mythology the destruction of the world comes by means of a deluge poured out from a celestial water jug.) I have seen this in several places on the Maya Riviera as well, and there is an older version in the main square, the zocalo, in

A Maya girl videotapes in the Arch Group at Labná.

Valladolid. I'm always struck by her snow-white complexion in these sculptured monuments. I suppose you could say that the moon is white or silver faced. But she is always dressed in a huipil, the traditional Maya woman's dress, so I always wish (vainly) she had a Maya complexion.

They have moved the back entrance to the ruins so that the Mayaland guests have direct access. They also are building a defensive wall and a fake arch there too. This will probably be the new back entrance when they are done. I got into the ruins about ten o'clock, and the place was filling up. I overheard a guide tell his group that this was a ceremonial center only, and residences were seven kilometers away, and farms to feed everyone were twenty kilometers away. This was a story that was current fifteen years ago. Even then archaeological research had proved that explanation entirely wrong. I wonder when the tour guides will change that story. Also makes me wonder what other fantasy stories they tell the tourists?

I began photographing the tourists. I walked over to the Great Well of the Itzá, then to the Caracol and Monjas around noon. Many, many

Maya staff at the luxury resort Hacienda Santa Rosa in western Yucatán.

tourists by then, and all the vendors had set up along all the pathways, although not out to the Monjas. I noticed most groups now are internal tourists from Mexico and many from Spain.

I made good time to Chunchucmil. Major roadwork on the Kantunil-Mérida stretch. The *periférico* (peripheral road) is wonderful along the south side of the city, and the road to Chunchucmil is getting a major upgrade. I met with the two TV producers, Daniela and Ivan, who want to use my footage. Showed my prints to them and all and held a show-and-tell of the Waka' Project in the evening. I'm in

the casita hanging my hammock with Chris and Dylan, Arizona State and Harvard, respectively—5:30 a.m. wake-up call.

Tourist
I like to think that I view the ancient Maya ruins like an archaeologist, and that is true most of the time. But I am a tourist otherwise. What we see as tourists is the outside of the pyramids, which means only the latest building episode of the city. In Yucatán we mostly see the Terminal Classic and Postclassic periods of construction. And, since

Europeans at the Sacred Well, Chichén Itzá.

we view in almost all cases only the restored central and ceremonial precinct of these ruins, what we experience are the theatrical stage sets of the divine kings, or the ruling warrior elite in the case of Chichén Itzá. These were places where the lords of creation, the legitimizing forces of creation, and the attendant ancestors were conjured up to legitimize and intercede for the people. In a sense it is no different today in the way that theatrical tourism is brought into play. In the big ancient cities, the modern authorities stage dances and melodramatic light and sound shows. The great snake shadow appearing on El Castillo at equinox brings a quarter of a million new age tourists to Chichén Itzá, suggesting that these great ruined cities have become part of an international religion. They have become scenes of global pilgrimage, the ancient places becoming secular cathedrals. We expend enormous energy and intellectual talent studying them, developing them, making great journeys to stand in their ritual precincts. Then we worship in our museums the artifacts discovered in these sacred grounds—whether found by formal excavation or by looting. These reliquaries fetch enormous sums, just as the relics of saints and the life of Christ were bought and sold, at the level of national ransoms, during the medieval era.

The Age of Tourism follows all the other eras, the Pre-Columbian, the Conquest, the Colonial, the Caste War, and the Henequen Boom. And in telling the story of economic Yucatán, it brings us up to the present. The Maya have acted in, endured, and survived all these eras. I wonder if the fundamental culture of the Maya, created from three thousand years of civilization, can survive the transforming and destructive forces of globalization? This may be the flood that overwhelms them.

Street scene, Umán.

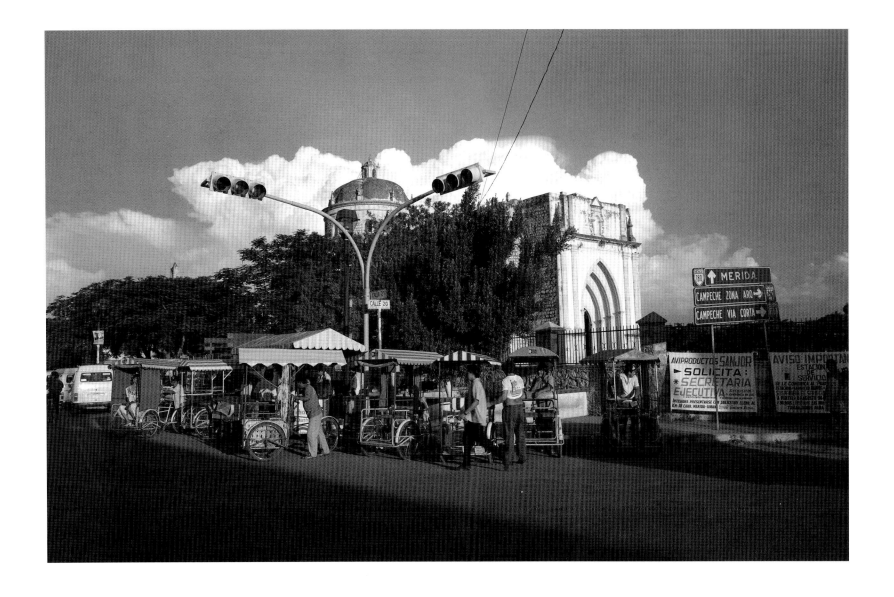

Epilogue

Viewing the pyramids at Palenque, a tourist asks,
" . . . but where did all the people go?"
Shaking his head, the tourist guide answers,
"We're still here. We never left."

—Guy Garcia Palenque

Resistance and Endurance

For the Spanish the Maya were the most difficult Native Americans to subdue. It required almost two hundred years before the last of the Maya kingdoms (the Petén Itzá at Tayasal) was conquered, and not until 1901 did the final, die-hard Maya forces lay down their weapons of the Caste War.¹ In large ways and small they are still not completely reconciled. The 1994 New Year's Day uprising of the Zapatistas in highland Chiapas was clearly a present-day episode in that ancient twenty-five-hundred-year-old tension between the Maya area and Central Mexico. The center of gravity in Mesoamerica has not rested always in highland Mexico, so this interlude of central power may be just that, an interlude.

By the time of the first European contact, Mesoamerican power had shifted to the Valley of Mexico once again, and the defeat of the Aztecs there merely continued the concentration of power in the central zone, this time by imperial Spanish authority. Under this regime, the Maya have these past 450 years lived with genocide, slavery, oppression, and exclusion. But they have survived by living with determination in their villages and by insisting on following traditional Maya lives, strongly aided by sustaining belief, however submerged or unconscious, in a spiritual story that has endured from ancient times.

Continuity

Holding to this primal story as the undercurrent to their lives, the Maya demonstrated repeatedly their deeply conservative nature. Through five centuries of catastrophe they have retained at heart their essential Maya-ness. In many ways, they are living still in the so-called contact period. The Maya continue the struggle with and adapt to the arrival of the Europeans. They are painfully aware of the shortcomings of their existence: the malnourishment, the inadequate education of their children, the lack of medical care, the lack of opportunity in a society that viewed them before as mere slave labor and mostly dismisses them now. And, above all, they still endure violent oppression, for in the highlands, in recent memory, they have suffered genocide. In spite of all that, they stand unconquered.

They have accomplished this through an implacable stamina and hardness that the Maya demonstrate on their lands. I traveled once with some farmers from Iowa through several backcountry towns where villagers were growing maize. These American corn farmers were astonished and impressed that anyone could coax any amount of produce from that stony ground. I won't say *soil*, because to say *soil* is to be too generous. To the unpracticed eye the land we were traveling through looked practically like bare limestone.

The Imagined Past

I was prepared and indeed I have come to admire the Maya people. But it is an admiration from an outsider looking in. I had wished that these personal observations and many years of travel in the Maya world would lift me out of my culture—if even for a brief moment—and into a true and authentic understanding of their ancient ways. That was a fantasy. The closest I got was to experience the white-hot heat of the

The fiesta at Mama—a traditional Maya town on the old Convent Trail.

The mission church at Mama with its fiesta colors.

Devotions during the fiesta at Mama.

Jarana dance—traditional Maya dancers waiting for the music to begin again.

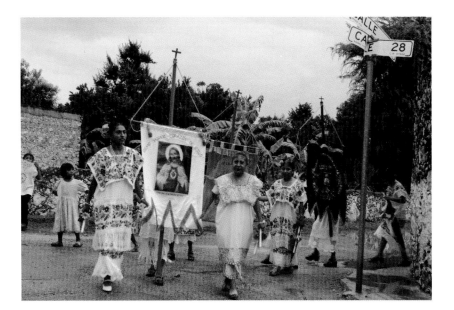

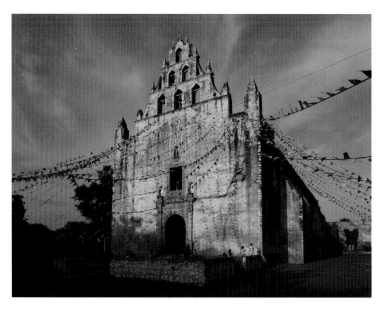

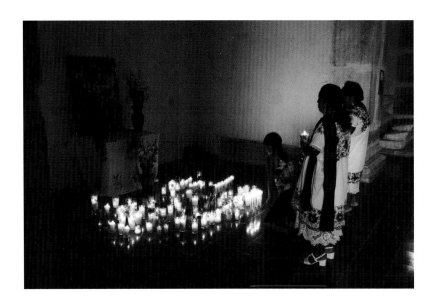

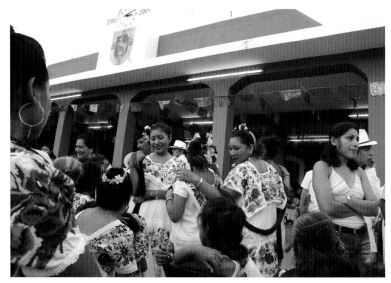

Yucatán sun, the humidity of the field and forest, and the beauty of the village Maya, their landscape, and the ruined cities of their ancestors. I could sense, but could not experience, why the gods of the ancient Maya had come into being.

I believe that what I had wanted, in an unconscious and inchoate way, was to find a lost heritage, a lost spirituality. In a way I did find it in the churches that the Maya had built under the Spanish conquest.

In these places I could experience the depth of belief and emotion that a people must sustain in order to survive under the hardship and rigors of the maize cycle. This spirituality is a necessary response, as well, to the fierce face that Yucatán presents every day to challenge human existence. When I stand in those spare and muscular churches I can sense the ancient ways and feel the connection to the spirituality of my childhood. For me it is a fusion of old beliefs, my old belief and theirs.

That was the closest approach I made. That, and watching don Pablo, the shaman, performing a rite of benediction or chanting the ancient ceremony of the Ch'a Chaak.[2]

Beauty of Yucatán

Nevertheless . . . what may have been my greatest gain was the simple grace of seeing beauty in that country. Seeing beauty may be most of what an artist requires. On one occasion traveling in the primordial jungle of the southern peninsula, I remember looking out from the summit of Structure II, the immense dynastic pyramid at Calakmul. From that vantage I could behold the unbroken forest laid out to the horizon in all directions. In that southern zone the Maya people abandoned their cities—and even their farms—more than a thousand years ago. Around this ancient superpower city the forest had not been cleared for milpa in that vast stretch of time. Looking at those jungle lands stepping gently down to the Mirador and Río San Pedro basins, I filled up with that primordial feeling of an earth and nature so ancient as to defy all our ambitions and destructive passion.

These sights and experiences, these beauties, often gave me the intuition that I was walking on sacred ground. Several times in the Yucatán Peninsula, in Chiapas, and in the Petén jungles of Guatemala, I witnessed a sudden rain of tree blossoms cover the ground all around me. On occasion in the ruins, and sometimes just in the forest, the hair stood up—for no apparent reason—on the back of my neck. I admit these were rare events and have not happened to me in other places. But here in these ancient cities, I was and am aware that the ancient people constructed them to a cosmological design—that they are maps of the cosmos inhabited by gods, ancestors, spirits, and people. I also know that the temples at the pyramid summits are like the altar that don Pablo erects to appeal to Chac, the Rain God. These are all portals to the otherworld: they can be opened and closed, and messages may be passed back and forth. I believe these portals operate still. Even so, I did not put much weight on sensing the *genii loci*, but in the ruins I did feel them on occasion.

They never struck me as good or evil, that particular duality, but rather as benign or fierce. Almost all the ones I sensed in the ruins seemed benign. Once, however, I saw a representation of the fierce kind of spirit at the Courtly Art of the Ancient Maya exhibition. I saw this show at the Legion of Honor museum in San Francisco, and in there I saw a face, a white masked figure from Palenque. It was not evil, but it expressed in material form, with its terrible beauty, its premodern intensity, what I had felt on one occasion at the jungle site of El Perú-Waka' in northern Guatemala. It was a Maya face that knew the dark ways of the world. It knew the beauties and terrors of existence and understood the merciless, amoral deities that govern our fate on earth.

Maya Yucatán

The Maya people and their culture still live in Yucatán. They live in and among the different historic strata there. They are the fundamental layer; everything else in Yucatán is built upon their foundation, despite the conquest and colonial periods. These latest periods, conquest and colonial, are only five hundred years along. Yet in Yucatán the ancestors lead back three thousand years or more. The system they developed for growing maize in the limestone country has survived to this day, and the contemporary Maya, in their folkways and fortitude, in their stubbornness, their cultural stamina and patience, reflect those three millennia of living on this land. In their small traditional pueblos, in the

Timeless Yucatán—a late rainy season sky and an old Maya house in a henequen field.

cities and towns as well as in the capital Mérida, the Maya people of Yucatán are the enduring civilization.

I've been looking at Maya art for three decades, and I have come to some general feelings about it. In viewing all the gods of the Maya pantheon I understand the completeness of their universe. Theirs is not a broken world, but a pragmatic and knowing one. In their art, the ancient Maya recognized the symmetry of existence. They saw that it was a balance between the ecstasies of creation and the terrors and regrets of mortality. To my mind, the sureness and authority of Maya artists shines forth from the conceptual perfection of their universe, and particularly with regard to the story of its genesis.

It was my great privilege to witness Maya art through my association with archaeologists. Beginning in 1990 I worked with several excavation projects in the Yucatán Peninsula and Guatemala and traveled in Chiapas and Belize. This past summer of 2008 I returned to Kiuic and Yaxuná to continue my work there. During those eighteen years I captured many thousands of images and many hours of video interviews with dozens of archaeologists. In the end, though, the most satisfying artwork for me was not in a form for which I am known, a photograph or some video footage. No, the most satisfying was a chalk pastel. This small work was a direct response to the benediction ceremony that don Pablo had performed as part of his shaman duties within the archaeological project at Yaxuná. In this depiction, against a black background of a dark, starry night, I drew the pale golden-white road to the ruins. Then I set down don Pablo's altar, with its attendant glowing cross. Next I drew a chicken claw pulsing in its aura, which represented the stew vessels set beneath the altar with their several chicken feet sticking up. Mentioned elsewhere in this book, this benediction had an enormous effect on me and became one of the signal experiences of my life. That experience lives on in the little chalk pastel, a bit of memory floating somewhere in the world.

Notes

Chapter One

1. Keith Muscutt's explorations in the Chachapoyas domain of mountainous northern Peru can be followed in his UNM Press book *Warriors of the Clouds*, as well as the two-hour Discovery Channel documentary that shows his struggles to protect Chachapoyas cave mummies.

2. He lived from AD 682 to 734 and was first known as Ruler A when his tomb was discovered. Found deep in the interior of Temple 1, he led the resurgence of his city in the early eighth century, defeating the powerful city of Calakmul and capturing its king. He was also known to Mayanists as Ah Cacao.

3. The henequen plant with its thick, swordlike leaves is a species variety of the agave cactus family. It was the basis for a vast plantation system that produced sisal rope and twine. This strategic product, crucial to the industrial twining requirements of American mechanized farming as well as to the rigging for sailing ships, brought fabulous wealth to the white European inhabitants. But this production on the plantation haciendas in the latter half of the nineteenth century virtually enslaved the Maya populations of the northwest peninsula.

Chapter Two

1. Scholars generally understand the Terminal Classic period in the Northern Lowlands as AD 900–1100; in the Southern Lowlands, this period began a century earlier at AD 800–900.

2. Changes in art and other cultural styles are used to demarcate the period transitions. Another interesting marker for these transitions is the influence—or the rise and fall—of leading cities of the various regions. For example, the Maya cities of the El Mirador complex in present-day northern Guatemala held sway during the Late Preclassic period. When these cities collapsed circa AD 200 (this was the other, earlier great collapse of the southern Maya), the center of gravity shifted to Teotihuacán and its domination of Mesoamerica in the Early Classic. Teotihuacán was overrun and burned about AD 600, and the focus shifted back to the Maya superpowers of Tikal and Calakmul, which carried on their alliance wars throughout the Late Classic. In their turn, these Southern Lowlands cities collapsed circa AD 900, and the leadership mantle shifted to Uxmal and then Chichén Itzá in the north. By the Late Postclassic, around AD 1400, the Aztecs began their imperium in the Valley of Mexico, and thenceforth, through the conquest, the dominant power in Mesoamerica has remained there.

3. Pope John Paul II made a special point to make the great convent at Izamal the focal point of his 1994 visit to Yucatán. He was clearly signaling that his church, the venerable institution, remembered well the authority of Izamal in the history of the peninsula.

4. Built from the temple stones of Tiho, the Maya city that stood where Mérida stands now, San Idelfonso was the first cathedral built in the New World. Compare this cathedral of the Maya to the smaller church, Templo de la Tercera Orden de Jesús, two blocks to the north. Consecrated in 1618 as a Jesuit church, its gilt altar and decorations, its large frescos and oil paintings covering the walls, and its general luxurious tone reveal its status as a parish house of a higher social status.

5. See David Freidel's passage from *Maya Cosmos* that describes the Maya Foliated Cross at the Yaxcabá mission church, pages 173–75.

6. The Mani, or the Convent Trail, was that circle of missions south of Mérida that centered on the principal Franciscan monastery at Mani, established there in recognition of the crucial role that the Xiu clan had played in the early battles of conquest in the northwest peninsula.

7. Trova is the performance of traditional guitar ballads of old Yucatán. Some of the finest music I have ever heard was folk performances of these out in the country beyond Mérida whose own trova clubs feature excellent singing and playing as well. The word *trova* has the same etymological root as *troubadour*. Nearby Cuba also possesses a trova tradition that was closely shared in colonial times with Yucatán.

8. The milpa system is the traditional Maya planting technique that features intercropping of maize, beans, and squash, the three sisters of Mesoamerican agriculture. In the milpa cycle, past and present-day Maya farmers clear areas of forest, burn the slash, and plant the maize seed in the ashes. They use the milpa plot for two years and in Yucatán allow up to twenty years of fallow to allow regrowth of the forest. Using this fallow system, the milpa process can be sustained indefinitely.

Chapter Three

1. Cenote (sey-NO-tey)—from the Yucatec Mayan *dznot*, meaning "sacred well." Usage note: the word *Mayan* is properly used exclusively when referring to Mayan languages. All other noun and adjective instances should use the word *Maya*. In other words, the phrases "Mayan pyramid" or "Mayan people" are incorrect usage.

2. The villagers of Yaxuná in central Yucatán have a word for the scrub jungle and the countryside that surrounds their town: el monte. The traditional Spanish meaning of this word is "mountain." But in central Yucatán it can indicate also the forest, jungle, or the wild country beyond the borders of their maize fields (milpas).

3. Chultuns are underground recesses and chambers for food or water storage. Food storage chultuns can be rough and unfinished and sometimes quite small, the size of a man or two. I've often stumbled across several of these underground storage holes while exploring palaces or even humble house mounds. Water chultuns or cisterns underground were sealed with plaster or clay and can be quite large, as they would need to be to carry over through the several months of the dry season.

4. At Yaxuná in the early to mid-1990s during a three-year drought, the crisis point arrived each year as the crop failed at the time of the annual canícula. By the end of the growing season in the second year the pueblo was so desperate that the government shipped in relief corn so that the people would not starve. The Yaxuná Archaeological Project also contributed a truckload of maize. Yaxuná was not the only mid-Yucatán town in these straits, and the situation continued into the third year. The region directly in the center of the peninsula is more vulnerable to these dry spells, for on average it sees less rainfall than the areas closer to the coasts.

Chapter Four

1. David Lee (personal communication).

2. "David [Lee] discovered a large mud patch in the southern wall of the room he excavated in 2005, and he went through that hole in 2006 and found an elaborate very Late Classic reverential termination ritual deposit. This deposit includes large ceramic drums, one of which has a polychrome painted scene of the presentation of a plated helmet—likely a ko'hal. The destruction of this palace facade must have been a major undertaking, and the hiatus between this event and the final staircase is a period of interest that is not well understood as yet" (David Freidel, personal communication).

3. I have boundless admiration for their brilliant work—they truly have made marvelous, even revolutionary, breakthroughs. For their dedication to their students we should hold out equal esteem. Their reward for this dedication is to see, in the past decade, many of their students proceeding to their doctorates and becoming excellent scholars, professors, and directors of their own research projects. I count myself most fortunate to have witnessed this fine tradition at work in Yucatán archaeology.

4. I've had arguments with some of the Yaxuná archaeologists about the true "scientific" nature of their work. They—not all—argued that archaeology is a social science and therefore not science in the strict sense. My view is that archaeologists use scientific method and scientific technology in the conduct and analysis of their excavations, and therefore they are scientists.

Chapter Six

1. Written in the Yucatecan Mayan language but recorded in Roman letters, the Chilam Balams are oral histories and prophetic works originating in the Postclassic period of Yucatán.

2. *Alux* (ä loosh'), Mayan plural: *aluxob*. Spanish plural: *aluxes*.

3. At the time of this writing, Travis has managed to return to Yaxuná with a project to map/survey the greater environs of the city. It will be interesting to see any evidence of the ancient frontier zone with Chichén Itzá, the sacbé region to the east, and the citadel of Sakuil also standing high on its limestone outcrop to the east. Traci went on from Chunchucmil to found and direct the Xuenkal Project.

Chapter Seven

1. The name *Pakbeh* is a made-up name from two Mayan words meaning "wall street" after the unique albarradas, or low-lying stone walls, that surround the residential compounds and line the pathways/alleys of the city.

Chapter Eight

1. I've seen the name of the place spelled several different ways: Kihuic, Kiwick, Kiwic, and Kiuic on a late-edition road map.

Chapter Nine

1. Morales is famous for producing with his artist wife, Patricia Morales, some of the loveliest reproductions of Maya polychrome pots. Rodrigo fashions the pots themselves, and Patricia, with her sure hand, paints the intricate designs, copied mostly from Classic period polychrome vessels. Their shop-studio is located in Muna, on the north end of town.

Epilogue

1. In isolated villages in the southeast peninsula region, the remnant Cruzob, the people of the Chan Santa Cruz, still have not admitted defeat.

2. Don Pablo taught me another lesson. His practice as a shaman of the Maya stands as a model for contemporary artists. Artists, like the shaman, should be embedded in their social orders, not alienated from them. Like the shaman, artists should open the portals to the Otherworld and handle the messages that pass back and forth between the worlds.

To contact the author:

phillip.hofstetter@csueastbay.edu

Maya Yucatan Blog at: http://maya.csueastbay.edu/